THE STAIR-STEP EXPOSURE SYSTEM FOR COLOR SLIDE PHOTOGRAPHY

THE STAIR-STEP EXPOSURE SYSTEM FOR COLOR SLIDE PHOTOGRAPHY

A Practical Approach to Accurate Color Slide Exposure

George P. Hypes
Carol L. Hypes

VNR VAN NOSTRAND REINHOLD COMPANY
New York Cincinnati Toronto London Melbourne

Published by Van Nostrand Reinhold Company Inc.
135 West 50th Street
New York, New York 10020

Van Nostrand Reinhold Company Limited
Molly Millars Lane
Wokingham, Berkshire RG11 2PY, England

Van Nostrand Reinhold
480 La Trobe Street
Melbourne, Victoria 3000, Australia

Macmillan of Canada
Division of Gage Publishing Limited
164 Commander Boulevard
Agincourt, Ontario, M1S 3C7, Canada

16 15 14 13 12 11 10 9 8 7 6 5 4 3 2 1

Library of Congress Cataloging in Publication Data
Hypes, George P
 The stair-step exposure system for color slide
photography.
 Bibliography: p. 158
 Includes index.
 1. Photography—Exposure. 2. Color photography.
I. Hypes, Carol L., joint author. II. Title.
TR591.H96 778.6 80–18447
ISBN 0-442-25424-5

CONTENTS

PREFACE

Being able to correctly expose a high percentage of the frames on a roll of color slide film is important to all photographers. The stair-step exposure system for color slides enables any photographer to learn how to correctly use an exposure meter and calculate the correct exposure for a color slide under a variety of lighting conditions.

The stair-step exposure system uses the Munsell color classification system and adaptations of United States National Bureau of Standards color names as the foundations for an exposure system that is based on color theory and color classification. By learning to visualize your slide before taking the picture and by understanding the basic middle-gray principle upon which an exposure meter is designed, you will be able to predict the appearance of your color slides.

The principles in the stair-step system can be applied to multiple exposures, montages, duplicate slides, and titles for programs, as well as to the exposure of color movie film. Using this system will markedly increase your satisfaction with photography as a profession or hobby.

This book is the result of extensive research and contains information never previously published. A list of carefully selected books and articles for additional reading is in the annotated bibliography in the back of the book. These books and articles will be especially helpful to the beginning photographer and to photographers who have never photographed montages, multiple exposures, titles, or slide duplicates.

We wrote this book after many years of frustration and disappointment caused by our inability to obtain a high percentage of correctly exposed color slides. This marred what was otherwise a delightful hobby. Searching through libraries made us keenly aware that no books or photography magazine articles

described how to expose color slide film precisely. We could find no photography books, pamphlets, or articles that provided definitive explanations on how to obtain correct exposure. Information about exposure was limited either to a paragraph or to a couple of pages. These authors nearly always concluded by stating that the only sure way to obtain accurate exposure was by bracketing— taking several pictures of the same subject at different exposures. This lack of information existed in spite of the fact that Kodachrome movie film was introduced in 1935 and Kodachrome slide film, in 1936. We were convinced that an accurate method of exposure less wasteful than bracketing could be devised.

In 1967 we purchased our first Asahi Pentax one-degree spot meter. Until we learned how to use the spot meter, the initial results were far worse than those we had obtained with our hand-held averaging meters. We were not then aware of the middle-gray principle of exposure meters. We soon discovered a successful pattern in the use of the spot meter, however, and we worked to systematize the pattern. We began the manuscript for this book in 1973 after collecting data. In 1975 we discovered that we could relate our eleven-step exposure scale to the principles of the Munsell color classification system. We purchased ten basic color charts (Glossy edition) and the gray scale from Munsell Color. We also obtained a publication by the United States National Bureau of Standards that gave color names to some of the hue, value, and chroma samples of the Munsell system.

After continued experimentation and analysis, we perfected simple data forms to assist in data collection and to enable others to quickly learn our exposure system. We discovered that our techniques could be applied to multiple exposures, montages, slide duplication, and titling for programs, and we consequently developed the multiple-exposure and montage calculator charts. In 1977 we developed the value-selector chart and exposure slide rule. These accessories, combined with the Munsell color classification system and adaptations of the National Bureau of Standards color names, enabled us to clearly explain our exposure system based on standard color terminology.

We searched through thousands of pictures that had been taken when developing the system and selected slides that clearly and simply illustrated the exposure principles for each of the basic colors. After thirteen years of research, experimentation, and analysis, including eight years of writing, the manuscript was completed in 1980. The application of this system of exposure is not limited to the current films on the market, nor to specific equipment available at the time this book was written. The concepts set forth will not become obsolete with changes in film and equipment. It is for this reason that there is minimal mention of film names and equipment. Black-and-white versions of some color slides have been used in the book for reasons of economy when they did not detract from the points being discussed. The values in the black-and-white prints coincide as closely as possible to the values in the original color slides. Although the discussion herein is limited to color slides, the exposure principles are applicable to color-movie film as well.

We now offer the comprehensive stair-step exposure system for color-slide photography to amateur and professional photographers around the world.

INTRODUCING THE STAIR-STEP EXPOSURE SYSTEM

I

INTRODUCTION TO THE STAIR-STEP EXPOSURE SYSTEM

<div align="right">1</div>

The stair-step exposure system is a practical, comprehensive, and easy method of precision color slide exposure. The accuracy of the system will enable you to obtain rich, deep colors, black shadows, and dark blue skies when desired and to determine precise exposures for pastel hues. You can work with color to reproduce a literal representation of the subject or to create a special mood. The stair-step system value-selector chart and exposure slide rule guarantee results close to the picture you envision. The unique montage calculator reveals how you can determine in advance whether the exposure of one frame will properly combine with the exposure of the second frame to create a montage. The multiple-exposure calculator assures accuracy in multiple-exposure pictures. The system may also be used in a simple technique for making title slides for slide presentations. Stair-step exposure principles will enable you to duplicate color slides for enhanced contrast and creative effects without guessing at exposure and wasting film. And, finally, you may analyze and understand your previous photographic exposure errors to help you avoid such errors in the future. In addition to saving you film because of increased exposure accuracy, the stair-step exposure system expands the potential for adventures in color photography.

This book describes the principle upon which exposure meters are designed. No meter will give correct exposures under all conditions for all types of film without modification of the readings. You must, therefore, learn to use the meter reading as a point of departure in determining the correct exposure for each picture. Exposure latitude in color slide film is minimal because the slide is the finished product—there is no printing procedure in which exposure errors can be corrected. Reliable and consistent color-slide development makes it possible to use uniform

exposure methods and obtain excellent results. Beginning photographers will find the techniques practical and easy to understand. Advanced amateurs and professional photographers will benefit from the exposure refinements and creative potential of the system. Many old ideas must be discarded when adopting these precision exposure techniques.

HUE, VALUE, AND CHROMA

The stair-step exposure system is based on widely recognized concepts of color theory and color classification, combined with extensive experimentation. In order to obtain the slide you envision, you must know how to identify the colors you wish to reproduce. An understanding of hue, value, and chroma is therefore essential in determining precise color-slide exposure. *Hue* is the color itself. Typical hues include blue, green, orange, red, yellow, and purple. The term *value* refers to the amount of lightness or darkness in any color and in gray. Values are generally referred to as white, light, middle, dark, and black. White and black are at opposite ends of the value scale. Every hue has light, middle, and dark values. *Chroma* indicates the purity or intensity of a hue. Vivid red, rich violet, bright yellow, and brilliant orange are examples of high-chroma colors. Dull colors that contain gray, such as slate blue, are examples of low chroma. Brown is a low-value, low-chroma version of orange, red, and yellow.

MIDDLE GRAY AND MIDDLE VALUE

An understanding of *middle gray* is essential to anyone who uses an exposure meter, including built-in camera meters. Middle gray in the stair-step system reflects 19.77 percent of the light falling upon it. Middle gray actually falls exactly between black and white, even though, logically, you may think 50 percent reflectance should be the middle-gray figure. *Middle value* is the colored counterpart of middle gray. Every hue has a variety of values, including middle value. The term *middle value* as used in the stair-step exposure system includes middle-gray and middle-reflectance samples of all hues. The reflectance of middle value in the stair-step system is centered on 19.77 percent, encompassing a range from approximately 15 percent to 22 percent reflectance.

MIDDLE GRAY AND EXPOSURE METERS

Exposure meters that measure reflected light are designed to convert any single value to middle value. Many photographers find this middle-value principle difficult to believe because they seldom photograph a single-value subject and analyze the result. Comprehension of the middle-value principle is essential to effective use of a reflected-light exposure meter with any type of film, because it is the point of departure from which accurate exposures are determined. If a black card is photographed according to the meter reading, the resulting film will be middle gray, rather than black. If a white card is photographed according to the meter reading, the film will be middle gray, rather than white. If a middle-gray card is photographed according to the exposure meter reading, the result will be middle gray. If a dark blue sky is exposed according to the meter reading, the result will be a middle-value blue sky rather than a dark blue sky. If a pink object is photographed and the meter reading is followed, the result will be a middle-value grayish red. The conversion of any one value to middle value and the averaging of a group of values to middle value occur regardless of the film used.

ELEVEN BASIC VALUES IN THE STAIR-STEP EXPOSURE SYSTEM

The stair-step exposure system contains eleven basic steps. Each step will produce specific colors. The steps are one-half f/stop apart. The middle step is the point of departure for the system. This point is a logical choice because the meter will dependably convert all values to middle value regardless of color. Because each step reproduces a predictable value, you can control the amount of darkness or lightness produced in the color you photograph. The nine steps in the middle of the eleven-step range are designated for scales of colors and of gray. The other two steps are white at the top of the range and black at the bottom.

CODE NAMES FOR EACH STEP

Each step has a simple, meaningful code name. The middle step is known as *Step MV,* which stands for *Step Middle* Value. It is the value obtained by exposing at the meter reading. The five steps above Step MV are known as the *L* steps, indicating that they are used to reproduce values progressively lighter than middle value. Each receives progressively more exposure than the meter reading indicates. The top step is the *LW* step. It is reserved for exposure of textureless white objects. The five steps below Step MV are the dark value steps, known as the *D* steps. They are used to reproduce values progressively darker than middle value. Each receives progressively less exposure than the meter reading indicates. The bottom step, black, is known as the *DB* step.

The stair-step exposure system requires photographers to work with one-half f/stop increments. The numbers associated with the letters *L* and *D* indicate how many f/stops each step is from middle value.

The first step above Step MV is called *Step ½L* because it is one-half f/stop lighter than the meter reading. The second step above Step MV is *Step 1L,* one f/stop above middle value. To reproduce a value one f/stop lighter than Step MV, adjust the lens aperture to give the film one f/stop more exposure to light than the meter reading indicates. The same result can be achieved by using the next slower shutter

1-1 Names of each basic step in the stair-step exposure system.

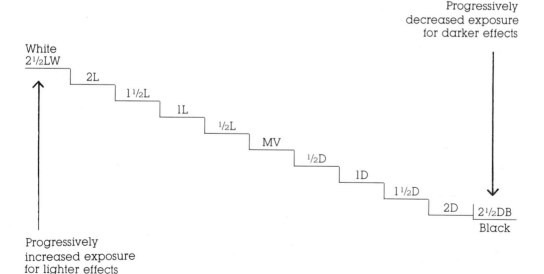

Progressively decreased exposure for darker effects

White
2½LW

2L

1½L

1L

½L

MV

½D

1D

1½D

2D

2½DB
Black

Progressively increased exposure for lighter effects

speed, because shutter speeds on most modern cameras are arranged in equivalents of f/stops. The first step below Step MV is *Step ½D*, one-half f/stop darker than Step MV. It is obtained by giving the film one-half f/stop less exposure to light than the meter indicates. The fourth step below Step MV is *Step 2D*, two f/stops darker than middle value. All of the other steps are coded in a similar manner.

TEXTURE IN THE STAIR-STEP SYSTEM

Texture consists of details visible in a subject or on its surface. Some surfaces are very smooth and have no texture, such as the painted surface of an automobile. Other surfaces, such as a lawn, have much texture. Texture is not determined by the sensation you receive when you touch an object; rather, it is evaluated according to the amount of detail you *see* in a subject. Thus, new furniture may be smooth to the touch, but its visible grain is considered texture within the definition of the stair-step exposure system.

Texture consists not only of shadows and highlights, but also of color variations. For example, a piece of cloth described as being a certain color may have threads in the material that vary in color and also produce highlights and shadows. This is texture. The direction of light striking the surface of any object influences the amount of visible texture. Strong sidelight accentuates texture. Front light or diffused light may either minimize or eliminate texture.

Maximum texture is visible when a subject is exposed at middle value. As exposure is progressively darkened through the D steps, texture gradually disappears into black at Step 2½DB. When exposure is gradually lightened from Step MV through the L steps, texture progressively disappears into white at Step 2½LW. In actual practice texture must be evaluated for each object: texture may need to be sacrificed for precision color exposure or, to achieve optimum texture, color value may need to be compromised. The amount of theoretical texture for each step can be described as follows:

Step	Amount of texture
2½LW	None
2L	Minimum
1½L	Adequate
1L	Considerable
½L	Extensive
MV	Maximum
½D	Extensive
1D	Considerable
1½D	Adequate
2D	Minimum
2½DB	None

CORRECT AND INCORRECT EXPOSURE

Exposure is the process by which light-sensitive chemicals on the film are subjected to rays of visible light. These chemicals change when light enters the camera lens and shutter. For each type of film, unique developer chemistry and procedures eliminate the sensitivity to light and cause the photographed images to become visible on the film. *Correct exposure* signifies that the major proportion of the picture, the entire picture, or the center of interest has colors reproduced in values that literally represent the subject or that interpret a mood envisioned by the pho-

tographer. *Incorrect exposure* means that the values of these colors are unacceptable. The photographer's objective when determining exposure is to reproduce the majority of colors within his or her preconceived notion of an acceptable range of values and textures. For some subjects, such as blue sky, the exposure range can encompass three f/stops or more. For colors such as yellow and orange, the range of permissible exposure may be limited to only three stair-steps.

Overexposure occurs when all or selected colors are too light to be acceptable. *Underexposure* means the colors are too dark. Inappropriate amounts of texture may accompany overexposure and underexposure. For example, an overexposed snow scene loses texture. An underexposed snow scene has too much texture. An underexposed shadow loses the hue and texture within the shadow. The words *underexposure* and *overexposure* are frequently but inaccurately used to describe exposures that are different from those the meter indicated. Adjustments from the meter reading are usually needed to obtain correct exposure. The accuracy of exposure can be evaluated on the screen.

Saturated exposure describes the reproduction of colors in acceptable values that are darker than the original subjects but not dark enough to be considered underexposed. *Desaturated exposure* refers to colors reproduced lighter than the original subjects but not light enough to be labeled overexposed. Personal preferences determine if the colors in a picture are considered saturated or desaturated.

ASA, ISO, DIN, AND EXPOSURE-INDEX FILM-SPEED RATINGS

ASA stands for the American Standards Association, now called the American National Standards Institute, Inc. ANSI sets film speeds in the United States. These correspond with the DIN ratings in other parts of the world. For standardization purposes, ASA and DIN ratings are soon to be replaced by ISO ratings. The new designation stands for the International Standards Organization, which is a federation of the world's national standard bodies. During the transition period, film cartons will carry ASA, DIN, and ISO ratings. The actual numbers of the film speeds will stay the same, preceded by ISO. Any film-speed variation from the ASA, ANSI, DIN, or ISO standards should technically be referred to as the exposure index. The terms are, however, used interchangeably by photographers. Moreover, the term ASA is so deeply ingrained in photographic language that it will be used to encompass ANSI, DIN, ISO, and exposure index throughout this book.

ASA film speeds assist photographers in obtaining correctly exposed films. Each film has its own sensitivity to light. Films with low ASA numbers, such as ASA 25, are slow films, and they require more light than films with high ASA ratings, for example, ASA 400. A film with an ASA of 25 requires twice as much light as an ASA 50 film and four times as much light as an ASA 100 film. Color slide films must be exposed within a five f/stop parameter, with the ASA number at the center of the parameter. Several other variables must also be evaluated to obtain accurately exposed slides. The major variables are screen size and surface. Slides projected on a lenticular or matte white screen are one f/stop darker than when projected on a glass-beaded screen. Conversely, slides projected on a glass-beaded screen are one f/stop lighter than when projected on a lenticular or matte white screen. One f/stop is equivalent to doubling or halving the ASA. Slides projected on an eight-foot glass-beaded screen are one f/stop darker than if projected on a six-foot glass-beaded screen. Slides projected on a six-foot lenticular or matte screen will be one f/stop darker if projected on an eight-foot lenticular or matte white screen. Thus, if the

photographer uses an ASA adjusted for a six-foot glass-beaded screen, the slides will be two f/stops darker if projected on an eight-foot lenticular or matte white screen.

Moreover, variations among projectors and cameras influence the ASA selected. The camera shutter must be accurate. The amount of light that actually reaches the film can vary from one lens to another at given f/stops. The quantity of light produced by projectors varies according to bulb wattage, lens aperture, and condenser systems. Two bulbs of the same wattage but of different design may project different amounts of light. The darkness of the room where films are projected influences the appearance of the slides. Most photographers select ASA ratings based upon projection in totally dark rooms.

If the majority of slides are consistently too dark, the ASA should be progressively lowered until the correct ASA for the equipment and color-saturation preference is determined. For example, if the majority of pictures exposed on ASA 50 are too dark by one f/stop, reduce the ASA to 25. If most of the pictures are too light, increase the ASA accordingly. ASA adjustments are usually made in one-third f/stops, according to the numbers on the meter. Carefully evaluate the majority of pictures on each succeeding roll of film, making additional ASA refinements until the precise film speed for your color preferences and equipment is determined.

ENVISIONING SLIDES IN THE STAIR-STEP EXPOSURE SYSTEM

Being able to envision what a color slide should look like is one of the most important tasks in determining exposure. Ideally, what is projected on the screen will be exactly what you envisioned when taking the picture—if you used the correct exposure. (This final image need not, incidentally, be an accurate reproduction of what your eyes saw. You may want to darken or lighten colors to create a particular mood, for example. The colors in the final slide will not be the exact colors you saw, but they will be the colors you envisioned.) The stair-step system will teach you to see in your mind's eye how each part of the picture will appear at several tentative exposures, enabling you to choose the exposure best suited to the subjects, textures, colors, and contrasts that you envision. The use of the color names and texture descriptions on the value-selector chart and on the exposure slide rule make it easy to envision the best exposure. These exposure techniques also apply to color reversal movie film equivalents of slide film.

GENERAL DESCRIPTIONS OF THE STAIR-STEP VALUES

The following descriptions of the stair-steps reveal how various colors are reproduced when exposed on certain steps. These color descriptions also indicate the proper steps for exposure of many colors. Knowledge of the color names will help you envision the results of several tentative exposures, from which you will select the best exposure. The words *light* and *dark* will be used to qualify specific color names. For example, on Step 1L, note that there is a light kelly green and a dark pink. More detailed descriptions of each color on these steps will be found in Part 2.

THE STEPS

Step 2½LW(white). Exposure on Step 2½LW requires two and one-half f/stops more light than the meter reading indicates. If, for example, the meter reading calls for f/16, the adjustment to Step 2½LW requires a setting of f/6.3 (between f/8 and f/5.6). A color should be exposed on Step 2½LW only for special purposes, such as taking pictures of excessively contrasty subjects in which the dark values require sufficient exposure to retain color and texture. A large area of color on Step 2½LW will appear overexposed. Step 2½LW should be reserved only for white, nontextured objects, usually those that constitute a small proportion of the picture format. Step 2½LW is the color-transparency equivalent of a pure white area in a print that reflects 90 percent or more of the light falling upon it.

Step 2L. Exposure at this step is obtained by opening the lens aperture two f/stops more than the meter indicates. For example, the change might be from f/22 to f/11. It could also be done by using a slower shutter speed, such as 1/30 rather than 1/125. Minimum texture is preserved on Step 2L in textured objects. This step should be reserved for white and whitish colors: whitish baby blue, whitish blue green, whitish green, whitish vivid yellow, whitish orange, whitish pink, and whitish beige. This is the lightest step to use for reproduction of colors. It is the transparency equivalent of a value in a photographic print that reflects 79 percent of the light falling upon it.

9

Step 1½L. This step requires one and one-half f/stops more light than the meter indicates. Adequate texture is maintained in light-value subjects such as snow, white sand, and colored objects. This step is therefore ideal for these types of subjects. Colors that are correctly exposed on this step include baby blue, pastel turquoise, light green, light vivid green yellow, vivid yellow, light vivid orange, baby pink, light beige, purple pink, and light lavender. Step 1½L is the darkest step on which yellow should be exposed. Step 1½L is the color-slide equivalent of an area in a print that reflects 59 percent of the light falling upon it.

Step 1L. This step requires one f/stop more exposure than the meter indicates. Considerable texture is retained in medium light gray and colored subjects that have texture. It is the darkest step to use for large proportions of snow or other white objects in sunlight. Their rendition will be light gray. Step 1L is usually the lightest step on which to expose blue sky. Names for colors correctly exposed on this step include dark baby blue, bright turquoise, light kelly green, vivid green yellow, dark yellow, dark pink, vivid orange, skin beige, dark purple pink, and lavender. Yellow becomes too dark when exposed on Step 1L. This is the ideal step for exposure of the high-chroma colors orange and yellow green. It is the color-slide counterpart of a color in a print that reflects 43 percent of the light falling upon it.

Step ½L. Step ½L requires opening the lens aperture one-half f/stop more than the meter reading indicates. For example, if the meter says f/11, the adjustment would change it to f/9.5 (between f/11 and f/8). Extensive texture is preserved on this step in medium gray and in colors. Typical names of colors that should be exposed on Step ½L include very light blue sky, vivid turquoise, kelly green, dark vivid green yellow, mustard yellow, dark vivid orange, coral red, dark beige, light red purple, and dark lavender. Bright yellow should not be exposed on Step ½L; antique gold or mustard are versions of yellow correctly exposed on this step. It is the transparency equivalent of a color in a print that reflects 30 percent of the light falling upon it.

Step MV. Step MV is obtained by exposing at the camera settings indicated by the meter reading. This step is the point of departure for determining exposure in the stair-step system. All versions of hues described for the L steps will be darkened to the descriptions for colors at this value if the exposure-meter reading is followed, resulting in saturated or underexposed colors. The descriptions of colors and values for the D steps will be lightened to the descriptions for Step MV if the meter reading is followed, resulting in desaturation or overexposure. Maximum texture is reproduced on this step for middle gray and middle-value colors. Colors that should be exposed on middle value include: middle gray, light blue sky, turquoise green, dark kelly green, medium green yellow, olive yellow, dark orange, crimson red, light brown, medium red purple, and middle violet. Step MV is the color-slide equivalent of an area in a monochrome or color print that reflects 19.77 percent of the light falling upon it.

Step ½D. Step ½D is obtained by exposing one-half f/stop darker than the meter reading indicates. For example, the change might be from f/4.5 to f/5.6. Extensive texture is preserved in textured medium dark gray and in hues exposed on this step. Colors to be exposed on this step include sky blue, deep turquoise, pepper green, dark green yellow, light olive, very dark orange, bright red, brown, vivid red purple, and vivid purple. This is one of the three best steps for exposing blue sky. Dark-value subjects will not blend with Step ½D blue sky. Step ½D is the transparency equivalent of a print that reflects 12 percent of the light falling on it.

Step 1D. Step 1D exposure requires stopping down the aperture one f/stop from the meter reading. For example, if the meter indicates f/8, the alteration is to f/11. It can also be done with the shutter speed. If the meter indicates $^1/_{125}$, it is changed to $^1/_{250}$. Considerable texture is preserved in hues and in dark gray exposed on this step. Typical colors to be exposed on this step include dark blue sky, dark blue green, hunter green, olive green, dark orange brown, vivid red, dark brown, dark red purple, and royal purple. On Step 1D, yellow and orange will be too dark to resemble their traditional appearance. This step is also for exposure of higher value colors that are in shadow. Step 1D is the darkest step you can use if you want to prevent blue sky from blending with dark colors, such as those of evergreen trees and shadows. It is the transparency equivalent of a print that reflects 6.5 percent of the light falling on it.

Step 1½D. Step 1½D is achieved by giving a color one and one-half f/stops less exposure than the meter reading indicates. For example, if the meter indicates f/4.5, the adjustment to Step 1½D requires f/8. Adequate texture is maintained in textured dark gray and in textured dark colors exposed on Step 1½D. Orange and yellow should not be exposed on Step 1½D. All colors will be very dark, as the following list indicates: very dark blue sky, very dark blue green, forest green, dark olive green, dark olive, chocolate brown, maroon, and very dark purple. Step 1½D is an ideal step for exposure of dark blue sky if no dark objects that might blend with the sky are present. Colors that are complementary to blue (red, orange, yellow) are less likely to blend. Subjects such as evergreen trees may blend with the sky. This is usually the lightest step used for shadows in scenic photography. The amount of light transmitted through an area of a slide exposed on this step is equivalent to a value in a print that reflects 3 percent of the light falling upon it.

Step 2D. Step 2D is achieved by exposing two f/stops darker than the meter reading indicates. For example, if the meter reading suggests f/4, it is changed to f/8. It can also be adjusted on the shutter speed dial. For example, if the meter indicates $^1/_{30}$, change it to $^1/_{125}$. This step is reserved for black and blackish colors with minimum texture. Exposure of most hues on this step will result in significant loss of color. This is the darkest step on which to expose blue sky, but it is not recommended because the sky will be reproduced blackish blue. Sky, shadows, evergreen foliage, and dark objects adjacent to each other will blend on Step 2D. Minimal texture is retained on this step. A description of colors reproduced on this step indicates the blackness in them: blackish blue sky, blackish cyan, blackish blue green, blackish green, blackish olive green, blackish brown, blackish maroon, blackish red purple, and blackish purple. Step 2D is excellent for shadows in which few details are visible. This step represents the transparency equivalent of a blackish color in a print that reflects 1.5 percent of the light falling upon it.

Step 2½DB(pure black). This step should be reserved for untextured black. Loss of hue is obvious in any color exposed on Step 2½DB. This step is equivalent to unexposed film. Step 2½DB is ideal for small, nontextured shadows that provide accent in photographs. This step is the color-slide equivalent of a black area in a photographic print that reflects 0.5 percent of the light falling upon it.

SPECIAL STEPS IN THE STAIR-STEP EXPOSURE SYSTEM

Step 3LW. This step will be referred to frequently in this book. It represents the maximum practical transparency of the film. Texture and color will be absent. This step is used for making montages and for exposing highlights in scenes of in-

tense contrast. Steps 3LW, 3½LW, and 4LW are used to indicate the contrast range of a scene. They do not exist within the exposure latitude of the film. These steps are for glare white.

Step 1¾LY. This special step is reserved for very precise exposure of high-chroma yellows, including light yellow, brilliant yellow, and vivid yellow. This step is located between Steps 1½L and 2L. Correct exposure of these yellows is limited to one-fourth of an f/stop.

Step 3DB. This special step is used for dark portions of extremely contrasty scenes. Step 3DB is as opaque as the film base permits. Occasional reference will also be made to Steps 3½DB and 4DB to indicate the contrast range of scenes. These steps do not exist within the exposure latitude of most color slide films. No texture will be present in these black steps.

LENS APERTURE AND SHUTTER SPEED ADJUSTMENT CHARTS

Figures 2-1, 2-2, 2-3, and 2-4 provide data to adjust lens apertures and shutter-speed settings. Figures 2-1 and 2-2 indicate adjustments from the meter reading of a single-value color to the L steps. Figures 2-3 and 2-4 provide the adjustments of lens and shutter from the meter reading to steps in the D values. A wider range of f/stops and shutter speeds has been included than is available on most 35mm cameras. Select those settings that are possible on your camera. All lens apertures can be adjusted to the settings between the marked f/stops. The shutter speeds marked with asterisks cannot, however, be used on the majority of cameras.

2-1 Adjustment of apertures in one-half f/stops in the L steps.

Meter reading	Step ½L	Step 1L	Step 1½L	Step 2L	Step 2½LW	Step 3LW
f/32	f/27	f/22	f/18.5	f/16	f/12.5	f/11
f/27	f/22	f/18.5	f/16 .	f/12.5	f/11	f/9.5
f/22	f/18.5	f/16	f/12.5	f/11	f/9.5	f/8
f/18.5	f/16	f/12.5	f/11	f/9.5	f/8	f/6.3
f/16	f/12.5	f/11	f/9.5	f/8	f/6.3	f/5.6
f/12.5	f/11	f/9.5	f/8	f/6.3	f/5.6	f/4.5
f/11	f/9.5	f/8	f/6.3	f/5.6	f/4.5	f/4
f/9.5	f/8	f/6.3	f/5.6	f/4.5	f/4	f/3.5
f/8	f/6.3	f/5.6	f/4.5	f/4	f/3.5	f/2.8
f/6.3	f/5.6	f/4.5	f/4	f/3.5	f/2.8	f/2.5
f/5.6	f/4.5	f/4	f/3.5	f/2.8	f/2.5	f/2
f/4.5	f/4	f/3.5	f/2.8	f/2.5	f/2	f/1.8
f/4	f/3.5	f/2.8	f/2.5	f/2	f/1.8	f/1.5
f/3.5	f/2.8	f/2.5	f/2	f/1.8	f/1.5	f/1.2
f/2.8	f/2.5	f/2	f/1.8	f/1.5	f/1.2	
f/2.5	f/2	f/1.8	f/1.5	f/1.2		
f/2	f/1.8	f/1.5	f/1.2			
f/1.8	f/1.5	f/1.2				
f/1.5	f/1.2					

2-2 **Adjustment of shutter speeds in one-half f/stop increments in the L steps.**

Meter reading	Step ½L	Step 1L	Step 1½L	Step 2L	Step 2½LW	Step 3LW
1/2000	1/1500*	1/1000	1/750*	1/500	1/375*	1/250
1/1500*	1/1000	1/750*	1/500	1/375*	1/250	1/185*
1/1000	1/750*	1/500	1/375*	1/250	1/185*	1/125
1/750*	1/500	1/375*	1/250	1/185*	1/125	1/90*
1/500	1/375*	1/250	1/185*	1/125	1/90*	1/60
1/375*	1/250	1/185*	1/125	1/90*	1/60	1/45*
1/250	1/185*	1/125	1/90*	1/60	1/45*	1/30
1/185*	1/125	1/90*	1/60	1/45*	1/30	1/22*
1/125	1/90*	1/60	1/45*	1/30	1/22*	1/15
1/90*	1/60	1/45*	1/30	1/22*	1/15	1/12*
1/60	1/45*	1/30	1/22*	1/15	1/12*	1/8
1/45*	1/30	1/22*	1/15	1/12*	1/8	1/6*
1/30	1/22*	1/15	1/12*	1/8	1/6*	1/4
1/22*	1/15	1/12*	1/8	1/6*	1/4	1/3*
1/15	1/12*	1/8	1/6*	1/4	1/3*	1/2
1/12*	1/8	1/6*	1/4	1/3*	1/2	3/4*
1/8	1/6*	1/4	1/3*	1/2	3/4*	1
1/6*	1/4	1/3*	1/2	3/4*	1	1½*
1/4	1/3*	1/2	3/4*	1	1½*	2*
1/3*	1/2	3/4*	1	1½*	2*	3*†
1/2	3/4*	1	1½*	2*	3*†	5½*†
3/4*	1	1½*	2*	3*†	5½*†	7*†
1	1½*	2*	3*†	5½*†	7*†	9*†

*In actual practice, these in-between shutter speeds cannot be used on the majority of cameras. Therefore, the adjustment would involve a combination of shutter speed and f/stop. For example, an adjustment of 1/2000 to Step ½L would require opening the aperture one-half f/stop. An adjustment from 1/2000 to Step 1½L would require changing the shutter speed to 1/1000 plus opening the aperture one-half f/stop.

†Adjustments exceeding two seconds require additional exposure to counteract loss of film speed caused by reciprocity failure characteristics.

2-3 **Adjustment of apertures in one-half f/stops in the D steps.**

Meter reading	Step ½D	Step 1D	Step 1½D	Step 2D	Step 2½DB	Step 3DB
f/27	f/32	*	*	*	*	*
f/22	f/27	f/32	*	*	*	*
f/18.5	f/22	f/27	f/32	*	*	*
f/16	f/18.5	f/22	f/27	f/32	*	*
f/12.5	f/16	f/18.5	f/22	f/27	f/32	*
f/11	f/12.5	f/16	f/18.5	f/22	f/27	f/32
f/9.5	f/11	f/12.5	f/16	f/18.5	f/22	f/27
f/8	f/9.5	f/11	f/12.5	f/16	f/18.5	f/22
f/6.3	f/8	f/9.5	f/11	f/12.5	f/16	f/18.5
f/5.6	f/6.3	f/8	f/9.5	f/11	f/12.5	f/16
f/4.5	f/5.6	f/6.3	f/8	f/9.5	f/11	f/12.5
f/4	f/4.5	f/5.6	f/6.3	f/8	f/9.5	f/11
f/3.5	f/4	f/4.5	f/5.6	f/6.3	f/8	f/9.5
f/2.8	f/3.5	f/4	f/4.5	f/5.6	f/6.3	f/8
f/2.5	f/2.8	f/3.5	f/4	f/4.5	f/5.6	f/6.3
f/2	f/2.5	f/2.8	f/3.5	f/4	f/4.5	f/5.6
f/1.8	f/2	f/2.5	f/2.8	f/3.5	f/4	f/4.5
f/1.5	f/1.8	f/2	f/2.5	f/2.8	f/3.5	f/4
f/1.2	f/1.5	f/1.8	f/2	f/2.5	f/2.8	f/3.5

*F/stops for these adjustments have been omitted because most 35mm slide cameras do not have f/stops smaller than f/32.

2-4 Adjustment of shutter speeds in one-half f/stop increments in the D steps.

Meter reading	Step ½D	Step 1D	Step 1½D	Step 2D	Step 2½DB	Step 3DB
1/1500*	1/2000	†	†	†	†	†
1/1000	1/1500*	1/2000	†	†	†	†
1/750*	1/1000	1/1500*	1/2000	†	†	†
1/500	1/750*	1/1000	1/1500*	1/2000	†	†
1/375*	1/500	1/750*	1/1000	1/1500*	1/2000	†
1/250	1/375*	1/500	1/750*	1/1000	1/1500*	1/2000
1/185*	1/250	1/375*	1/500	1/750*	1/1000	1/1500*
1/125	1/185*	1/250	1/375*	1/500	1/750*	1/1000
1/90*	1/125	1/185*	1/250	1/375*	1/500	1/750*
1/60	1/90*	1/125	1/185*	1/250	1/375*	1/500
1/45*	1/60	1/90*	1/125	1/185*	1/250	1/375*
1/30	1/45*	1/60	1/90*	1/125	1/185*	1/250
1/22	1/30	1/45*	1/60	1/90*	1/125	1/185*
1/15	1/22*	1/30	1/45*	1/60	1/90*	1/125
1/12*	1/15	1/22*	1/30	1/45*	1/60	1/90*
1/8	1/12*	1/15	1/22*	1/30	1/45*	1/60
1/6*	1/8	1/12*	1/15	1/22*	1/30	1/45*
1/4	1/6*	1/8	1/12*	1/15	1/22*	1/30
1/3*	1/4	1/6*	1/8	1/12*	1/15	1/22*
1/2	1/3*	1/4	1/6*	1/8	1/12*	1/15
3/4*	1/2	1/3*	1/4	1/6*	1/8	1/12*
1	3/4*	1/2	1/3*	1/4	1/6*	1/8
1½*	1	3/4*	1/2	1/3*	1/4	1/6*
2*	1½*	1	3/4*	1/2	1/3*	1/4

†Shutter speeds faster than 1/2000 have not been included because most slide cameras do not have faster shutter speeds.

*In actual practice these shutter speeds cannot be used on the majority of cameras. Therefore, the adjustment involves a combination of shutter speed and f/stop. For example, an adjustment of 1/500 to Step 1½D requires changing the shutter speed to 1/1000 and closing the aperture one-half f/stop.

USING THE STAIR-STEP SYSTEM FOR THE FIRST TIME

It is time to take some pictures. Purchase from your camera store an 18 percent reflectance gray card and two thirty-six-exposure rolls of color-slide film. Tape the card to a wall in sunlight. Position the camera on a tripod to photograph a full frame of the card. The card need not be in focus. Move the camera as close to the card as required to fill the frame. If a hand-held meter is used, take a close-up reading of the gray card. Be careful no other colors affect the meter reading. Do not let the shadow of your hand fall on the card.

Obtain a meter reading of the gray card. This meter reading is the point of departure from which exposure modifications will be made. Write down the camera settings and then take a series of thirteen exposures. The first exposure must be three f/stops darker than the meter reading indicates. This will be Special Step 3DB. For example, if the meter indicates f/8, set the lens aperture on f/22. Each successive exposure should be on a step one-half f/stop lighter than the preceding one. The sixth picture will be exposed at Step MV, which is the meter reading. The thirteenth picture will be exposed three f/stops lighter than the meter reading. This will be Special Step 3LW. The use of the aperture and shutter-speed adjustment charts will help you determine the camera settings. By taking these thirteen pictures, you will

have made exposures of the gray card on all the values of the stair-step exposure system. Keep notes on the camera settings.

In the second exposure test, photograph the white side of the gray card. Obtain a new meter reading of the white side of the card for a new point of departure. Determine the exposures and make notes of the thirteen camera settings to be used for the test series of the white card. These will also vary by one-half f/stop, from three f/stops darker than the meter reading to three f/stops lighter than the reading. For the third exposure test, repeat the procedure using a black card. Take a new meter reading to obtain a new point of departure, then determine the camera settings for the thirteen exposures.

After the film is processed, write the following on each slide: which card was photographed, camera settings, and the stair-step of each slide. The middle frame in each of the three series should be identical, even though the subjects were gray, white, and black. These three slides represent the transparency version of middle value for that film for the ASA at which the film was exposed.

Next, notice that each of the frames in each of the series is identical to its counterparts. Surprised? Being unaccustomed to photographing full-frame, single-value, solid-color subjects, most photographers do not learn this basic exposure lesson. If the frames are not identical to their counterparts or if the increments are not evenly graded, the camera settings may have been made in error. There may also be reason to question the accuracy of the shutter speeds, aperture markings, or both. Do not discard these slides, because they have educational, corrective, and creative uses. Additional experiments will be conducted with them.

PHOTOGRAPHIC EXAMPLES IN THIS BOOK·

The color prints in this book were reproduced from slides that have been exposed according to the principles of the stair-step system. These color prints have been reproduced as closely to the original slides as possible. They may exhibit minor variations in value, chroma, hue, and texture, and, of course, any projected slide will look slightly different than its printed version. These color reproductions have been carefully selected; the thorough analysis to which they have been subjected is intended to assist your understanding of the exposure system.

The black-and-white photographs in this book are converted from color slides. They have been exposed, developed, and printed to match precisely the values of the colors in the original slides. This was done with the aid of the eleven-step gray scale. Every value in every slide was compared to the gray-scale value, and the print was made accordingly. For example, a Step 1D vivid red has been reproduced as a Step 1D dark gray. A Step MV light blue sky appears as a Step MV middle gray. The effect of this procedure makes the black-and-white examples appear flat. This impression of flatness occurs because we are accustomed to seeing more contrast in black-and-white prints. Increased contrast compensates for the lack of color in black-and-white photography. For the purposes of this book, however, and especially in chapter 21, it was more important that the black-and-white prints retain the same contrast and values as the original slide than that they look "good" by virtue of greater contrast. Please take this into consideration when evaluating the black-and-white versions of the color slides in this book.

EQUIPMENT AND SUPPLIES 3

The equipment and supplies used in the stair-step system include standard photographic items available in most camera stores or by special order. The remaining supplies can either be ordered from the authors or easily made from instructions in this book.

EXPOSURE METERS

Any type of exposure meter that measures reflected light can be used with the stair-step exposure system. One-degree spot meters are especially well suited to use with the system because obtaining single-value readings with them is so easy. Photographers who use cameras with automated f/stops or automated shutter speeds must use these cameras in their nonautomatic mode to make adjustments in the meter readings. Contrary to the claims of some camera manufacturers, no automatic camera meter will accurately expose pictures under all conditions for all types of film, especially color slide film.

Spot meters are sensitive to a very small area in the scene. Most spot meters have camera-type viewfinders that permit you to see an area surrounding the metered spot. For example, at a distance of ten feet, the viewfinders on some spot meters show an area two feet by three feet. The one-degree sensitive circle is two inches in diameter. At a distance of one hundred yards, the viewfinder shows an area approximately twenty-five yards by thirty-seven yards. The one-degree metered circle is seven feet in diameter. Spot metering makes it possible to obtain single-value readings from the camera position.

Any meter with a sensitive area wider than one degree is herein defined as an averaging meter. Such meters average several values to middle value. Through-the-lens meters on cameras are averaging meters. Averaging meters can take sin-

gle-value readings if they are close to a particular subject. On many occasions, however, it is impossible to get close enough to the subject. Most exposure errors are caused by the averaging of several values to middle value.

The exposure value system is a series of numbers included on some exposure meters in addition to camera settings and ASA film ratings. These numbers are one f/stop apart. The range may be from one to nineteen, but it can be wider or narrower. The exposure value system (EVS) has been standardized among many photographic equipment manufacturers. Each number represents a group of camera settings that result in the same exposure. For example, the EVS number 15 indicates that any of the following combinations of camera settings will result in the same amount of light reaching the film if the ASA is set on 100:

1/30 @ f/32	1/25 @ f/16	1/500 @ f/8
1/60 @ f/22	1/250 @ f/11	1/1000 @ f/5.6

The photographer chooses the best setting based upon depth of field requirements and/or the necessity to stop or blur moving objects.

The absence of EVS numbers on hand-held meters or camera meters requires photographers to use either f/stop rotation or shutter-speed rotation procedures. These will be described in chapter 4.

The ability of an exposure meter to obtain accurate readings through a polarizing filter is essential, especially if scenery is being photographed or reflections are to be reduced or eliminated. It is helpful if the polarizer can be attached to the meter with filter-adapter threads, although it can be held in front of the meter.

Spot meters with viewfinders that have ultraclose-up focusing ability or those that can have portrait lenses attached to them offer distinct advantages. Readings can be obtained on subjects that are very small and very close to the meter. The use of a +10 portrait lens on a spot-meter lens permits the photographer to focus on a spot one-eighth inch in diameter. The portrait lens can be screwed into the filter-adapter threads on the lens of some spot meters. The portrait lens is used because readings on extremely close objects not in focus in the spot-meter viewfinder will not be accurate, since the values will be averaged. Using portrait lenses on the spot meter will allow you to obtain accurate readings for macrophotography and for slide duplication.

Most of the medium- and high-priced cameras with built-in meters are capable of obtaining readings under very dark conditions. Spot meters and many other hand-held meters are also capable of this. The wider the range of sensitivity, the more useful the meter will be. An EVS range of one to nineteen or wider should be considered essential.

A built-in light to illuminate the metering screen under dark conditions is very helpful. A manually rotated dial will be more convenient to use than motor-driven dials. The meter should have a battery-checking device.

POLARIZING FILTERS

The polarizer is the most popular filter used with color-slide film. It provides extensive control of sky value, reduces or eliminates unwanted reflections, reduces haze, and accentuates clouds. Landscape photography is enhanced by polarization. Most polarizers are the parallel type. Certain through-the-lens camera meters cannot, however, obtain accurate readings through parallel polarizers. Check this

feature with the camera dealer or manufacturer. Circular polarizers have solved this problem. Circular polarizers are made by the B & W Filter Company in Germany and are distributed through Leica camera dealers.

You can evaluate the effect of polarization by looking through the filter while rotating it. The filter may be on or off the camera during the viewing. Polarizers may be fitted into the filter threads of spot meters or held in front of meters. The polarizer absorbs approximately two f/stops of light; therefore, after the exposure is determined, it must be increased by two f/stops. If the meter reading is taken through the filter, the meter adjusts itself to the reduced amount of light. Exposure is precisely determined by reading the meter through the filter, especially if large proportions of reflections are present. When photographing with wide-angle lenses or when aiming upward, use care to retain blueness in the sky. Very dark blue, present in the upper sky, could be made black or blackish blue by polarization. It may not be necessary to use the polarizer when the camera is aimed high into the sky.

The polarizer reduces or eliminates unwanted reflections from statues, cars, wood, water, leaves, eyeglasses, buildings, signs, windows, and other surfaces. The effect is often dramatic. A reflection may prevent the viewer from seeing any detail in the surface. Reduction of white reflections from an overcast sky on foliage enriches color. If the reflection occupies a major proportion of the picture, the meter reading should be taken through the polarizer. A bright reflection on a window or sign, for example, may give a reading in excess of the usual two f/stop allowance for the polarizer.

STAIR-STEP EXPOSURE SYSTEM DATA FORMS

The data forms shown in figure 3-1 will help you learn the stair-step exposure system more quickly because they assign colors to the correct steps. This information also helps to evaluate your slides after processing. One form is used for each scene. The place and subject spaces on the form provide a means of correctly identifying the objects photographed. Spaces are alloted for the film name and ASA. Frame numbers can be taken from the camera exposure counter, then verified with the numbers on the cardboard or plastic mounts after processing. The forms provide space for three exposure variations of each scene. You may vary exposures for mood, experimentation, or to use different lenses to change the composition of the scene. There are two blanks for indicating the use of two filters. The polarizer and color-correction filters are often used together. It is essential to enter the name of the film, ASA, meter readings, assigned steps, shutter speed, and f/stop on the form in order to evaluate the slide after processing.

You may also enter optional information on the form. You may wish to include the date and time of day the picture was taken or the focal length of the lenses used for each of three compositions. The miscellaneous space and the back of the form may be used for information about bellows extension, fill-in flash, additional filters, and other technical information. You may also use the back of the form for script ideas for programs, as well as for scientific and historical information about the subject.

Note that the column under *Meter* contains exposure value numbers, shutter speeds, and f/stops, with each line representing one-half f/stop. Colors of subjects are written on the form according to their meter readings in the *Meter* column. The values are from light to dark, from top to bottom of the form. The f/stop range on the form is from f/32 to f/1, exceeding the range of most slide-camera lenses. Those who

3-1 **Stair-step exposure system data form for colored slides.**

STAIR-STEP EXPOSURE SYSTEM DATA FORM FOR COLOR SLIDES

Place		Frame			
		Lens			
Subject		Shutter			
		f/Stop			
Film ASA		Filter			
Date Misc.		Filter			

Meter	Colors and Color Values of Objects	Step	Step	Step
19 2000 13½ f/32				
18½ 1500 13 f/27				
18 1000 12½ f/22				
17½ 750 12 f/19				
17 1/500 11½ f/16				
16½ 375 11 f/14				
16 1/250 10½ f/11				
15½ 185 10 f/9.5				
15 1/125 9½ f/8				
14½ 1/90 9 f/6.3				
14 1/60 8½ f/5.6				
13½ 1/45 8 f/4.5				
13 1/30 7½ f/4				
12½ 1/22 7 f/3.5				
12 1/15 6½ f/2.8				
11½ 1/12 6 f/2.5				
11 1/8 5½ f/2				
10½ 1/6 5 f/1.8				
10 1/4 4½ f/1.5				
9½ 1/3 4 f/1.2				
9 1/2 3½ f/1				
8½ 3/4 3				
8 1 sec 2½				
7½ 1½ s. 2				
7 2 sec 1½				
6½ 2½ s. 1				

Evaluation:

follow the f/stop rotation technique will use these numbers. If you practice the shutter-speed rotation technique, you will use the shutter-speed numbers. Those owning spot meters will use the exposure value system numbers. Keep the data forms for future study.

THE STAIR-STEP SYSTEM EXPOSURE CALCULATOR

The stair-step calculator is another practical instrument to use in learning the exposure system. Combined with an understanding of the stair-step system and careful use of an exposure meter, consistent use of the calculator assures precise exposures after the ASA for each film has been determined. After you memorize the system, you will no longer need to use the calculator.

The calculator consists of two parts: the stair-step data form and the value-selector chart. The steps range from 3LW to 3DB. The stair-step data form fits across the center of the value-selector chart. The value-selector chart contains brief descriptions of the gray scale, colors, values, and textures. Eleven hues are briefly described with abbreviated color names. *Dk Viv Y-Gr* means dark vivid green yellow. *V Lt Bl Sky* means very light blue sky. Reading from top to bottom, the color values become progressively darker. The color names in each horizontal row describe the same value in different colors. The 103 color names on the chart were selected to represent five million distinguishable colors.

STAIR-STEP SYSTEM COLOR SLIDE VALUE-SELECTOR CHART

Blue / Lavender	Turq / Green	Yellow-Green / Yellow	Step	Value / Texture	Orange / Brown	Pink / Red
Use Steps 2½LW, 3LW, and lighter steps for white textureless high-lights in wide contrast scenes whose dark areas require color or texture.			3LW	Glare White / No Texture	All colors will be re-produced essentially white on 2½LW and 3LW. Faint color may remain.	
			2½LW	Pure White / No Texture		
Wh Baby Blu / Whit Lavend	Whit Bl-Grn / Whit Green	Whit Yel-Gr / White Yel	2L	Off-White / Min Texture	Wh Orange / Whit Beige	White Pink / Wh Pur Pink
Baby Blue / Lt Lavender	Pastel Turq / Light Green	Lt Viv Y-Gr / Viv Yellow	1½L	White-Gray / Adeq Text	Lt Viv Org / Light Beige	Baby Pink / Purple-Pink
Dk Baby Blu / Med Lavend	Bright Turq / Lt Kelly Gr	Viv Yel-Grn / Dark Yellow	1L	Light Gray / Consid Text	Viv Orange / Med Beige	Dark Pink / Dk Pur-Pink
V Lt Bl Sky / Dk Lavender	Vivid Turq / Kelly Green	Dk Viv Y-Gr / Mustard Yel	½L	Med Lt Gray / Ext Texture	Dk Viv Org / Dark Beige	Coral Red / Lt Red-Pur
Lt Blue Sky / Lt Viv Pur	Turq-Green / Dk Kelly Gr	Med Yel-Grn / Olive Yello	▲ MV	Middle Gray / Max Texture	Burnt Org / Lt Brown	Crimson Red / Med V Red-P
Med Blu Sky / Viv Purple	Deep Turq / Pepper Grn	Dk Yel-Grn / Light Olive	½D	Med Dk Gray / Ext Texture	Dk Burnt Or / Med Brown	Bright Red / Viv Red-Pur
Dk Blue Sky / Dk Viv Pur	Dk Blue-Grn / Hunter Grn	Olive Green / Med Olive	1D	Dark Gray / Consid Text	Dk Org-Brn / Dark Brown	Vivid Red / Dk Red-Pur
V Dk Bl Sky / V Dk Purple	V Dk Bl-Grn / Forest Grn	Dk Olive Gr / Dark Olive	1½D	V Dk Gray / Adeq Text	V Dk Org-Br / Choc Brown	Maroon / V Dk Red-P
Blk-Blu Sky / Blksh-Purpl	Blk-Blu-Grn / Blksh-Green	Blk-Olive-G / Blksh Olive	2D	Text Black / Min Texture	Blk-Org-Brn / Blkish Brn	Blk-Maroon / Blk-Red-Pur
Use Steps 2½DB, 3DB, and darker steps for black textureless shadows in wide contrast scenes whose highlights require color and texture.			2½DB	Pure Black / No Texture	All colors will be re-produced textureless black on Steps 2½DB, 3DB and darker steps.	
			3DB	Opaque Blk / No Texture		

3-2 Stair-step exposure system value-selector chart.

Stair-step data form positioned on top of the value-selector chart in one of thirty-four different positions. The data form and value-selector chart combined make the exposure calculator.

STAIR-STEP EXPOSURE SYSTEM DATA FORM FOR COLOR SLIDES

Place		Frame Number			
		Lens			
		Shutter Speed			
Subject		f/stop			
Film	ASA	Filter			
Date	Misc.	Filter			

Meter	Colors and Color Values of Objects	Step	Step	Step
19 2000 13½ f/80				
18½ 1500 13 f/64				
18 1000 12½ f/56				
17½ 1/750 12 f/45				
17 1/500 11½ f/40				
16½ 1/375 11 f/32				
16 1/250 10½ f/28				
15½ 1/185 10 f/22				
15 1/125 9½ f/20				
14½ 1/90 9 f/16				
14 1/60 8½ f/14				
13½ 1/45 8 f/11				
13 1/30 7½ f/10				
12½ 1/22 7 f/8				
12 1/15 6½ f/7				
11½ 1/12 6 f/5.6				
11 1/8 5½ f/5				
10½ 1/6 5 f/4				
10 1/4 4½ f/3.5				
9½ 1/3 4 f/2.8				
9 1/2 3½ f/2.5				
8½ 3/4 3 f/2				
8 1 sec 2½ f/1.7				
7½ 1½ sec 2 f/1.4				
7 2 sec 1½ f/1.2				
6½ 2½ sec 1 f/1				
Evaluation				

Left value-selector chart:

	Step
Use Steps 2½LW, 3LW, and lighter steps for white textureless highlights in wide contrast scenes whose dark areas require color or texture.	3LW
	2½LW

			Step
Wh Baby Blu Whit Lavend	Whit Bl-Grn Whit Green	Whit Yel-Gr White Yel	2L
Baby Blue Lt Lavender	Pastel Turq Light Green	Lt Viv Y-Gr Viv Yellow	1½L
Dk Baby Blu Med Lavend	Bright Turq Lt Kelly Gr	Viv Yel-Grn Dark Yellow	1L
V Lt Bl Sky Dk Lavender	Vivid Turq Kelly Green	Dk Viv Y-Gr Mustard Yel	½L
Lt Blue Sky Lt Viv Pur	Turq-Green Dk Kelly Gr	Med Yel-Grn Olive Yello	MV
Med Blu Sky Viv Purple	Deep Turq Pepper Grn	Dk Yel-Grn Light Olive	½D
Dk Blue Sky Dk Viv Pur	Dk Blue-Grn Hunter Grn	Olive Green Med Olive	1D
V Dk Bl Sky V Dk Purple	V Dk Bl-Grn Forest Grn	Dk Olive Gr Dark Olive	1½D
Blk-Blu Sky Blksh-Purpl	Blk-Blu-Grn Blksh-Green	Blk-Olive-G Blksh Olive	2D

	Step
Use Steps 2½DB, 3DB, and darker steps for black textureless shadows in wide contrast scenes whose highlights require color and texture.	2½DB
	3DB

Right value-selector chart:

Step			
3LW	Glare White No Texture	All colors will be reproduced essentially white on 2½LW and 3LW. Faint color may remain.	
2½LW	Pure White No Texture		
2L	Off-White Min Texture	Wh Orange Whit Beige	White Pink Wh Pur Pink
1½L	White-Gray Adeq Text	Lt Viv Org Light Beige	Baby Pink Purple-Pink
1L	Light Gray Consid Text	Viv Orange Med Beige	Dark Pink Dk Pur-Pink
½L	Med Lt Gray Ext Texture	Dk Viv Org Dark Beige	Coral Red Lt Red-Pur
MV	Middle Gray Max Texture	Burnt Org Lt Brown	Crimson Red Med V Red-P
½D	Med Dk Gray Ext Texture	Dk Burnt Or Med Brown	Bright Red Viv Red-Pur
1D	Dark Gray Consid Text	Dk Org-Brn Dark Brown	Vivid Red Dk Red-Pur
1½D	V Dk Gray Adeq Text	V Dk Org-Br Choc Brown	Maroon V Dk Red-P
2D	Text Black Min Texture	Blk-Org-Brn Blkish Brn	Blk-Maroon Blk-Red-Pur
2½DB	Pure Black No Texture	All colors will be reproduced textureless black on Steps 2½DB, 3DB and darker steps.	
3DB	Opaque Blk No Texture		

THE STAIR-STEP SYSTEM EXPOSURE SLIDE RULE

Use the exposure slide rule shown on the next pages after you become familiar with the data form and value-selector chart combination. The data forms may be used with the slide rule if you wish to record the required information for later evaluation. The exposure slide rule consists of two parts: the stator and the slider. The stator contains the value-selector chart with descriptions of the gray scale, colors, values, and textures. The values range from Step 3LW to 3DB. Each vertical column contains the names of different colors of the same step. The steps are arranged horizontally, with Step 3LW on the left and Step 3DB on the right. The back of the stator contains three charts: Montage and Overlay Exposure Chart, Multiple-Exposure Calculator Chart, and Reciprocity Failure Correction Chart.

Side One of the slider contains four major sections of EVS numbers, each containing four rows. These are used with the EVS procedure. Side Two of the slider contains two sections of f/stops and two sections of shutter speeds. Each of these sections contains four rows. These are to be used with the f/stop and shutter-speed rotation procedures.

Assembling the Stair-step Exposure Slide Rule

You may photocopy the exposure slide rule parts from this book and assemble them. Use dry-mounting tissue, spray glue, or rubber cement to attach the slider parts to both sides of flexible poster board. After attaching one side of the slider to the poster board, cut it carefully along the lines with a paper cutter or scissors. Glue the second side of the slider to the poster board carefully to assure proper positioning. Trim the edges. To make the stator tube, fold flexible poster board around the slider so that the slider fits snugly but moves easily. Use dry-mounting tissue or glue to fasten the front of the stator to the stator tube. With a sharp razor blade or Exacto knife, cut holes in the stator as indicated by the twenty-six rectangles. Then dry-mount or glue the back of the stator together to finish the tube through which the slider moves. Dry-mount or glue the three charts of the stator to the back of the tube.

You may also use Warp's Flex-O-Pane, available in hardware stores, for the stator tube. Flex-O-Pane is clear, flexible plastic that will fold without cracking. Spray glue or double-coated tape may be used to attach the printed sheet to the plastic. Fold the plastic around the long edges of the slider. Cut the plastic with an overlap the width of the double-sided tape and seal the overlap with the tape. Fasten the three charts to the back of the plastic sleeve. If you wish, you may use Flex-O-Pane instead of poster board for the slider. The printed surfaces of the stator and slider can be protected from wear by sealing them with laminate sheet. This self-adhesive material is available in stationery stores. It is also recommended that the value-selector chart to be used with the data forms be attached to poster board or Flex-O-Pane and protected by laminate sheet.

You may make photocopies of the data forms, value-selector chart, and exposure slide rule from this book or you may order them from George and Carol Hypes, 3011 West Fifth Street, Greeley, CO 80631. Write for current price list.

MUNSELL CONSTANT HUE CHARTS

Reproductions of ten of the forty constant-hue charts manufactured by Munsell Color are included in this book. Copies of the original charts, from the *Munsell Book of Color*, are available from Munsell Color. The gray scale is available as a separate item, which you can cut into chips to position in the charts. Order these from Munsell Color, 2441 North Calvert Street, Baltimore, MD 21218.

STAIR-STEP SYSTEM COLOR TRANSPARENCY EXPOSURE SLIDE RULE

3LW	2½LW	2L	1½L	1L	½L	MV	½D	1D	1½D	2D	2½DB	3DB
No Texture Glare White	No Texture Pure White	Min Texture Off White	Adeq Text V Lt Gray	Consid Text Light Gray	Ext Texture Med Lt Gray	Max Texture Middle Gray	Ext Texture Med Dk Gray	Consid Text Dark Gray	Adeq Text V Dk Gray	Min Texture Text Black	No Texture Pure Black	No Texture Opaque Blk

← REPRODUCTION OF SIGNIFICANT COLORS MUST BE LIMITED TO THESE NINE VALUES →

2L	1½L	1L	½L	MV	½D	1D	1½D	2D
Wh Baby Blu	Baby Blue	Dk Baby Blu	V Lt Bl Sky	Lt Blue Sky	Med Blu Sky	Dk Blue Sky	V Dk Bl Sky	Blk-Blu Sky
Whit Bl-Grn	Pastel Turq	Bright Turq	Vivid Turq	Turq Green	Deep Turq	Dk Blue-Grn	V Dk Bl Grn	Blk-Blu-Grn
White Green	Light Green	Lt Kelly Gr	Kelly Green	Dk Kelly Gr	Pepper Grn	Hunter Grn	Forest Grn	Blksh-Green
Whit Yel-Gr	Lt Viv Y-Gr	Vivid Y-Gr	Dk Viv Y-Gr	Med Yel-Grn	Dk Yel-Grn	Olive Green	Dk Olive Gr	Blk Oliv Gr
Wh Viv Yell	Viv Yellow	Dark Yellow	Mustard Yel	Oliv Yellow	Light Olive	Med Olive	Dark Olive	Blksh Olive
Wh Orange	Lt Viv Org	Viv Orange	Dk Viv Org	Burnt Org	Dk Burnt Or	Dk Org Brn	V Dk Or Brn	Blkish Brn
White Pink	Baby Pink	Dark Pink	Coral Red	Crimson Red	Bright Red	Vivid Red	Maroon	Blk Maroon
White Beige	Light Beige	Med Beige	Dark Beige	Light Brown	Med Brown	Dark Brown	Choc Brown	Blkish Brn
Wh Pur Pink	Purple Pink	Dk Pur Pink	Lt Red Purp	Med Viv R-P	Viv Red-Pur	Dk Red Purp	V Dk Red-P	Blk Red-Pur
Whit Lavend	Lt Lavender	Med Lavend	Dk Lavender	Lt Viv Purp	Vivid Purpl	Dk Viv Purp	V Dk Purple	Blksh Purpl

Use Steps 2½LW, 3LW, or lighter steps for white textureless highlights in wide contrast scenes whose dark areas require illumination to show colors or texture. Do this with the recognition that colors on Steps 2½LW and lighter will be "overexposed," leaving only slight traces of color and no texture. Compromise is based on predictable appearance of values.

Use Steps 2½DB, 3DB, or darker steps for black textureless shadows in wide contrast scenes whose highlights require color and texture. Do this with the recognition that colors and texture will be sacrificed in the black steps. This may be more desirable in some types of scenes than too much exposure. Compromise by careful selection of values.

3-4 Stair-step system exposure slide rule showing value-selector chart on the front of the stator.

3-5 Stair-step system exposure slide rule showing montage and multiple-exposure calculator charts and reciprocity failure correction chart on back of stator.

STAIR-STEP SYSTEM COLOR TRANSPARENCY EXPOSURE SLIDE RULE

STAIR-STEP EXPOSURE SYSTEM
Montage and Overlay Exposure Calculator

	1D	½D	MV	½L	1L	1½L	2L	2½LW	3LW
3LW	1½D	1D	½D	MV	½L	1L	1½L	2L	2½LW
2½LW	2D	1½D	1D	½D	MV	½L	1L	1½L	
2L	2D	1½D	1D	½D	MV	½L	1L		
1½L	2½DB	2D	1½D	1D	½D	MV			
1L	2½DB	2D	1½D	1D	½L				
½L	2½DB	2D	1½D	1D					
MV	2½DB	2D	1½D						
½D	2½DB	2D							
1D	2½DB								

STAIR-STEP EXPOSURE SYSTEM
Multiple-Exposure Calculator Chart

	2D	1½D	1D	½D	MV	½L	1L	1½L
2L	2½LW	2½LW	2½LW ·	2½LW	2½LW	2½LW	2½LW	3LW
1½L	2L	2L	2L	2L	2L	2L	2L	2½LW
1L	1½L	1½L	1½L	1½L	1½L	1½L	1½L	
½L	1L	1L	1L	1L	1½L	1½L		
MV	½L	½L	½L	½L	1L			
½D	MV	½L	½L	½L				
1D	½D	MV	½L					
1½D	1D	½D						
2D	1½D							
2½DB	2D							

RECIPROCITY FAILURE CORRECTION CHART

MR	CE	MR	CE	MR	CE	MR	CE	MR	CE
2s =	2s	9s =	16	16 =	34	35 =	99	3½ =	20
2½ =	3s	10 =	18	17 =	37	40 =	2M	4M =	23
3s =	4s	11 =	21	18 =	40	45 =	3M	4½ =	27
4s =	5½	12 =	24	19 =	42	1M =	3½	5M =	31
5s =	7s	13 =	27	20 =	45	2M =	9M	5½ =	33
6s =	9s	14 =	29	25 =	60	2½ =	13	6M =	36
7s =	11	15 =	32	30 =	80	3M =	17	6½ =	40
8s =	13							7M =	50

25

Side One Rows CD: EVS Procedure Slider
Row C

Row D

STAIR-STEP SYSTEM COLOR TRANSPARENCY EXPOSURE SLIDE RULE

Side One Rows ABCD: EVS Procedure Slider
Row A

Row B

3-6 Stair-step system exposure slide rule slider showing side one for use with EVS numbering scale.

Side Two Rows GH: F/Stop Rotation Procedure

Row G

f/45	f/40	f/32	f/28	f/22	f/20	f/16	f/14	f/11
f/32	f/28	f/22	f/20	f/16	f/14	f/11	f/10	f/8
f/22	f/20	f/16	f/14	f/11	f/10	f/8	f/7	f/5.6
f/16	f/14	f/11	f/10	f/8	f/7	f/5.6	f/5	f/4

Row H

f/11	f/10	f/8	f/7	f/5.6	f/5	f/4	f/3.5	f/2.8	f/2.5	f/2	f/1.7	f/1.4	f/1.2
f/8	f/7	f/5.6	f/5	f/4	f/3.5	f/2.8	f/2.5	f/2	f/1.7	f/1.4	f/1.2	f/1	
f/5.6	f/5	f/4	f/3.5	f/2.8	f/2.5	f/2	f/1.7	f/1.4	f/1.2	f/1			
f/4	f/3.5	f/2.8	f/2.5	f/2	f/1.7	f/1.4	f/1.2	f/1					

STAIR-STEP SYSTEM COLOR TRANSPARENCY EXPOSURE SLIDE RULE

Side Two Row DE: Shutter-Speed Rotation Procedure

Row E

3/4	1/2	1/3	1/4	1/6	1/8	1/12	1/15
1½ s	1 s	3/4	1/2	1/3	1/4	1/6	1/8
	2 s	1¼ s	1 s	3/4	1/2	1/3	1/4
			2 s	1½ s	1 s	3/4	1/2

Row D

1/22	1/30	1/45	1/60	1/90	125	185	250	375	500	750	1000	1500	2000
1/12	1/15	1/22	1/30	1/45	1/60	1/90	125	185	250	375	500	750	1000
1/6	1/8	1/12	1/15	1/22	1/30	1/45	1/60	1/90	125	185	250	375	500
1/3	1/4	1/6	1/8	1/12	1/15	1/22	1/30	1/45	1/60	1/90	125	185	250

THREE EXPOSURE METER PROCEDURES **4**

Thiis chapter describes three procedures for determining exposure. The exposure value system (EVS) procedure is for use with meters equipped with an exposure value numbering system. The f/stop rotation procedure is used with through-the-lens meters and with direct-reading meters that do not have EVS numbers. The shutter-speed rotation procedure is used with through-the-lens meters and with direct-reading meters that do not have an exposure value numbering system. When a specific f/stop is required to take a picture, the shutter-speed rotation procedure is used. Conversely, if the picture must be taken at a particular shutter-speed, then the f/stop rotation procedure is used. In addition, each photographer should use the procedure that works best with the unique features of his or her equipment. The use of the exposure calculator will also be described in this chapter.

EXPOSURE VALUE SYSTEM (EVS) PROCEDURE

The assignment was to correctly expose the San Diego Mission in California (see fig. C-1). The picture contained a range of values from white to black, with colors that included blue and green. The general EVS procedural steps are indicated in italics.

1. *Define the perimeters of the format to determine proportionate sizes of colors. Select the lens to be used.*
2. *Determine if polarization is required to darken the sky or eliminate reflections.* The sky was light blue compared to the white wall, indicating that polarization might be needed to darken the sky. No reflections needed to be eliminated. Blue sky could possibly have blended with the adjacent green trees if the sky were darkened too much by polarization.
3. *Obtain spot readings of several single-value colors within the format, including those that make up the largest proportion of the format and those in the main subject.* Readings were taken of the white wall, blue sky, green shrubbery, and shadows

within the green shrubbery. The one-degree spot meter made it easy to obtain the single-value readings from the camera position. If an averaging meter had been used, it would have been necessary to move close to the areas.

4. *Write the colors on the stair-step data form on lines corresponding with the meter readings. This keeps the colors separated on the basis of the contrast between them. The lines on the data form are one-half f/stop apart. There will usually be blank lines.*

5. *Center the value-selector chart under the data form entries. The range of significant color reproduction is limited to the nine steps from 2L to 2D.* When the data form for this example was centered, the white wall was on Step 2L and the shadows were on Step 2D.

4-1 Data form entries centered on top of excerpt from value-selector chart.

			Meter	Colors and Color Values of Objects	Step	
Wh Baby Blu / Whit Lavend	Whit Bl-Grn / Whit Green	2L	16½ 375 / f/14	White Bell Wall	2L	Off-White / Min Texture
Baby Blue / Lt Lavender	Pastel Turq / Light Green	1½L	16 1/250 / 10½ f/11		1½L	White-Gray / Adeq Text
Dk Baby Blu / Med Lavend	Bright Turq / Lt Kelly Gr	1L	15½ 185 / f/9.5	Sky — Not Polarized	1L	Light Gray / Consid Text
V Lt Bl Sky / Dk Lavender	Vivid Turq / Kelly Green	½L	15 1/125 / 9½ f/8		½L	Med Lt Gray / Ext Texture
Lt Blue Sky / Lt Viv Pur	Turq-Green / Dk Kelly Gr	MV	14½ 1/90 / 9 f/6.3		MV	Middle Gray / Max Texture
Med Blu Sky / Viv Purple	Deep Turq / Pepper Grn	½D	14 1/60 / f/5.6	Sunny Green Foliage	½D	Med Dk Gray / Ext Texture
Dk Blue Sky / Dk Viv Pur	Dk Blue-Grn / Hunter Grn	1D	13½ /45 / f/4.5	Sunny Green Foliage	1D	Dark Gray / Consid Text
V Dk Bl Sky / V Dk Purple	V Dk Bl-Grn / Forest Grn	1½D	13 /30 / f/4	Shaded Green Foliage	1½D	V Dk Gray / Adeq Text
Blk-Blu Sky / Blksh-Purpl	Blk-Blu-Grn / Blksh-Green	2D	12½ /22 / f/3.5	Shaded Green Foliage	2D	Text Black / Min Texture

6. *Evaluate color values, shadows, highlights, and textures by moving the chart up and down under the data form to select the best exposure. The size of each colored and textured area must be considered in proportion to the format, especially for those areas that require sacrifice of hue or texture.* It was tentatively determined that the white wall could be exposed on Step 1½L, which would result in adequately textured white gray according to the description on the chart. Therefore, the white wall reading of 16½ was positioned on the Step 1½L line of the chart. The contrast between the white wall and the blue sky indicated that if the white wall were exposed on Step 1½L, the blue sky would be on Step ½L. This can be seen by looking for the blue sky reading, which was 15½. Step ½L blue is described in the value-selector chart as very light blue sky. This was considered too light. Meter readings of 13½ and 14 on sunny green foliage were aligned with Steps 1D and 1½D, both of which were acceptable reproductions. Shadow readings of 12½ and 13 aligned with Steps 2D and 2½DB could be satisfactory for reproduction of shaded green foliage. The first alternative to darken the sky was to reduce exposure. Repositioning the calculator by lowering the data form one line made the white wall reading of 16½ align with Step 1L. This would make the white wall light gray. The sky reading of 15½ was on Step MV, a light blue sky. This was still considered too light, especially because it surrounded a large white object and more contrast was desirable between the blue and white. This positioning also indicated that the sunny green foliage would be blackish green on Step 2D. This was too dark, it would make shaded green foliage textureless black. Therefore, reduction of exposure was not a suitable technique to darken the sky. Polarization would darken the sky without darkening other colors. The photographer returned to the third step of the procedure.

4-2 Data form and value-selector chart excerpts showing white wall positioned on Step 1½L.

		Meter	Colors and Color Values of Objects	Step		
Baby Blue / Lt Lavender	Pastel Turq / Light Green	1½L	16½ 375 / 11 f/14	White Bell Wall	1½L	White-Gray / Adeq Text
Dk Baby Blu / Med Lavend	Bright Turq / Lt Kelly Gr	1L	16 1/250 / 10½ f/11		1L	Light Gray / Consid Text
V Lt Bl Sky / Dk Lavender	Vivid Turq / Kelly Green	½L	15½ 185 / 10 f/9.5	Sky —Not Polarized	½L	Med Lt Gray / Ext Texture
Lt Blue Sky / Lt Viv Pur	Turq-Green / Dk Kelly Gr	MV	15 1/125 / 9½ f/8		MV	Middle Gray / Max Texture
Med Blu Sky / Viv Purple	Deep Turq / Pepper Grn	½D	14½ 1/90 / 9 f/6.3		½D	Med Dk Gray / Ext Texture
Dk Blue Sky / Dk Viv Pur	Dk Blue-Grn / Hunter Grn	1D	14 1/60 / 9½ f/5.6	Sunny Green Foliage	1D	Dark Gray / Consid Text
V Dk Bl Sky / V Dk Purple	V Dk Bl-Grn / Forest Grn	1½D	13½ /45 / 8 f/4.5	Sunny Green Foliage	1½D	V Dk Gray / Adeq Text
Blk-Blu Sky / Blksh-Purpl	Blk-Blu-Grn / Blksh-Green	2D	13 /30 / 7½ f/4	Shaded Green Foliage	2D	Text Black / Min Texture
		2½DB	12½ /22 / 7 f/3.5	Shaded Green Foliage	2½DB	Pure Black / No Texture

4-3 Data form and value-selector chart excerpts showing white wall positioned on Step 1L.

			Meter	Colors and Color Values of Objects	Step		
Dk Baby Blu / Med Lavend	Bright Turq / Lt Kelly Gr	Viv Yel-Grn / Dark Yellow	1L	16½ 375 / 11 f/14	White Bell Wall	1L	Light Gray / Consid Text
V Lt Bl Sky / Dk Lavender	Vivid Turq / Kelly Green	Dk Viv Y-Gr / Mustard Yel	½L	16 1/250 / 10½ f/11		½L	Med Lt Gray / Ext Texture
Lt Blue Sky / Lt Viv Pur	Turq-Green / Dk Kelly Gr	Med Yel-Grn / Olive Yello	MV	15½ 185 / 10 f/9.5	Blue Sky—Not Polarized	MV	Middle Gray / Max Texture
Med Blu Sky / Viv Purple	Deep Turq / Pepper Grn	Dk Yel-Grn / Light Olive	½D	15 1/125 / 9½ f/8		½D	Med Dk Gray / Ext Texture
Dk Blue Sky / Dk Viv Pur	Dk Blue-Grn / Hunter Grn	Olive Green / Med Olive	1D	14½ 1/90 / 9 f/6.3		1D	Dark. Gray / Consid Text
V Dk Bl Sky / V Dk Purple	V Dk Bl-Grn / Forest Grn	Dk Olive Gr / Dark Olive	1½D	14 1/60 / 8½ f/5.6	Sunny Green Foliage	1½D	V Dk Gray / Adeq Text
Blk-Blu Sky / Blksh-Purpl	Blk-Blu-Grn / Blksh-Green	Blk-Olive-G / Blksh Olive	2D	13½ 1/45 / 8 f/4.5	Sunny Green Foliage	2D	Text Black / Min Texture
Use Steps 2½DB, 3DB, and darker steps for black textureless shadows in wide contrast scenes whose highlights require color and texture.			2½DB	13 1/30 / 7½ f/4	Shaded Green Foliage	2½DB	Pure Black / No Texture
			3DB	12½ 1/22 / 7 f/3.5	Shaded Green Foliage	3DB	Opaque Blk / No Texture

3. *Obtain spot readings of several single-value colors within the format, including those that make up the largest proportion of the format and those in the main subject.* This time readings were taken through the polaroid filter, which was rotated for maximum polarization.

4. *Write the colors on the stair-step data form on lines corresponding with the meter readings. This keeps the colors separated on the basis of the contrast between them. There will usually be blank lines.*

5. *Center the selector chart under the data form entries. The range of significant color reproduction is limited to the nine steps from 2L to 2D.* When the data form was centered in this example, the white wall remained on Step 2L and the shadows were on 2D. Polarization substantially increased the contrast difference between the sky and wall. This difference reproduced the sky in a more desirable dark blue.

4-4 Data form and value-selector chart excerpts showing data form entries centered on top of value-selector chart.

			Meter	Colors and Color Values of Objects	Step		
Wh Baby Blu / Whit Lavend	Whit Bl-Grn / Whit. Green	2L	14½ /90, 9 f/6.3	White Bell Wall		2L	Off-White / Min Texture
Baby Blue / Lt Lavender	Pastel Turq / Light Green	1½L	14 1/60, 8½ f/5.6			1½L	White-Gray / Adeq Text
Dk Baby Blu / Med Lavend	Bright Turq / Lt Kelly Gr	1L	13½ 1/45, 8 f/4.5			1L	Light Gray / Consid Text
V Lt Bl Sky / Dk Lavender	Vivid Turq / Kelly Green	½L	13 1/30, 7½ f/4			½L	Med Lt Gray / Ext Texture
Lt Blue Sky / Lt Viv Pur	Turq-Green / Dk Kelly Gr	MV	12½ 1/22, 7 f/3.5			MV	Middle Gray / Max Texture
Med Blu Sky / Viv Purple	Deep Turq / Pepper Grn	½D	12 1/15, 6½ f/2.8	Sunny Foliage, Sky		½D	Med Dk Gray / Ext Texture
Dk Blue Sky / Dk Viv Pur	Dk Blue-Grn / Hunter Grn	1D	11½ /12, 6 f/2.5	Sunny Foliage		1D	Dark Gray / Consid Text
V Dk Bl Sky / V Dk Purple	V Dk Bl-Grn / Forest Grn	1½D	11 1/8, 5½ f/2	Shaded Foliage		1½D	V Dk Gray / Adeq Text
Blk-Blu Sky / Blksh-Purpl	Blk-Blu-Grn / Blksh-Green	2D	10½ 1/6, 5 f/1.8	Shaded Foliage		2D	Text Black / Min Texture

6. *Evaluate color values, shadows, highlights, and textures by moving the data form up and down on the chart to select the best exposure. The size of each colored and textured area in proportion to the format must be considered, especially for those areas that require sacrifice of hue or texture.* The white wall was positioned on Step 1½L. All of the resulting values were envisioned as providing the desired exposure. The sky was a pleasant blue, yet light enough on Step 1D to prevent blending with the adjacent dark green foliage. The sunny green foliage and shadows would be correctly exposed.

7. *Write the steps selected from the value-selector chart on the data form in order to evaluate the slide after processing.*

8. *The EVS exposure meter number on the Step MV line of the data form is used to determine the camera settings. Set this number so that the arrow on the meter dial points at it.* The EVS number at Step MV for the San Diego Mission was 13. Note that no colored object falls on this line. In fact, no colors fall on several adjacent lines. This is not important. The exposure would be selected from the EVS 13 combinations.

9. *Choose the best combination of f/stop and shutter speed for the picture, based upon the requirements of depth of field and motion control. Write the camera settings on the data form.* With the meter set on EVS 13, the dial indicated a choice of camera settings, each of which would deliver the same amount of light to the film. These choices were:

1/8 @ f/22	1/125 @ f/5.6
1/15 @ f/16	1/250 @ f/4
1/30 @ f/11	1/500 @ f/2.8
1/60 @ f/8	1/1000 @ f/2

The slow shutter speeds would have required a tripod and would have provided more depth of field than necessary. Leaves moving in the breeze would blur. The fast shutter speeds would eliminate leaf motion and not require the use of a tripod. Large lens apertures would not provide sufficient depth of field and would have caused some parts of the picture to be severely blurred. Depth of field requirements indicated f/8 would be adequate. Therefore, 1/60 was chosen as the shutter speed. These settings were written on the data form.

10. *Set the camera shutter and f/stop and take the picture.*

4-5 Data form and value-selector chart excerpts showing white wall positioned on Step 1½L. Final steps written on data form.

Baby Blue / Lt Lavender	Pastel Turq / Light Green	Lt Viv Y-Gr / Viv Yellow	Step	Meter	Colors and Color Values of Objects	Step	Step	Step	White-Gray / Adeq Text	
Baby Blue / Lt Lavender	Pastel Turq / Light Green	Lt Viv Y-Gr / Viv Yellow	1½L	14½ 1/90 f/6.3	White Bell Wall	1½L			White-Gray / Adeq Text	1½L
Dk Baby Blu / Med Lavend	Bright Turq / Lt Kelly Gr	Viv Yel-Grn / Dark Yellow	1L	14 1/60 8½ f/5.6		1L			Light Gray / Consid Text	1L
V Lt Bl Sky / Dk Lavender	Vivid Turq / Kelly Green	Dk Viv Y-Gr / Mustard Yel	½L	13½ 1/45 8 f/4.5		½L			Med Lt Gray / Ext Texture	½L
Lt Blue Sky / Lt Viv Pur	Turq-Green / Dk Kelly Gr	Med Yel-Grn / Olive Yello	MV	13 1/30 7½ f/4		MV			Middle Gray / Max Texture	MV
Med Blu Sky / Viv Purple	Deep Turq / Pepper Grn	Dk Yel-Grn / Light Olive	½D	12½ 1/22 7 f/3.5		½D			Med Dk Gray / Ext Texture	½D
Dk Blue Sky / Dk Viv Pur	Dk Blue-Grn / Hunter Grn	Olive Green / Med Olive	1D	12 1/15 6½ f/2.8	Sunny Foliage, Sky	1D			Dark Gray / Consid Text	1D
V Dk Bl Sky / V Dk Purple	V Dk-Bl-Grn / Forest Grn	Dk Olive Grn / Dark Olive	1½D	11½ 1/12 6 f/2.5	Sunny Foliage	1½D			Lt Dk Gray / Adeq Text	1½D
Blk-Blu Sky / Blksh-Purpl	Blk-Blu-Grn / Blksh-Green	Blk-Olive-G / Blksh Olive	2D	11 1/8 5½ f/2	Shaded Foliage	2D			Text Black / Min Texture	2D
Use Steps 2½DB, 3DB, and darker steps for black textureless shadows in wide contrast scenes whose highlights require color and texture.			2½DB	10½ 1/6 5 f/1.8	Shaded Foliage	2½DB			Pure Black / No Texture	2½DB
			3DB	10 1/4 4½ f/1.5					Opaque Blk / No Texture	3DB

11. *After processing, evaluate the slide with the stair-step data. Refine the ASA, if necessary, as explained in chapter 1.*
12. *Memorize the appearance of the colors, textures, highlights, and shadows at the various steps.*

F/STOP ROTATION PROCEDURE

The f/stop rotation procedure is used with through-the-lens camera meters. It is also used with hand meters that convert the meter reading directly into f/stops and shutter speeds without using intermediate EVS numbers. If the picture must be taken on a certain shutter speed, the f/stop rotation procedure should be used. Figure C-2 contains a large off-white wall, evergreens, blue sky, brown grass, brown roof, and a variety of shadows (see color section). The general instructions for the f/stop rotation procedure are indicated in italics.

1. *Define the perimeters of the format to determine proportionate sizes of colors. Select the lens to be used.*
2. *Determine if polarization is required to darken the sky or eliminate reflections.* The camera had a built-in meter that could not obtain accurate readings through the polarizer. The camera was aimed at a ninety-degree angle to the noon sun. This made the sky darken extensively when the polarizer was rotated. It appeared that the polarizer would darken the sky too much, so a decision was made to not use it unless additional information indicated it was necessary.
3. *Obtain spot readings of several single-value colors within the format, including those that make up the largest proportion of the format and those in the main subject. The lens aperture setting ring is rotated to obtain meter readings. When using the f/stop rotation procedure, the camera shutter is placed on any speed that might be used to take the picture. The shutter speed is not to be changed while obtaining the meter readings. The shutter speed selected for this purpose should permit readings of the lightest and darkest areas.* In this example medium-speed film permitted 1/250 to be selected. Readings were taken of the white wall, evergreen shrubbery, brown grass, blue sky, and shaded bricks. These readings were not influenced by other values because the photographer walked up to the objects to get close-up readings. The lens aperture was rotated, and when the meter needle was aligned with the index mark, the closest one-half f/stop was circled on the form.
4. *Write the colors on the stair-step data form on lines corresponding with the meter readings. This keeps the colors separated on the basis of the contrast between them. The lines on the data form are one-half f/stop apart. There will usually be blank lines.*
5. *Center the value-selector chart under the data form entries. The range of significant color reproduction is limited to the nine steps from 2L to 2D.* In this picture the f/22 white wall was on Step 2½LW. The range of values extended down to Step 2D.
6. *Evaluate color values, shadows, highlights, and textures by moving the data form up and down on the chart to select the best exposure. The size of each colored and textured area must be considered in proportion to the format, especially those that require sacrifice of hue or texture.* The light gray color of the concrete wall indicated that the value for it should be darker than Step 2½LW. Therefore, it was tentatively positioned on Step 1½L. The other colors were then compared with the descriptions on the calculator. This was determined to be the best compromise for exposure. One-half f/stop lighter would have been acceptable for desaturated colors. Step 1½L resulted in accurate reproduction of the off-white wall. Sky values ranged from Step MV to 1D. The middle-value sky was along the lowest horizon, part of which was blocked from view by the church. The Step 1D sky was across the upper format, an ideal exposure for blue sky. Polarization would have darkened it too much. The evergreens were filled with shadows from side lighting, and exposure on Step 2D retained minimal hue and texture in them. Brown objects were on Step ½D. The shaded bricks were on Special Step 3DB black.
7. *Write the steps selected from the value-selector chart on the data form in order to evaluate the picture after processing.*

4-6 Data form entries approximately centered on excerpt of value-selector chart.

Blue Sky / Lavender	Blue-Green / Green	Step	Meter	Colors and Color Values of Objects	Step	Neutral	Orange / Brown
Wh Baby Blu / Whit Lavend	Whit Bl-Grn / Whit Green	2½LW	18 1/1000, 12½ f/22	*White Wall*	2½LW	Pure White / No Texture	Wh Orange / Whit Beige
Baby Blue / Lt Lavender	Pastel Turq / Light Green	2L	17½ 750, 12 f/19	♥	2L	Off-White / Min Texture	Lt Viv Org / Light Beige
Dk Baby Blu / Med Lavend	Bright Turq / Lt Kelly Gr	1½L			1½L	White-Gray / Adeq Text	Viv Orange / Med Beige
V Lt Bl Sky / Dk Lavender	Vivid Turq / Kelly Green	1L	16½ 375, 11 f/14	*Horizon Blue Sky*	1L	Light Gray / Consid Text	Viv Orange / Med Beige
Lt Blue Sky / Lt Viv Pur	Turq-Green / Dk Kelly Gr	½L	16 1/250, 10½ f/11	*Sky, Grass, Roof*	½L	Med Lt Gray / Ext Texture	Dk Viv Org / Dark Beige
Med Blu Sky / Viv Purple	Deep Turq / Pepper Grn	MV	15½ 185, 10 f/9.5	*Blue Sky at Top*	MV	Middle Gray / Max Texture	Burnt Org / Lt Brown
Dk Blue Sky / Dk Viv Pur	Dk Blue-Grn / Hunter Grn	½D	15 1/125, 9½ f/8		½D	Med Dk Gray / Ext Texture	Dk Burnt Or / Med Brown
V Dk Bl Sky / V Dk Purple	V Dk Bl-Grn / Forest Grn	1D	14½ 90, 9 f/6.3	*Evergreens*	1D	Dark Gray / Consid Text	Dk Org-Brn / Dark Brown
Blk-Blu Sky / Blksh-Purpl	Blk-Blu-Grn / Blksh-Green	1½D	14 1/60, 8½ f/5.6		1½D	V Dk Gray / Adeq Text	V Dk Org-Br / Choc Brown
		2D	13½ 1/45, 8 f/4.5	*Shaded Bricks*	2D	Text Black / Min Texture	Blk-Org-Brn / Blkish Brn

4-7 Data form and value-selector chart excerpt showing white wall positioned on Step 1½L.

Blue Sky / Lavender	Blue-Green / Green	Step	Meter	Colors and Color Values of Objects	Step	Neutral	Orange / Brown
Wh Baby Blu / Whit Lavend	Whit Bl-Grn / Whit Green	2L	18½ 1500, 13 f/27				
Baby Blue / Lt Lavender	Pastel Turq / Light Green	1½L	18 1000, 12½ f/22	*White Wall*	1½L	White-Gray / Adeq Text	Lt Viv Org / Light Beige
Dk Baby Blu / Med Lavend	Bright Turq / Lt Kelly Gr	1L	17½ 750, 12 f/19		1L	Light Gray / Consid Text	Viv Orange / Med Beige
V Lt Bl Sky / Dk Lavender	Vivid Turq / Kelly Green	½L	17 1/500, 11½ f/16		½L	Med Lt Gray / Ext Texture	Dk Viv Org / Dark Beige
Lt Blue Sky / Lt Viv Pur	Turq-Green / Dk Kelly Gr	MV	16½ 375, 11 f/14	*Horizon Blue Sky*	MV	Middle Gray / Max Texture	Burnt Org / Lt Brown
Med Blu Sky / Viv Purple	Deep Turq / Pepper Grn	½D	16 1/250, 10½ f/11	*Sky, Grass, Roof*	½D	Med Dk Gray / Ext Texture	Dk Burnt Or / Med Brown
Dk Blue Sky / Dk Viv Pur	Dk Blue-Grn / Hunter Grn	1D	15½ 185, 10 f/9.5	*Blue Sky at Top*	1D	Dark Gray / Consid Text	Dk Org-Brn / Dark Brown
V Dk Bl Sky / V Dk Purple	V Dk Bl-Grn / Forest Grn	1½D	15 1/125, 9½ f/8		1½D	V Dk Gray / Adeq Text	V Dk Org-Br / Choc Brown
Blk-Blu Sky / Blksh-Purpl	Blk-Blu-Grn / Blksh-Green	2D	14½ 90, 9 f/6.3	*Evergreens*	2D	Text Black / Min Texture	Blk-Org-Brn / Blkish Brn
		2½DB	14 1/60, 8½ f/5.6		2½DB	Pure Black / No Texture	
		3DB	13½ 1/45, 8 f/4.5	*Shaded Bricks*	3DB	Opaque Blk / No Texture	

8. *Note the f/stop on the Step MV line of the data form. This lens aperture setting, combined with the shutter speed, indicates the correct exposure.* In this photograph the lens aperture at Step MV was f/12.5. The shutter speed of 1/250 had not been changed during the meter-reading process. Therefore, 1/250 at f/12.5 would provide the film with the correct amount of light.
9. *Choose the best combination of f/stop and shutter speed for the picture, based upon the requirements of depth of field and motion control. Write the camera settings on the data form. Photographers using the f/stop rotation procedure may alter the combination of lens aperture and shutter speed, but the amount of light reaching the film must not change.* The following f/stop and shutter-speed combinations were acceptable for this picture, based upon depth of field and motion control requirements:

> 1/125 @ f/19
> 1/250 @ f/12.5
> 1/500 @ f/9.5

10. *Set the camera shutter and f/stop and take the picture.*
11. *After processing, evaluate the slide with the stair-step data.*
12. *Memorize the appearance of colors, textures, highlights, and shadows at various steps.*

SHUTTER-SPEED ROTATION PROCEDURE

The shutter-speed rotation procedure is used with through-the-lens camera meters. It is also used with hand meters that convert meter readings directly into shutter speeds and f/stops without using EVS numbers. The selection of a specific f/stop to take the picture requires that the shutter-speed rotation procedure be used. The scene photographed in figure C-3 contained a large white wall, evergreen trees, blue sky, brown roof, grass, and a variety of shadows. The general instructions for using the shutter-speed rotation procedure are indicated in italics.

1. *Define the perimeter of the format to determine proportionate sizes of colors. Select the lens to be used.*
2. *Determine if polarization is required to darken the sky or eliminate reflections.* The photographer viewed the scene through a polaroid filter that darkened the sky from a light blue. Therefore, the scene would be photographed through the polaroid filter unless subsequent meter readings indicated the sky would be reproduced blackish blue.
3. *Obtain spot readings of several single-value colors within the format, including those that make up the largest proportion of the format and those in the main subject. The shutter-speed dial is rotated to obtain the meter readings. When using the shutter-speed rotation procedure, the f/stop is placed on any setting that might be used to take the photograph. The f/stop should not be changed while obtaining the meter readings. Consider whether a tripod must be used to obtain sufficient depth of field. This f/stop must allow readings to be taken of the lightest and darkest areas.* Slow-speed film was being used. Minimal depth of field would be required. Therefore, f/5.6 was selected for obtaining the meter readings. For convenience a 70mm to 210mm zoom lens helped obtain single-value readings; small areas could be read from a distance when the lens was set on 210mm. All meter readings were taken through the polarizer with this camera because its meter worked properly with the polaroid filter. Meter readings were taken of the white wall, evergreen trees, sky, roof, grass, and shaded walls. The shutter-speed dial was rotated until the meter needle was aligned with the index mark, then the nearest one-half f/stop was circled on the data form.
4. *Write the colors on the stair-step data form on lines corresponding with the meter readings. This keeps the colors separated on the basis of the contrast between them. There will usually be blank lines.* If meter readings cannot be obtained with a particular camera at the in-between shutter speeds (1/45, 1/90, etc.) get readings at the

standard shutter speeds. The in-between readings can be determined when colors fall between the standard shutter speeds.

5. *Center the data form entries on top of the value-selector chart. The range of significant color reproduction is limited to the nine steps from 2L to 2D.* The data entries were centered on the value-selector chart with the white wall on Step 2½LW and the shadow on 2D.

6. *Evaluate color values, shadows, highlights, and textures by moving the chart up and down to select the best exposure. The size of each colored and textured area must be considered in proportion to the format, especially for those areas that require sacrifice of hue or texture.* Evaluation of other exposure possibilities indicated that exposure of the white wall on Step 2½LW would result in the best exposure of all colors and textures. The polarized blue sky on Step 1D at the top of the format would dramatically contrast with the large white wall on Step 2½LW. This step was appropriate for a brilliant white, textureless wall. Minimal texture would be retained in the shaded bricks on Step 2D. Saturated colors would result if the exposure were one-half f/stop less, and the bricks would lose their texture. Desaturated colors would result from one-half f/stop more exposure.

7. *Write the steps selected from the value-selector chart on the data form in order to evaluate the slide after processing.*

8. *The shutter speed on the Step MV line of the data form is used to determine the camera settings. This shutter speed, combined with the f/stop used while obtaining the meter readings, indicates the correct camera settings.* The shutter speed at Step MV was 1/90. The f/5.6 had remained constant while the readings were taken. Therefore, 1/90 at f/5.6 would provide the film with the correct amount of light.

9. *Choose the best combination of f/stop and shutter speed for the picture, based upon the requirements of depth of field and motion control. Write the camera settings on the data form. Photographers using the shutter-speed rotation procedure may alter the combination of lens aperture and shutter speed, but the amount of light reaching the film must not change.* The following f/stop and shutter-speed combinations would provide the same amount of light for this picture:

1/15 @ f/12.5	1/60 @ f/6.3
1/22 @ f/11	1/90 @ f/5.6
1/30 @ f/9.5	1/125 @ f/4.5
1/45 @ f/8	1/185 @ f/4

Little depth of field was required, and no objects were moving. The camera shutter could not be used at the in-between speeds. The photographer did not want to use a tripod. These factors limited the choice of shutter speed and f/stop to only two combinations: 1/60 @ f/6.3 and 1/125 @ f/4.5. The shutter speed selected for any hand-held picture should not be lower than the millimeter length of the lens to be used. This helps prevent camera motion. The zoom lens was to be used at the 70mm focal length, eliminating shutter speed choices of 1/60 and slower. Therefore, the picture was taken at 1/125 at f/4.5. If a tripod had been used, the photographer could have chosen from slower shutter-speed combinations.

10. *Set the camera shutter and f/stop and take the picture.*

11. *After processing, evaluate the slide with the stair-step data. Refine the ASA, if necessary, as explained in chapter 1.*

12. *Memorize the appearance of colors, textures, highlights, and shadows at various steps.*

Blue / Lavender	Turq / Green	Step	Meter	Colors and Color Values of Objects	Step	Step	Gray Scale	Orange / Brown
Wh Baby Blu / Whit Lavend		3LW	17½ 1/750 / 12 f/19			3LW	Glare White / No Texture	Wh Orange / Whit Beige
		2½LW	16½ 1/500 / 12 f/16 *(circled)*	White Wall	2½LW	2½LW	Pure White / No Texture *(circled)*	
Baby Blue / Lt Lavender	Whit Bl-Grn / Whit Green	2L	16½ 1/375 / 11 f/14		2L	2L	Off-White / Min Texture	Lt Viv Org / Light Beige
Dk Baby Blu / Med Lavend	Pastel Turq / Light Green	1½L	16 1/250 / 10½ f/11		1½L	1½L	White-Gray / Adeq Text	Viv Orange / Med Beige
V Lt Bl Sky / Dk Lavender	Bright Turq / Lt Kelly Gr	1L	15½ 1/185 / 10 f/9.5		1L	1L	Light Gray / Consid Text	Light Gray / Consid Text
Lt Blue Sky / Lt Viv Pur	Vivid Turq / Kelly Green *(circled)*	½L	14 1/125 / 9½ f/8 *(circled)*	Sky, Side Roof, Grass	½L	½L	Med Lt Gray / Ext Texture *(circled)*	Dk Viv Org / Dark Beige *(circled)*
Med Blu Sky / Viv Purple	Turq-Green / Dk Kelly Gr *(circled)*	MV ▲	14½ 1/90 / 9 f/6.3 *(circled)*	Sky, Front Roof, Grass	MV	MV ▲	Middle Gray / Max Texture	Burnt Org / Lt Brown *(circled)*
Dk Blue Sky / Dk Viv Pur	Deep Turq / Pepper Grn *(circled)*	½D	14 1/60 / 8½ f/5.6	Sky, Evergreen in Sun	½D	½D	Med Dk Gray / Ext Texture	Dk Burnt Or / Med Brown
V Dk Bl Sky / V Dk Purple	Dk Blue-Grn / Hunter Grn *(circled)*	1D	13½ 1/45 / 8 f/4.5 *(circled)*	Evergreen in Sun	1D	1D	Dark Gray / Consid Text *(circled)*	Dk Org-Brn / Dark Brown
	V Dk Bl-Grn / Forest Grn	1½D	13 1/30 / 7½ f/4		1½D	1½D	V Dk Gray / Adeq Text	V Dk Org-Br / Choc Brown
Blk-Blu Sky / Blksh-Purpl	Blk-Blu-Grn / Blksh-Green	2D	12½ 1/22 / 7 f/2.9 *(circled)*	Shadow Under Front Roof	2D	2D	Text Black / Min Texture *(circled)*	Blk-Org-Brn / Blkish Brn *(circled)*

APPLIED COLOR THEORY
FOR PHOTOGRAPHERS

<div align="right">5</div>

The Munsell color classification system offers color slide photographers unique training tools for visualizing exposure variations and increasing exposure accuracy. The Munsell system teaches recognition of color in terms of hue, value, and chroma with exceptional clarity. The concepts of the Munsell system also clarify the reasoning behind the middle-value calibration of exposure meters. By combining the stair-step system with the Munsell color classification system, the effects of exposure variations on forty hues can be examined.

Albert H. Munsell systematically arranged a variety of colors into three scales of hue (the color itself), value (the lightness or darkness of a color), and chroma (the vividness of a color). Each of these scales is made up of visually equal-spaced samples, allowing interpolation between samples and extrapolation beyond them. Professor Munsell used ten major hues: red, red purple, purple, purple blue, blue, blue green, green, green yellow, yellow, and yellow red. In the late 1930s and early 1940s, an in-depth study of the Munsell scales was undertaken by the United States National Bureau of Standards, the Munsell Color Company, Inc., and a large number of contributing specialists. The 1976 Glossy version of the *Munsell Book of Color* contains 1,488 colored samples of forty hues that conform to the standards of the in-depth study. Each Munsell chart contains chips of one hue arranged in rows of constant value and columns of constant chromas, as illustrated by the reproductions in this book. These reproductions are for illustrative purposes only. They do not conform to the tolerances of the charts available from the Munsell Color. An eleven-step gray scale, also available from Munsell, has been combined with the colored charts reproduced in this book to assist photographers in learning the exposure system.

Middle gray was chosen as the value reproduced on film when the exposure meter reading is followed. Middle gray is precisely in the middle of a theoreti-

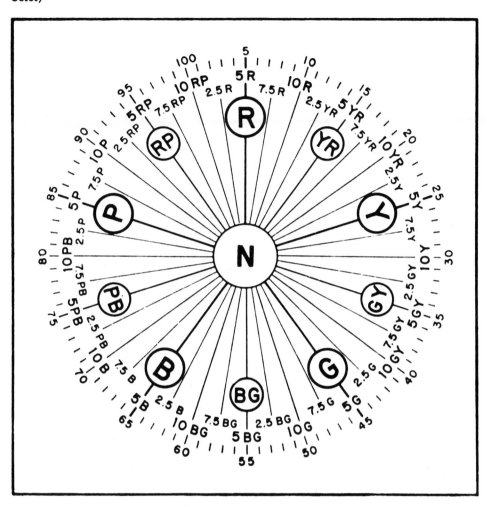

cal color solid. A description of the Munsell color solid explains why middle gray was chosen by exposure meter manufacturers for the point of calibration. It is for the same reason that Step MV was selected as the point of departure for the stair-step exposure system. Neutral gray is located in the center of a color wheel.

The point at which the gray scale passes vertically through the color wheel in figure 5-2 is middle-value gray. The space between the gray scale and the circumference of the wheel forms the chroma scale for each of the colors. The chroma scale for green is shown in this illustration. The hue becomes increasingly vivid as the rim of the wheel is approached. Each color becomes progressively grayer as the center of the color circle is approached along the chroma scale. Additional color circles may be conceptualized at each step up and down the gray scale, as illustrated in the Munsell charts. Going up the gray scale, the hues become lighter in value until they blend into white at the top of the color solid. Going down the gray scale, the colors become darker in value until they blend into black at the bottom of the color solid.

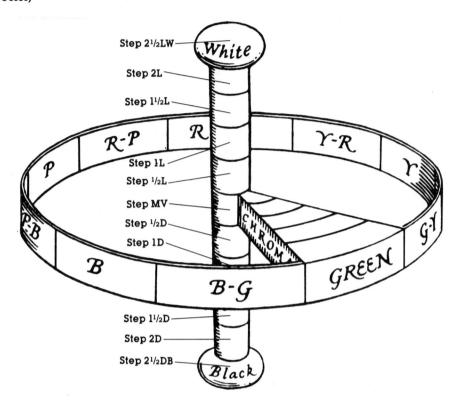

The color solid is actually very irregular in shape because of the varying lengths of the chroma scales for different colors. Middle gray with 19.77 percent reflectance is located in the exact center of the color solid. Millions of colors can be visualized as being plotted in the color solid, each at its own hue, value, and chroma position. Exposure meters are calibrated to middle gray in the center of the color solid. Step MV was chosen as the logical point of departure for the stair-step exposure system because it is precisely between black and white. Middle gray is also between all of the colors. Step MV represents a horizontal cross section through the color solid at middle value for all colors. Positioning the point of departure for a color exposure system at this location in the color solid is a sensible, simple, and practical approach to accurate exposure determination. It is two and one-half f/stops to white and two and one-half f/stops to black.

The United States National Bureau of Standards, in conjunction with the Inter-Society Color Council (ISCC-NBS), has developed 267 simple, easily understood, and accurately specified color names or designations. These are published in *Color: Universal Language and Names Dictionary, National Bureau of Standards Special Publication 440,* December, 1976. Colored chips of these colors are also available from the National Bureau of Standards. These designations are defined in terms of the Munsell system. Adaptations of 103 of these designations are included in the descriptions of colors for the stair-step exposure system value-selector chart and exposure slide rule.

5-3 Munsell color solid with one-quarter removed to show constant-hue 5Y yellow. In this example Step 1¾ LY is not represented by rectangular chips. Note the irregular shape of the color solid.

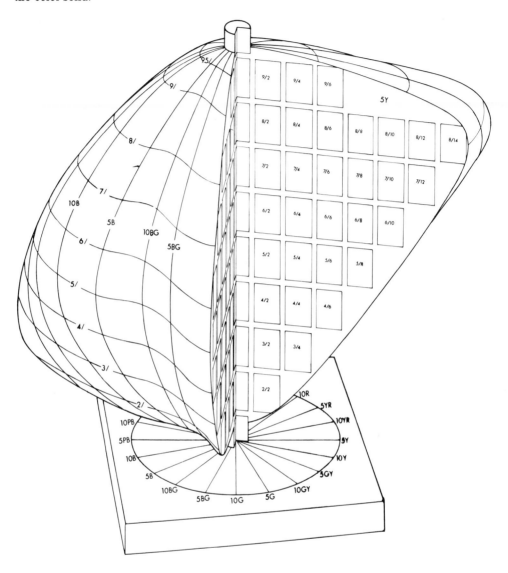

COLOR SLIDE FILM EXPOSURE ACCORDING TO COLOR

II

BLACK, GRAY, AND WHITE 6

T his chapter provides descriptions and uses for white, gray, and black exposed on the eleven regular steps and two special steps of the stair-step system. These descriptions apply to slides exposed with an ASA that has been refined to specific projection conditions and equipment. Projection on a different screen surface or other changes in projection conditions will alter the appearance of the values. Color slide photographers must know how to correctly expose black, gray, and white.

Special Step 3LW: Glare White. *LW* indicates that this step is used for nontextured glare white. Step 3LW is obtained by exposing the film three f/stops lighter than the meter reading of that color. For example, if the meter indicates f/11, the exposure would be f/4. Step 3LW can also be obtained by lowering the shutter speed the equivalent of three f/stops. For example, if the meter indicates a shutter speed of 1/250, that shutter speed would be changed to 1/30. Step 3LW may be used with excessively contrasty scenes; no texture or color will be present.

Step 2½LW: Pure White. *LW* indicates that this value should be reserved only for exposure of white, nontextured objects. It can be used for small areas of white clouds, whitecaps on water, small areas of white clothing, and similar white subjects that comprise a small proportion of the total format. This step is also used for high values in montages, to permit colors to show through the slide. It may also be used for exposure of high values in contrasty pictures.

Step 2L: Off-White. This step is used for reproducing minimally textured white that constitutes a small proportion of the format. It is excellent for areas of snow that occupy less than one-third of the picture. It will be excessively light for larger proportions of snow. This step can be used to reproduce whitecaps on water, including ocean breakers. It is also good for small clouds or small, sunny areas of large clouds.

45

Step 1½L: White Gray. This step will reproduce an adequate amount of texture in white or white gray subjects. If contrasted with a very dark mass, Step 1½L will appear white. Where contrast is not so dramatic, this value will appear light gray. This is a good value for the sunny areas of billowy clouds because texture in their surfaces will be apparent. This is also an ideal value for snow areas that make up one-third to two-thirds of the format. The snow will have the right amount of texture if it is cross-lighted.

Step 1L: Light Gray. Step 1L is excellent for clouds in dark blue sky. The sunny parts of the clouds will show considerable texture. This is also the best value for snow scenes in which the snow occupies two-thirds or more of the format. This light gray value will appear nearly white if adjacent to very dark values or if the majority of the format contains it. Considerable texture will be apparent in textured subjects.

Step ½L: Medium Light Gray. This step is excellent for exposure of large masses of stormy "white" clouds against very dark blue polarized sky. The dark gray cloud base will enhance the picture. This step is too dark to be used for snow except as a shadow value. Foggy scenes exposed at this value may be too light unless large subjects that have sufficient darkness to provide contrast are present. Extensive texture will be reproduced in textured subjects.

Step MV: Middle Gray. This step is the point of departure for determining exposure in the stair-step system. Middle gray is obtained by exposing any gray-scale value according to the meter reading of that value. If the meter reading is followed without modification, white, very light gray, and light gray will be darkened to middle gray. All of the *D* steps will be lightened to middle value if the meter reading is not modified. In other words, black and dark gray values will be raised to middle gray. This step is excellent for the gray cloud bases, giving clouds a stormy appearance. Shadows in snow will be dark enough to appear correctly exposed. Maximum texture is reproduced in textured gray objects exposed on Step MV.

Step ½D: Medium Dark Gray. This value is one-half f/stop darker than middle gray. The bases of clouds will have extensive texture and a stormy appearance. In snow photography only shadows should be exposed on Step ½D. Foggy scenes will appear slightly dark. Extensive texture will be retained in textured subjects.

Step 1D: Dark Gray. Care must be taken to ensure lighter parts of clouds are not too dark if the bases are exposed on Step 1D. The clouds will have a dark, stormy mood. Foggy scenes will be quite dark, and objects in the fog will probably be textureless black. Considerable texture is apparent in dark gray subjects that have texture. Step 1D is often used as a shadow value.

Step 1½D: Very Dark Gray. Step 1½D is usually reserved for shadows and dark objects. It is satisfactory for very dark stormy clouds, but other types of clouds will be too dark. Adequate texture will be maintained in dark areas.

Step 2D: Textured Black. This step will appear black if the subject itself does not have a textured surface or if it is adjacent to a very light subject. This is an excellent value for shadows in landscape photography. Minimum texture is reproduced in textured shadows.

Step 2½DB: Pure Black. Only subjects that the photographer envisions as textureless black should be exposed on Step 2½DB. It is excellent as a shadow value in which no details are visible.

Special Step 3DB: Opaque Black. Any gray value or any color exposed on Step 3DB will be reproduced as untextured black. This special step represents the maximum practical density of color transparency film. It is used when scenes of extreme contrast require that some areas be reproduced in textureless black so that light areas retain color and texture.

EXPOSURE EXAMPLE: BLACK, GRAY, WHITE AND BLUE

When photographing black, white, and gray subjects on color slide film, the impression of correct exposure is conveyed by sufficiently dark shadow and sky values. A large proportion of snow or white sand exposed on Step 2L will be too light, especially if the sky is pale blue and there are no black or dark subjects in the picture. A dark blue sky or dark shadow provides accent and contrast. Snow, white sand, brilliant white water, or other white subjects exposed at or below Step MV will be so dark that they will no longer appear white. In addition, other objects in the picture will probably be too dark if white is exposed at or below middle value. Shadows should be exposed on Steps 1½D, 2D, or 2½DB to contrast adequately with white areas. If the shadows are small, shadow texture is more readily sacrificed without ruining the picture.

A scene at White Sands National Monument (fig. 6-1) includes curved surfaces that reflect light in different directions. This makes the white appear as various shades of gray. The data form entries were centered on top of the value-selector chart. The white highlight was on Step 2L and the large shadow on Step 2D. If this contrast range had been one step wider, texture would have been sacrificed in either the shadow or the highlight. A center-weighted through-the-lens camera meter would have recommended that this picture be lighter because it would average the predominance of dark values in the center of the format to middle gray. This would have caused loss of texture in the white, as well as excessive texture and lightness in the shadow. The resulting overexposure would ruin the picture. The Step ½D blue sky assured separation of sky and shadow.

EXPOSURE EXAMPLE: MAJOR PROPORTION OF MIDDLE GRAY

Yosemite Falls in Yosemite National Park in California is surrounded by middle-gray granite (fig. 6-3). Very dark green, shaded foliage and blue sky are also present. Use of a polarizing filter darkened the sky. Meter readings of single-value areas were taken through the polarizer. When the meter reading of the gray granite was aligned with Step MV, the readings of the evergreens in the bottom of the picture were positioned on Steps 1½D and 2D, which would retain hue and texture. The branches of the evergreen trees on both sides of the picture were in deep shade. They would be reproduced in textureless black. The meter reading of the blue sky varied from Step MV to 1D. This prevented the sky from blending with the black evergreen branch in the upper left corner.

The photographer was standing in deep shade on the south side of the valley. Dark shadows, which would have caused erroneous readings and overexposure, were not permitted to influence the meter readings. The central mass was middle gray, with equal distribution of small black and white accents. Exposure was determined by the meter reading on middle value. Depth of field required that the black branches and the waterfall both be in focus. Shutter speed was determined according to the f/stop that was selected to obtain the necessary depth of field.

6-1 Exposure of black, gray, white, and blue shown in this black-and-white version of color slide of White Sands National Monument.

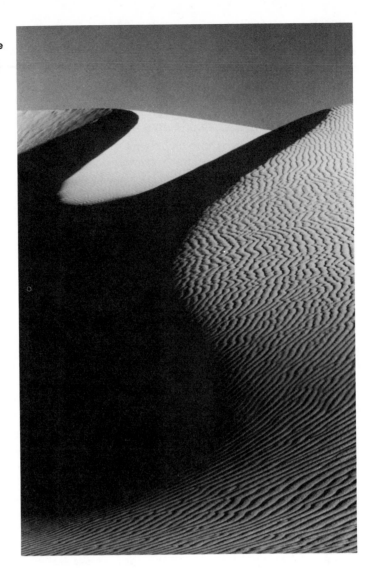

6-2 Data form and value- selector excerpt for figure 6-1.

		Colors and Color Values of Objects	Step		
Wh Baby Blu Whit Lavend	2L	Textured White at Top 2L	2L	Off-White Min Texture	
Baby Blue Lt Lavender	1½L		1½L	1½L	White-Gray Adeq Text
Dk Baby Blu Med Lavend	1L		1L	1L	Light Gray Consid Text
V Lt Bl Sky Dk Lavender	½L		½L	½L	Med Lt Gray Ext Texture
Lt Blue Sky Lt Viv Pur	MV ◀		MV	▶ MV	Middle Gray Max Texture
Med Blu Sky Viv Purple	½D	Blue Sky	½D	½D	Med Dk Gray Ext Texture
Dk Blue Sky Dk Viv Pur	1D		1D	1D	Dark Gray Consid Text
V Dk Bl Sky V Dk Purple	1½D		1½D	1½D	V Dk Gray Adeq Text
Blk-Blu Sky Blksh-Purpl	2D	Large Shadow 2D	2D	2D	Text Black Min Texture

48

6-3 Exposure of major proportion of middle gray shown in this black-and-white version of color slide of Yosemite Falls.

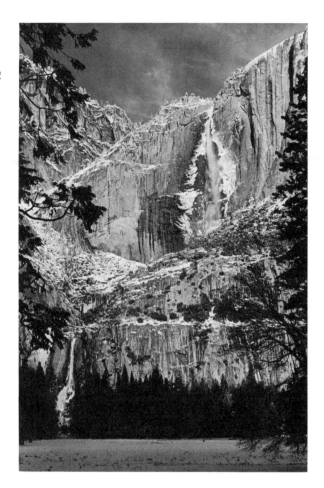

6-4 Data form and value-selector excerpt for figure 6-3.

			Colors and Color Values of Objects	Step	Step		
		2½LW	Small Areas of Snow + Ice	2½	LW	2½LW	Pure White / No Texture
Wh Baby Blu / Whit Lavend	Whit Bl-Grn / Whit Green	2L		2L		2L	Off-White / Min Texture
Baby Blue / Lt Lavender	Pastel Turq / Light Green	1½L		1½L		1½L	White-Gray / Adeq Text
Dk Baby Blu / Med Lavend	Bright Turq / Lt Kelly Gr	1L		1L		1L	Light Gray / Consid Text
V Lt Bl Sky / Dk Lavender	Vivid Turq / Kelly Green	½L		½L		½L	Med Lt Gray / Ext Texture
Lt Blue Sky / Lt Viv Pur	Turq-Green / Dk Kelly Gr	MV	Gray Granite, Sky	MV		MV	Middle Gray / Max Texture
Med Blu Sky / Viv Purple	Deep Turq / Pepper Grn	½D	Sky	½D		½D	Med Dk Gray / Ext Texture
Dk Blue Sky / Dk Viv Pur	Dk Blue-Grn / Hunter Grn	1D	Sky	1D		1D	Dark Gray / Consid Text
V Dk Bl Sky / V Dk Purple	V Dk Bl-Grn / Forest Grn	1½D	Evergreens	1½D		1½D	V Dk Gray / Adeq Text
Blk-Blu Sky / Blksh-Purpl	Blk-Blu-Grn / Blksh-Green	2D	Evergreens	2D		2D	Text Black / Min Texture
		2½DB	Shadows	2½	DB	2½DB	Pure Black / No Texture
		3DB	Shadows	3	DB	3DB	Opaque Blk / No Texture

EXPOSURE EXAMPLE: WHITE, GRAY, BLACK, BLUE, AND GREEN

The stormy mood of clouds can be enhanced by saturated colors and a darkened sky created by polarization. In the thunderstorm example (fig. C-4), the highest value of white was Step 1½L, preserving texture in the cloud. Positioning the meter's reading of the cloud on Step 1½L, the photographer used the value-selector chart to envision the effect of that exposure on other colors. The dark cloud base ranged down to Step 1D, emphasizing the stormy mood. Small shadows were acceptable on Steps 2D and 2½DB.

6-5 Data form and value-selector chart excerpt for figure C-4.

		Colors and Color Values of Objects	Step	Step		
Baby Blue / Lt Lavender	1½L	Lightest Cloud Area	1½L		1½L	White-Gray / Adeq Text
Dk Baby Blu / Med Lavend	1L		1L		1L	Light Gray / Consid Text
V Lt Bl Sky / Dk Lavender	½L		½L		½L	Med Lt Gray / Ext Texture
Lt Blue Sky / Lt Viv Pur	MV	Gray Base of Cloud	MV		MV	Middle Gray / Max Texture
Med Blu Sky / Viv Purple	½D	Gray Base of Cloud	½D		½D	Med Dk Gray / Ext Texture
Dk Blue Sky / Dk Viv Pur	1D	Cloud Base, Pola Sky	1D		1D	Dark Gray / Consid Text
V Dk Bl Sky / V Dk Purple	1½D	Blue Polarized Sky	1½D		1½D	V Dk Gray / Adeq Text
Blk-Blu Sky / Blksh-Purpl	2D	Shadows	2D		2D	Text Black / Min Texture
	2½DB	Shadows	2½DB		2½DB	Pure Black / No Texture

PURPLE BLUE 7

Blue is a cool, receding color. Purple blue objects include atmospheric haze, glassware, automobiles, flags, sky, and objects in nature. An examination of the Munsell purple blue chart (fig. C-5) reveals it is a hue almost equally divided on each side of middle value. Maximum chroma for purple blue is reached on Steps 1/2D and MV. Keep records of exposure of blue. Evaluate blue on the screen until you memorize the values.

The Munsell chart can be used to envision what happens to blue sky at different exposures. The darkness of sky may be altered because blue sky naturally occurs in a wide variety of values and chromas. It also varies in hue from cyan to purple blue. Judicious polarization, careful meter-reading technique, and use of the value-selector chart will permit you to envision the sky at different values. Polluted sky should not be polarized because it becomes gray rather than dark blue.

Evaluation of several hundred correctly exposed slides revealed that blue sky values encompassed steps from 1L to 2D. In this sampling the skies included those that had only one value, as well as those with a continuum of several values. If a picture had several sky values, each of these values was counted. A breakdown of the data revealed the following distribution of sky values.

Step 2L	Whitish Baby Blue	None
Step 1 1/2L	Baby Blue	None
Step 1L	Dark Baby Blue	4%
Step 1/2L	Very Light Blue Sky	6%
Step MV	Light Blue Sky	10%
Step 1/2D	Medium Blue Sky	25%
Step 1D	Dark Blue Sky	25%
Step 1 1/2D	Very Dark Blue Sky	25%
Step 2D	Blackish Blue Sky	6%
Step 2 1/2DB	Black	None

The polaroid filter helps keep sky within the three ideal sky exposure steps, Steps ½D, 1D, and 1½D. The sky values on Step MV and lighter resulted because polarization was not possible. The Step 2D skies were at the top of formats in superwide-angle lens pictures or in scenes of extreme contrast between snow and blue sky.

Purple blue on the nine colored steps of the exposure system is described as follows.

Step 2L: Whitish Baby Blue. This is the lightest step on which significant hue will be retained. Exposure of only the very lightest blue or bluish white should be considered for this step. Listed in order of increasing chroma, Step 2L blue samples would be described as very light grayish blue, whitish blue, and very light brilliant blue. Values of blue that match these descriptions should be exposed on this step for correct reproduction.

Step 1½L: Baby Blue. Designations of Step 1½L blue include very light blue, very pale blue, and brilliant blue. This value is usually too light for reproduction of the sky in slides.

Step 1L: Dark Baby Blue. Hull gray and light smoke blue are typical names for low-chroma samples of Step 1L blue. In addition, pale blue, light blue, sky horizon blue, and larkspur blue should be exposed on Step 1L. High-chroma blue includes brilliant blue, commonly found in clear blue sky. Step 1L should be used only for horizon sky.

Step ½L: Very Light Blue Sky. Light bluish gray and smoke blue are descriptions of low-chroma blue at this value. Proceeding across the chroma scale, light blue, brilliant blue, and vivid blue are samples of higher chroma blue on Step ½L. This value of blue is usually the lightest to be used for sky, except horizon sky.

Step MV: Light Blue Sky. This is the point of departure for determining correct exposure in the stair-step system. The descriptions for purple blue listed in the L steps will not be true if L-step purple blue samples are exposed at middle value. Samples of purple blue that belong in the D steps will be raised to middle-value descriptions if the meter reading on them is followed. Bluish gray, slate blue, and pale purple blue are low-chroma samples at this step. Light blue sky will result from exposure on Step MV. Note that the Step MV and Step ½D chroma scales on the Munsell purple blue chart are the longest, indicating the vividness of blue samples at these values.

Step ½D: Medium Blue Sky. Low-chroma grayish blue, known as steel blue, is correctly exposed on this step. Moderate blue is a middle-chroma blue that approximates mountain haze. Ultramarine, light royal blue, vivid blue, and azure are high-chroma designations of blue samples that should be exposed on Step ½D. Vivid blue is seen in very clean sky. Step ½D is the lightest of the three best values for exposure of blue sky, especially if a large proportion of sky is present in the format. This step is also a shadow value for lighter blue subjects.

Step 1D: Dark Blue Sky. Low-chroma Step 1D purple blue is designated dark grayish blue. Strong blue and deep blue are higher chroma designations for Step 1D blue. These might also be called queen blue, king blue, or Dutch azure. This is the darkest blue to use if blending with other dark colors must be prevented. Shadows and evergreen trees will not blend with a Step 1D dark blue sky. Vivid blue, as seen in clean sky, would be correctly exposed on this step. Polarization may be required to obtain a Step 1D dark blue sky and still retain accurate color and ample texture in other subjects. This is an ideal step for blue sky.

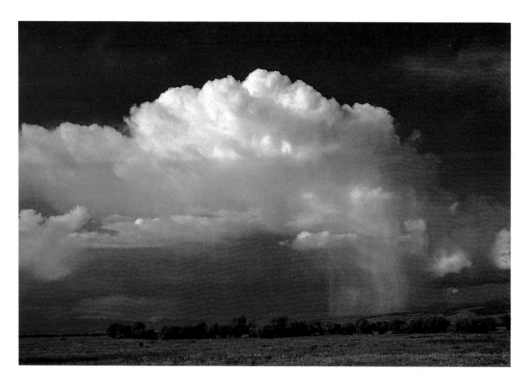

C-4 Exposure of white, gray, black, blue, and green shown in this color slide reproduction of a thunderstorm cloud in Montana.

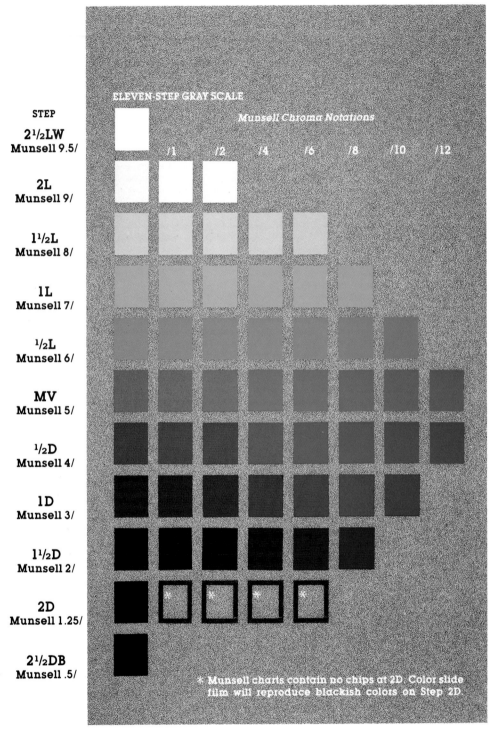

STEP

2½LW
Munsell 9.5/

2L
Munsell 9/

1½L
Munsell 8/

1L
Munsell 7/

½L
Munsell 6/

MV
Munsell 5/

½D
Munsell 4/

1D
Munsell 3/

1½D
Munsell 2/

2D
Munsell 1.25/

2½DB
Munsell .5/

ELEVEN-STEP GRAY SCALE

Munsell Chroma Notations

/1 /2 /4 /6 /8 /10 /12

* Munsell charts contain no chips at 2D. Color slide film will reproduce blackish colors on Step 2D.

C-5 Munsell constant-hue chart 5PB purple blue with eleven-step gray scale added as left column. (From *Munsell Book of Color,* reproduced courtesy of Munsell Color)

C-6 Exposure of black, white, and eight steps of blue shown in color slide reproduction of "Backlighted Cross."

C-7 Exposure of blue and white shown in color slide reproduction of ferris wheel at Expo '74 in Spokane, Washington.

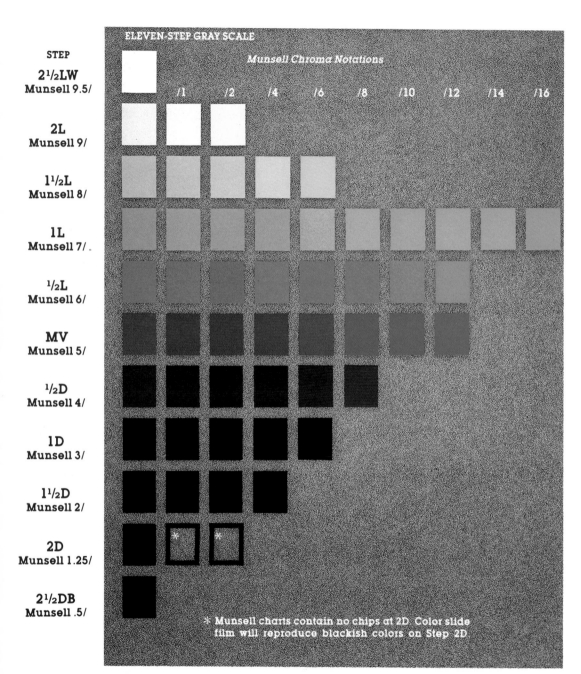

C-8 Munsell constant-hue chart 5YR yellow red with eleven-step gray scale added as left column. (From *Munsell Book of Color*, reproduced courtesy of Munsell Color)

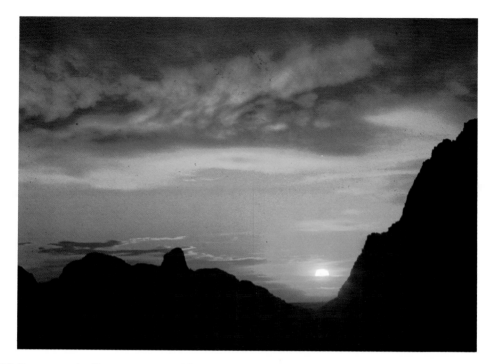

C-15 Exposure of yellow, orange, and black shown in this color slide reproduction of Badlands sunset, South Dakota.

C-16 Exposure of yellow and blackish maroon shown in this color slide reproduction of pansy blossom.

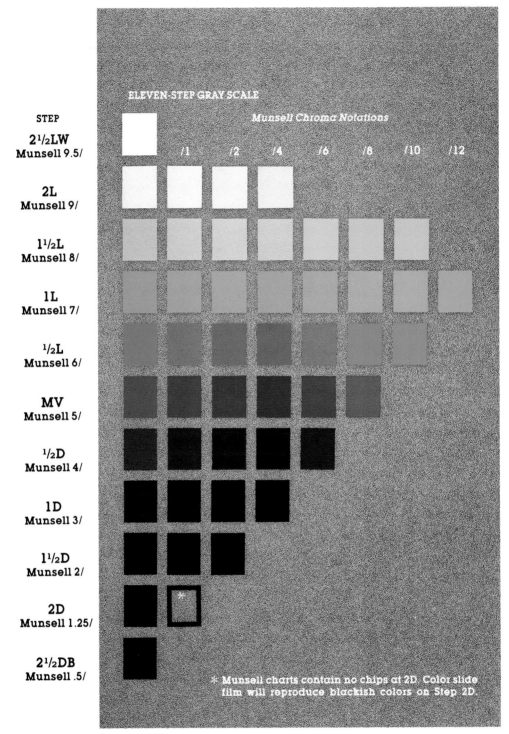

C-17 Munsell constant-hue chart 5GY green yellow with eleven-step gray scale added as left column. (From *Munsell Book of Color*, reproduced courtesy of Munsell Color)

C-18 Exposure of green yellow and olive green shown in this color slide reproduction of "Sun Rays in the Fog."

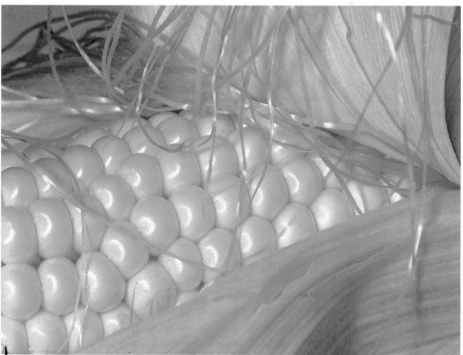

C-19 Exposure of green yellow and yellow shown in this color slide reproduction of yellow corn with green yellow husk.

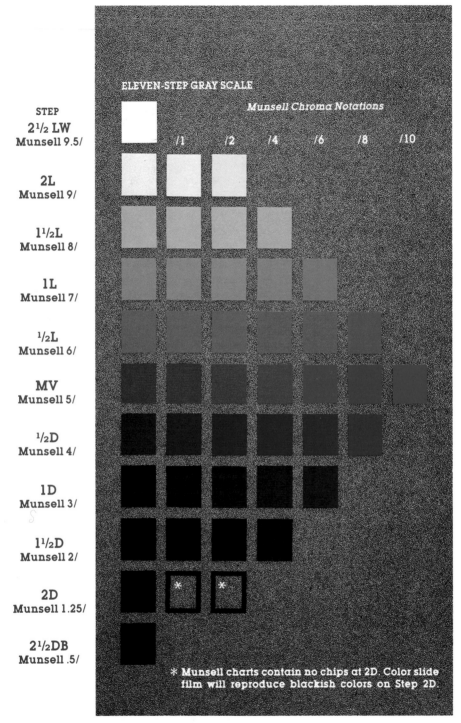

ELEVEN-STEP GRAY SCALE

Munsell Chroma Notations

STEP		/1	/2	/4	/6	/8	/10
2½ LW Munsell 9.5/							
2L Munsell 9/							
1½L Munsell 8/							
1L Munsell 7/							
½L Munsell 6/							
MV Munsell 5/							
½D Munsell 4/							
1D Munsell 3/							
1½D Munsell 2/							
2D Munsell 1.25/		*	*				
2½DB Munsell .5/							

* Munsell charts contain no chips at 2D. Color slide film will reproduce blackish colors on Step 2D.

C-20 Munsell constant-hue chart 5B blue with eleven-step gray scale added as left column. (From *Munsell Book of Color*, reproduced courtesy of Munsell Color)

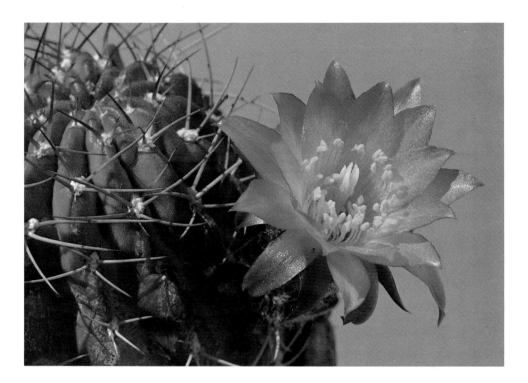

C-21 Exposure of cyan blue, green, red, and olive green shown in this color slide reproduction of cactus with simulated blue sky.

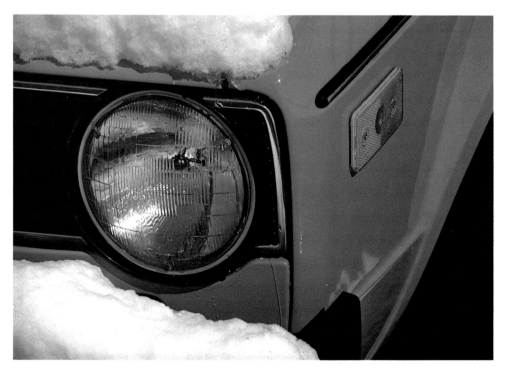

C-22 Exposure of cyan blue, white, black, and gray shown in this color slide reproduction of blue car in snow.

C-23 Exposure of beige, brown, dark brown, and black shown in this color slide reproduction of Cliff Palace.

C-24 Exposure of brown, gray, and white shown in this color slide reproduction of "Wintry Lunch."

C-25 Exposure of white, beige, and brown shown in this color slide reproduction of "Working Hands."

YELLOW RED (ORANGE) 8

O range is a high-value, high-chroma color. It should be exposed on Step 1L, but acceptable compromise exposures can be made on Steps 1½L and ½L. Exposure of vivid orange on any other steps will cause loss of chroma. Outside of the specified value and chroma, yellow red includes a variety of pink, brown, beige, and copper colors. The majority of chips on the Munsell yellow red chart are above middle value (see fig. C-8). Vivid orange does not exist in the D steps. Typical orange subjects include oranges, pumpkins, carrots, autumn leaves, flowers, home furnishings, tangerines, apricots, clothing, automobiles, fire, sunsets, and sunrises. Orange is a warm color. Brown versions of yellow red and brown examples will be fully described in chapter 13. The nine colored steps of yellow red in the exposure system are described as follows.

Step 2L: Whitish Orange. If a vivid orange is exposed on Step 2L, it will lose value and chroma, resulting in whitish or pinkish orange. These samples would be called light yellowish pink, very light orange, baby pink, peach pink, light orange, or orange pink.

Step 1½L: Light Vivid Orange. Low-chroma samples of yellow red at this value are beige, pale brown, brownish pink, and light brown. Higher chroma orange samples include salmon pink, peach, nectarine, and light vivid orange. Step 1½L is one of the three ideal steps for exposure of vivid orange.

Step 1L: Vivid Orange. Yellow red reaches maximum chroma on Step 1L. The hue and value traditionally known as orange exists from the middle to the end of the Step 1L chroma scale. The lowest chroma sample of orange at this value is pale brown. Proceeding along the chroma scale, brownish pink, dark beige, and dark buff are gray enough to not be called orange. In the middle of the chroma scale, dull orange, salmon pink, nectarine, peach, and apricot are present. High-chroma color names for Step 1L orange include strong orange, vivid orange, carrot,

and flame orange. The length of the orange chroma scale on Step 1L indicates that true orange must be exposed at this value. Acceptable compromise versions can be reproduced on Steps 1½L and ½L.

Step ½L: Dark Vivid Orange. Low-chroma versions of orange on this step include light grayish brown, sandalwood, sand, dark beige, and light brown. These colors are similar to old weathered wood. In the middle of the chroma scale, the orange samples could be called pumpkin, nasturtium, salmon orange, orange peel, and brownish orange. High-chroma designations of orange on this step include dark vivid orange and deep orange. Exposure of vivid orange on step ½L will result in partial loss of chroma.

Step MV: Burnt Orange. All versions of yellow red listed for the L steps will be reproduced at this value if the meter reading is followed. The vivid orange of Step 1L will lose most of its orange appearance at middle value, as the descriptions and color names for this step indicate. All of the D-step descriptions will be raised to middle value if the exposure meter reading is not modified. For example, dark browns will be changed to middle-value versions of brown. Step MV is the point of departure in the stair-step system from which modifications are made to achieve accurate exposure. The lowest chroma samples of yellow red at Step MV include light grayish brown, as found in weathered wood and sand. Light brownish orange is in the middle of the chroma scale. The remaining samples of dark orange at Step MV could be described as burnt orange or rust. Step MV is the darkest step on which vivid orange should be exposed, but it will be reproduced as burnt orange rather than vivid orange.

Step ½D: Dark Burnt Orange. Yellow red loses chroma rapidly as exposure is decreased in the D steps. This loss of chroma changes orange to brown. Low-chroma samples of yellow red on Step ½D include grayish brown, moderate brown, and strong brown. Middle chroma yellow red at this step includes light walnut, earth brown, copper brown, and rust brown. These colors are found in various types of wood, rusted metal, and soil. Vivid orange does not exist in the D steps.

Step 1D: Dark Orange Brown. Grayish brown, moderate brown, cinnamon brown, and walnut stain are descriptions for yellow red on Step 1D. Any higher value of brown will be changed to these descriptions if exposed on Step 1D. This step can be used for shaded portions of lighter brown or orange subjects. If a vivid orange is exposed on this step, it will be seriously underexposed, as will all of the other colors in the photograph.

Step 1½D: Very Dark Orange Brown. Yellow red in the form of dark brown, chocolate brown, and dark walnut stain should be exposed on Step 1½D for best reproduction.

Step 2D: Blackish Brown. This step should be reserved only for exposure of very dark brown or blackish brown. It is satisfactory for reproduction of shaded portions of lighter browns.

EXPOSURE EXAMPLE: BLACK, GRAY, WHITE, AND ORANGE

Vivid orange should be exposed at Step 1L. A compromise in exposure would be limited to Step 1½L or ½L. Fire is a typical example of orange. In figure C-9 the major proportion of the format is black. Fire occupies the center of interest. The large black mass in this subject should contain details of the burned wood texture. Meter readings were obtained of the white, black, and orange areas.

The value selector was positioned under the data form. The meter reading of the orange was aligned with Step 1L, the step on which orange reaches maximum chroma. The meter reading of the black area was positioned on Step 2D, which would be minimally textured black. Step 1½D would have shown more texture, but would have made the white lose all texture. Meter readings of the white areas were on Steps 2L and 2½LW. Lines between each of the wallboards broke up the solid white mass, permitting acceptable exposure on Steps 2L and 2½LW. This was a better compromise than darkening the black to Step 2½DB, which would have caused loss of texture in the black and darkened the orange. Camera settings were selected on the basis of the EVS number on Step MV. Depth of field requirements were almost nonexistent because the scene was a vertical wall. Practically any combination of shutter speed and f/stop could be selected from the choice offered by the EVS number on Step MV.

8-1 **Data form and value-selector chart excerpt for figure C-9.**

	Colors and Color Values of Objects	Step	Step				
2½LW	White Wall	2½ LW		2½LW	Pure White / No Texture		
2L	White Wall	2 LW		2L	Off-White / Min Texture	Wh Orange / Whit Beige	
1½L		1½ L		1½L	White-Gray / Adeq Text	Lt Viv Org / Light Beige	
1L	Fire Orange	1L		1L	Light Gray / Consid Text	Viv Orange / Med Beige	
½L		½ L		½L	Med Lt Gray / Ext Texture	Dk Viv Org / Dark Beige	
MV		MV		MV	Middle Gray / Max Texture	Burnt Org / Lt Brown	
½D		½D		½D	Med Dk Gray / Ext Texture	Dk Burnt Or / Med Brown	
1D		1D		1D	Dark Gray / Consid Text	Dk Org-Brn / Dark Brown	
1½D		1½ D		1½D	V Dk Gray / Adeq Text	V Dk Org-Br / Choc Brown	
2D	Black Burned Area	2D		2D	Text Black / Min Texture	Blk-Org-Brn / Blkish Brn	

EXPOSURE EXAMPLE: BURNT ORANGE, BROWN, BLACK, AND BLUE

Skyline Arch, photographed in Arches National Park in Utah (fig. C-10), would have been too light if the photographer had followed the recommendation of an averaging meter. The majority of the format consisted of brownish orange, blue sky, and shadows. All of these should be reproduced in middle and dark values, rather than being averaged to light, middle, and dark values. Several small areas of light beige were not large enough to balance the mass of dark values in an averaged meter reading.

Meter readings were taken of shadows, sky, and sunny orange brown rock. The reading of the sunny rock was initially positioned on Step 1D because this is one of the ideal steps for exposure of colored desert rock. In this picture however, it would have caused loss of texture in shadow areas. Repositioning the data form and value-selector chart with the sunny rock on Step MV raised the large shadows to Step 1½D. Small shadows were darker. Sunrise made the rock more orange than

8-2 Data form and value-selector chart excerpt for figure C-10.

Colors and Color Values of Objects			Step	Step			
Baby Blue / Lt Lavender	1½L	Beige Rock (Small)	1½L		1½L	White-Gray (Adeq Text)	Lt Viv Org (Light Beige)
Dk Baby Blu / Med Lavend	1L		1L		1L	Light Gray Consid Text	Viv Orange Med Beige
V Lt Bl Sky / Dk Lavender	½L		½L		½L	Med Lt Gray Ext Texture	Dk Viv Org Dark Beige
Lt Blue Sky / Lt Viv Pur	MV	Large Area of Rock	MV		MV	Middle Gray (Max Texture)	Burnt Org (Lt Brown)
Med Blu Sky / Viv Purple	½D	Shaded Rock	½D		½D	Med Dk Gray (Ext Texture)	Dk Burnt Or (Med Brown)
Dk Blue Sky / Dk Viv Pur	1D	Shaded Rock, Blue Sky	1D		1D	Dark Gray Consid Text	Dk Org-Brn (Dark Brown)
V Dk Bl Sky / V Dk Purple	1½D	Shaded Rock	1½D		1½D	V Dk Gray (Adeq Text)	V Dk Org-Br (Choc Brown)
Blk-Blu Sky / Blksh-Purpl	2D	Shaded Rock	2D		2D	Text Black (Min Texture)	Blk-Org-Brn (Blkish Brn)

usual. The sky would have been too light without polarization. Step 1D blue sky would not blend with shadows and would contrast dramatically with the orange rock. Camera settings were selected on the basis of the meter reading choices on Step MV. Depth of field required a small f/stop. Shutter speed was chosen accordingly and forced the photographer to use a tripod to prevent camera motion.

Color names for the nine steps of red will help you select the desired reproduction. Maximum chroma for red occurs on Steps MV and ½D (see fig. C-11). Red is a warm, advancing color. It is found in sunsets, sunrises, clothing, fire, flowers, flags, fruit, vegetables, package labels, household furnishings, jewelry, cosmetics, bricks, automobiles, and many other objects. Red contains such a wide variety of chroma samples that thinking of it in terms of pink, red, and maroon will make it easier to envision. These three divisions of red have important implications for selecting the correct step for exposure. Certain versions of red are considered brown; these are discussed in detail in chapter 13. Careful study of the Munsell chart and exposure records will enable you to envision correct and incorrect exposures of red.

*Step 2L: **Whitish Pink**.* Reddish white or pink are correctly exposed on this step. Pink at this value could be called pale pink, light baby pink, or whitish pink.

*Step 1½L: **Baby Pink**.* Grayish pink is a version of beige or light brown at low chroma. It is very warm because of the pink in it. Moderate pink, peach-blossom pink, baby pink, pink coral, and Chinese orange are also present on Step 1½L.

*Step 1L: **Dark Pink**.* Grayish pink, pale brown, dark pink, peach-blossom pink, pink coral, and vivid sun pink are on Step 1L. Red does not exist on Step 1L or higher steps; these colors are all versions of pink.

*Step ½L: **Very Dark Pink**.* Light grayish red, dull rose, very dark pink, and coral are correctly exposed on this step. A light pink object that is in light shade can be correctly exposed on Step ½L.

*Step MV: **Crimson Red**.* The lowest chroma samples on this step are grayish red, which is a devon brown or brick brown. Moderate red resembles amaryllis or coral. Strong red could be called flaming maple. Vivid red is vermilion or crimson at this value. Step MV is the point of departure from which exposures are determined. The versions of beige, pink, and coral described for the L steps will be low-

ered to middle value if the meter reading is followed. The red and maroons of the D steps will be raised to Step MV descriptions if the meter reading is followed.

Step ¹/₂D: Bright Red. The high-chroma color popularly called red is present on this step. The lowest chroma samples are described as grayish red, rose brown, rust, and slate rose. Moderate reds, such as watermelon red and dark coral belong on this step. This is the darkest step at which red can be called coral. Bright red and vivid red on Step ¹/₂D are known as scarlet, fire-engine red, Old Glory red, and stop-sign red.

Step 1D: Vivid Red. Dark grayish red is a low-chroma version of red at this value. Dull reddish brown, rust, burnt russet, chocolate maroon, and garnet brown are other color names for red at this value. Deep red is similar to chimney red. High-chroma reds are known as vivid red and cardinal red. This step can be used for exposure of shaded portions of pink subjects.

Step 1¹/₂D: Maroon. The middle- and upper-chroma ranges for Step 1¹/₂D contain maroon. Maroon should be exposed on this step and will also result from exposing red on Step 1¹/₂D.

Step 2D: Blackish Maroon. This step should be reserved for reproduction of blackish maroon and other blackish colors. Red in shadow can be exposed on this step as blackish maroon.

EXPOSURE EXAMPLE: VIVID RED, WHITE, BLACK, AND GRAY

Vivid red is found on fire engines, flowers, stop signs, automobiles, and commercially packaged products. Figure C-12 was taken of a vivid red car after a snowstorm. The scene encompassed a wide range of values, from the glaring white reflection of sun in the headlight to the black shaded tire. Meter readings were

9-1 Data form and value-selector chart excerpt for figure C-12.

		Colors and Color Values of Objects	Step	Step		
	2½LW	Glare in Headlight	2½ LW		2½LW	Pure White / No Texture
White Pink / White Pink	2L		2L		2L	Off-White / Min Texture
Baby Pink / Purple-Pink	1½L	Snow	1½L		1½L	White-Gray / Adeq Text
Dark Pink / Dk Pur-Pink	1L	Snow	1L		1L	Light Gray / Consid Text
Coral Red / Lt Red-Pur	½L	Snow	½L		½L	Med Lt Gray / Ext Texture
Crimson Red / Med V Red-P	MV		MV		MV	Middle Gray / Max Texture
Bright Red / Viv Red-Pur	½D	Red Car	½D		½D	Med Dk Gray / Ext Texture
Vivid Red / Dk Red-Pur	1D	Red Car	1D		1D	Dark Gray / Consid Text
Maroon / V Dk Red-P	1½D		1½D		1½D	V Dk Gray / Adeq Text
Blk-Maroon / Blk-Red-Pur	2D		2D		2D	Text Black / Min Texture
	2½DB		2½ DB		2½DB	Pure Black / No Texture
	3DB		3DB		3DB	Opaque Blk / No Texture
		Black Tire	3½ DB			

obtained on three areas of snow, the headlight, black tire, and two areas of red. The scene encompassed thirteen steps. This indicated that texture would have to be sacrificed at one or both ends of the value scale because texture could be preserved on only nine steps. Because the red was so vivid, the value-selector chart was positioned under the data sheet with red readings on Steps 1/2D and 1D. Moving the chart up and down a step or two established that no exposure of textured snow and red car would allow reproduction of textured black in the tire. Loss of texture in the tire was more acceptable than in the large area of snow. This would expose the snow on Steps 1/2L, 1L, and 1 1/2L. The white headlight reflection was acceptable on Step 2 1/2LW. Although the shaded black tire was on Step 3 1/2DB, the tire looks no different than if it had been exposed on Step 2 1/2DB. Step 3 1/2DB merely shows the actual contrast range of the scene on the data form. The brightness of the snow permitted the picture to be taken with a small f/stop on 1/1000.

EXPOSURE EXAMPLE: PINK, CORAL, RED, BLACK, WHITE, AND BLUE

The moody winter sunrise at Monument Valley in Utah and Arizona (fig. C-13) contains high-value pink, middle-value reds, shaded red, and a variety of grays. Exposure was based on the selection of the proper pink and shadow values. Middle-value reds would fall on steps determined by the contrast between pink, red, and the shadows. Loss of texture in small shadows was more acceptable than loss of texture and delicate hue in the clouds. The meter reading of the darkest shadows was aligned with Step 2 1/2DB on the value-selector chart. The contrast between shadows and clouds indicated the bright white cloud would be on Step 2L. Other cloud areas ranged from Steps 1 1/2L to MV. Red rock in sunlight was on Step 1/2D. Textured shadows on red rock resulted in maroon at Steps 1 1/2D and 2D. Blue sky encompassed both Steps 1/2D and 1D. If exposure had been one f/stop lighter or darker, the dramatic effect of the landscape would have been ruined.

9-2 **Data form and value-selector chart excerpt for figure C-13.**

		Colors and Color Values of Objects	Step	Step			
Wh Baby Blu / Whit Lavend	2L	White Cloud	2L		2L	Off-White / Min Texture	White Pink / White Pink
Baby Blue / Lt Lavender	1 1/2L	Pink Cloud	1 1/2L		1 1/2L	White-Gray / Adeq Text	Baby Pink / Purple-Pink
Dk Baby Blu / Med Lavend	1L	Pink Cloud	1L		1L	Light Gray / Consid Text	Dark Pink / Dk Pur-Pink
V Lt Bl Sky / Dk Lavender	1/2L	Pink Cloud	1/2L		1/2L	Med Lt Gray / Ext Texture	Coral Red / Lt Red-Pur
Lt Blue Sky / Lt Viv Pur	MV	Red Cloud	MV		MV	Middle Gray / Max Texture	Crimson Red / Med V Red-P
Med Blu Sky / Viv Purple	1/2D	Red Rock, Blue Sky	1/2D		1/2D	Med Dk Gray / Ext Texture	Bright Red / Viv Red-Pur
Dk Blue Sky / Dk Viv Pur	1D	Shaded Rock, Blue Sky	1D		1D	Dark Gray / Consid Text	Vivid Red / Dk Red-Pur
V Dk Bl Sky / V Dk Purple	1 1/2D	Shaded Rock	1 1/2D		1 1/2D	V Dk Gray / Adeq Text	Maroon / V Dk Red-P
Blk-Blu Sky / Blksh-Purpl	2D	Shaded Rock	2D		2D	Text Black / Min Texture	Blk-Maroon / Blk-Red-Pur
	2 1/2DB	Shadows	2 1/2DB		2 1/2DB	Pure Black / No Texture	

C orrect exposure of yellow is limited to a very narrow range. Remembering which steps are best for reproduction of yellow is easy because there are so few: vivid yellow must be exposed on Step 1½L or Special Step 1¾LY. A slightly lighter vivid yellow can be exposed on Step 2L. Outside of these steps, versions of yellow include beige, brown, olive, and blackish olive (see fig. C-14). Vivid yellow does not exist below Step ½L. Certain versions of yellow are considered brown; these are discussed in chapter 13.

 Step 2L: Whitish Vivid Yellow. The Munsell yellow chart is the only chart among the ten basic hue charts that contains as many as four chroma chips on Step 2L. This is because yellow is a very high value, high chroma color. High-chroma yellow samples on Step 2L include light brilliant yellow, light vivid yellow, yellowish white, and light yellow. Low-chroma yellows at this value are very light buff and very light beige.

 Step 1¾LY: Vivid Yellow. This is a special step in the stair-step system reserved for precise exposure of yellow. Vivid yellow must be exposed at this step or at Step 1½L. The vivid yellows on Step 1¾LY include light yellow, brilliant yellow, vivid yellow, dandelion, daffodil, and lemon. The Munsell yellow chart has a chroma range at this value that is one of the longest in the system. Step 1¾LY exposure is made by opening the lens aperture one and three-fourths f/stops lighter than the meter reading on yellow indicates. This special step does not appear on the stair-step value-selector chart. Make the necessary modification by setting the camera at a reading between Steps 1½L and 2L.

 Step 1½L: Vivid Yellow. True vivid yellow occurs only on Steps 1½L and 1¾LY. The high-chroma vivid yellows are named dandelion, daffodil, and lemon. Many commercial products are packaged in these bright colors. This is the darkest

step on which vivid yellow should be exposed. Middle-chroma yellows are called moderate yellow, strong yellow, and goldenrod. Low-chroma yellow on Step 1½L is known as dust, beige, putty, grayish yellow, flax brown, buff, light ivory, and egg-shell.

Step 1L: Dark Yellow. Yellowish gray and silver gray are low-chroma yellows that should be exposed on this step. Proceeding across the chroma scale, grayish yellow resembles old ivory or flax brown. Moderate olive could be named olive ocher. A shaded portion of yellow can be accurately exposed on this step, as can olive yellow that is in direct light.

Step ½L: Mustard Yellow. The low-chroma yellow of this value is light olive gray, which is a type of brown. Dark grayish yellow, antique gold, mustard yellow, and the shaded portions of bright yellow may be exposed on Step ½L.

Step MV: Olive Yellow. True yellow does not exist on Step MV or in the D steps. Yellowish brown, light olive, light brown, and olive yellow are versions of yellow on Step MV. Use of middle value as the point of origin for correct stair-step exposure of yellow will result in accurate exposure if it is exposed on Steps 1½L, 1¾LY, or 2L. Exposure of yellow according to the meter reading will result in underexposure of all colors in the photograph.

Step ½D. Light Olive. An attempt to expose yellow on the D steps will result in extreme underexposure. Olive gray, dark putty, and iron gray are low-chroma versions of yellow for Step ½D. Light olive is the highest chroma version of yellow at this value. Shaded portions of yellow could be exposed on Step ½D.

Step 1D: Medium Olive. Olive gray and medium olive colors are correctly exposed on Step 1D. This step can be used as a shadow value for yellow.

Step 1½D: Dark Olive. Dark grayish olive and dark olive subjects will be correctly exposed on this step. Both of these colors are also called dark olive drab and ebony yellow. This is a shadow value for yellow and light olive.

Step 2D: Blackish Olive. This step is for reproduction of shadow values and for reproduction of blackish olive. The chroma is so low that color is absent for all practical purposes and minimal texture is present.

EXPOSURE EXAMPLE: YELLOW, ORANGE, AND BLACK

In figure C-15 vivid yellow and orange highlights provide important clues to exposure. This is because vivid orange should be exposed on Step 1L and vivid yellow on Steps 1½L, 1¾LY, or 2L. Meter readings were written on the data form for the yellow and orange areas. The black area in the bottom of the picture was disregarded in determining the exposure. It was prevented from influencing the meter reading by using a spot meter. The exposure calculator chart was positioned under the data form with the meter readings of the yellows aligned with Steps 1½L and 2L. Meter readings in the middle third of the scene were on Step MV. The cloudy upper third of the format contained bright orange clouds on Step ½L and burnt orange clouds on Step 1D. These were ideal exposures, as indicated by comparing the colors with the color names on the value-selector chart. The black shadow was far below Special Step 3DB because of extreme contrast between it and the bright yellow. An attempt to preserve texture in the shadow area would have drastically overexposed the sunset colors. The sun is the lightest value in the picture. Note that meter readings of the sun should never be taken with a reflex viewing meter or a through-the-lens meter because serious eye damage may result. Readings on surrounding clouds are sufficient to determine exposure for sunset pictures.

10-1 Data form and value-selector chart excerpt for figure C-15.

		Colors and Color Values of Objects	Step	Step		
Lt Viv Yel	2L	Yellow Clouds	2L		Off-White / Min Texture	Lt Orange / V Lt Beige
Viv Yellow	1½L	Yellow Clouds	1½L		White-Gray / Adeq Text	Lt Viv Org / Light Beige
Dark Yellow	1L	Sunset Clouds	1L		Light Gray / Consid Text	Viv Orange / Med Beige
Mustard Yel	½L	Orange Clouds	½L		Med Lt Gray / Ext Texture	Dk Viv Org / Dark Beige
Med Yel-Grn / Olive Yello	MV	Dk Orange Clouds	MV		Middle Gray / Max Texture	Burnt Org / Lt Brown
Dk Yel-Grn / Light Olive	½D	Very Dk Org Clouds	½D		Med Dk Gray / Ext Texture	Dk Burnt Or / Med Brown
Olive Green / Med Olive	1D	Very Dk Org Clouds	1D		Dark Gray / Consid Text	Dk Org-Brn / Dark Brown
Dk Olive Gr / Dark Olive	1½D		1½D		V Dk Gray / Adeq Text	V Dk Org-Br / Choc Brown
Blk-Olive-G / Blksh Olive	2D		2D		Text Black / Min Texture	Blk-Org-Brn / Blkish Brn
	2½DB		2½DB		Pure Black / No Texture	All colors will be reproduced textureless black on Steps 2½DB and darker steps.
	3DB	Black Shadows	3DB		Opaque Blk / No Texture	

EXPOSURE EXAMPLE: YELLOW AND BLACKISH MAROON

The center of a pansy blossom was illuminated by the sun (fig. C-16). An aluminum reflector was used to soften the shadows. Meter readings were obtained by using a spot meter equipped with a +10 portrait lens for close focusing. Without the portrait lens, the spot meter could not be focused on the subject. The blurred meter reading would be similar to an averaged reading and would not be accurate. Meter readings of five circles one-eighth inch in diameter were obtained: lightest yellow in the right center, yellow in the upper left corner, yellow between these two spots, shaded yellow on the right edge, and blackish maroon. The reading of

10-2 Data form and value-selector chart excerpt for figure C-16.

		Colors and Color Values of Objects	Step	Step		
White Yel	2L	Yellow Yellow 1¾LY	2L		Off-White / Min Texture	White Pink / Wh Pur Pink
Viv Yellow	1½L	Yellow	1½L		White-Gray / Adeq Text	Baby Pink / Purple-Pink
Viv Yel-Grn / Dark Yellow	1L		1L		Light Gray / Consid Text	Dark Pink / Dk Pur-Pink
Dk Viv Y-Gr / Mustard Yel	½L		½L		Med Lt Gray / Ext Texture	Coral Red / Lt Red-Pur
Med Yel-Grn / Olive Yello	MV	Shaded Yellow	MV		Middle Gray / Max Texture	Crimson Red / Med V Red-P
Dk Yel-Grn / Light Olive	½D		½D		Med Dk Gray / Ext Texture	Bright Red / Viv Red-Pur
Olive Green / Med Olive	1D		1D		Dark Gray / Consid Text	Vivid Red / Dk Red-Pur
Dk Olive Gr / Dark Olive	1½D		1½D		V Dk Gray / Adeq Text	Maroon / V Dk Red-P
Blk-Olive-G / Blksh Olive	2D	Maroon	2D		Text Black / Min Texture	Blk-Maroon / Blk-Red-Pur

the lightest yellow was aligned with Step 2L on the value-selector chart. The darkest yellow was aligned with Step 1½L. The reading of the intermediate yellow was between these on Special Step 1¾LY, although no line on the chart is allotted for it. The meter reading of the dark area was aligned with Step 2D, which would reproduce minimally textured blackish maroon. The shaded yellow was on Step MV. Camera settings were determined by the EVS combinations for the EVS number at Step MV. The ultraclose-up required using the smallest f/stop on the lens to obtain maximum depth of field. This required the use of a slow shutter speed and a tripod to prevent camera motion.

GREEN YELLOW 11

Green yellow has classification characteristics similar to orange and yellow because it is a high-chroma, high-value color. Remembering how to expose bright green yellow is easy because of these characteristics. It is frequently called chartreuse. Green yellow is visible in early spring foliage and fall foliage when leaves change color. Darker versions may be found in succulents, cacti, and some types of evergreens. Most samples of spring green yellow require exposure in the L steps, especially Steps 1 1/2L, 1L, and 1/2L. An examination of the Munsell green yellow constant hue chart indicates that this hue has much longer chroma scales in the L steps than in the D steps (see fig. C-17). The hue encompasses a variety of color names including lime, chartreuse, olive, mistletoe, cypress, and deep olive. These names, combined with exposure records, will help you memorize the different values of green yellow and to distinguish it from yellows and greens.

Step 2L: Whitish Green Yellow. Pale green yellow, very light green yellow, light lime green, and whitish green yellow are very light colors that must be exposed on Step 2L.

Step 1 1/2L: Light Vivid Green Yellow. Light greenish gray and pale green yellow are two low-chroma samples that could also be called silver green because of the amount of gray in them. As chroma increases at this value, the color names change to include light green yellow, brilliant green yellow, lime yellow, bright lime green, light vivid green yellow, and bright chartreuse.

Step 1L: Vivid Green Yellow. Maximum chroma for green yellow is reached on this step. Low-chroma samples include light grayish green yellow. The color name green stone indicates the amount of gray present at low chroma. Strong green yellow and vivid green yellow are both vivid chartreuse at the end of the chroma scale. Compromise exposures can be made one step darker or lighter.

Step ½L: Dark Vivid Green Yellow. Grayish green yellow, also known as green haze, is a sample of low-chroma green yellow on Step ½L. Moderate- and strong-chroma samples include verdant and spring green. Vivid green yellow at this value is a dark chartreuse. Chartreuse must be exposed on Steps ½L, 1L, 1½L, or 2L, depending upon the desired value and other colors present. Chartreuse does not exist darker than this step.

Step MV: Medium Green Yellow. The point of departure in the stair-step system for determining exposures is at middle value. The color descriptions for Step MV include mistletoe, grayish green yellow, medium green yellow, fir green, and pea green. The olive version of green yellow begins at this value and extends through the D steps.

Step ½D: Dark Green Yellow. Dark grayish olive green, sage drab, moderate olive green, and dark green yellow are to be exposed on Step ½D.

Step 1D: Olive Green. Low-chroma dark greenish gray at this value would be called slate olive. Moderate-chroma olive green is a forest green or cypress green. Step 1D can be used for shaded areas of higher value green yellow subjects.

Step 1½D: Dark Olive Green. The chroma scale for green yellow at this value is very short. Grayish olive green, dark olive green, and deep olive green are present. These are also the color names of other green yellow samples if they are exposed on this step. Step 1½D is also a shadow value.

Step 2D: Blackish Olive Green. Green yellow subjects should not be exposed on this step unless the photographer wants them reproduced as blackish olive green with minimum texture. This step should be used only for blackish color and shadows.

EXPOSURE EXAMPLE: GREEN YELLOW AND OLIVE GREEN

Figure C-18 shows sunlight filtering through fog and evergreen trees. This resulted in a wide range of medium- and low-chroma green yellow values. The color names on the value-selector chart helped in envisioning the photograph. This example included green yellow on all nine color steps. The highlights and shadows

11-1 Data form and value-selector chart excerpt for figure C-18.

		Colors and Color Values of Objects	Step		
Whit Yel-Gr / White Yel	2L	Green-Yellow Highlights 2L	2L	Off-White / Min Texture	
Lt Viv Y-Gr / Viv Yellow	1½L	Green-Yellow	1½L	1½L	White-Gray / Adeq Text
Viv Yel-Grn / Dark Yellow	1L	Green-Yellow	1L	1L	Light-Gray / Consid Text
Dk Viv Y-Gr / Mustard Yel	½L	Green-Yellow	½L	½L	Med Lt Gray / Ext Texture
Med Yel-Grn / Olive Yello	MV	Green-Yellow	MV	MV	Middle Gray / Max Texture
Dk Yel-Grn / Light Olive	½D	Green-Yellow	½D	½D	Med Dk Gray / Ext Texture
Olive Green / Med Olive	1D	Green-Yellow	1D	1D	Dark Gray / Consid Text
Dk Olive Gr / Dark Olive	1½D	Green-Yellow Shadows	1½D	1½D	V Dk Gray / Adeq Text
Blk-Olive-G / Blksh Olive	2D	Green-Yellow Shadows	2D	2D	Near Black / Min Texture

are neither black nor white; they all have color and texture. An averaging meter will correctly expose a scene such as this that has a wide distribution of values.

EXPOSURE EXAMPLE: GREEN YELLOW AND YELLOW

Yellow and green yellow are both high-value, medium- to high-chroma colors. A subject that combines both of these colors and contains no other hues must be exposed using stair-step techniques. Exposing according to the meter reading will cause underexposure because the meter would average both values to middle value or reduce one of the colors to middle value. High-chroma, high-value yellow and green yellow must be exposed in the L steps.

Figure C-19 shows an ear of corn with the husk open to reveal the yellow kernels. Meter readings were obtained of the yellow corn, green yellow husk, and shadows. Because yellow reaches maximum chroma on Step 1¾LY and green yellow has its maximum chroma on Step 1L, the meter readings for these colors were aligned with the color names on the value-selector chart. Step 1¾LY does not appear on the chart, but by positioning the green yellow on Step 1L, the meter reading of the yellow fell between Steps 1½L and 2L. This illustrates the natural contrast range between the two colors. The meter reading of the shadow was aligned with Step MV. This exposure selection positions the mass of colored area above Step MV, achieving accurate exposure for these colors.

Depth of field requirements were determined, and the shutter speed was selected accordingly. The information was written on the data form for later evaluation. Note that on the form, yellow is written on both Step 2L and 1½L, indicating that it encompasses Step 1¾LY.

11-2 **Data form and value-selector chart excerpt for figure C-19.**

Colors and Color Values of Objects		Step		
White Yel-Grn / White Yel — 2L	Yellow Corn 1¾LY	2L	2L	Off White / Min Texture
Lt Viv Y-Gr / Viv Yellow — 1½L	Yellow Corn	1½L	1½L	White Gray / Adeq Text
Viv Yel-Grn / Dark Yellow — 1L	Green-Yellow Husk	1L	1L	Light Gray / Consid Text
Dk Viv Y-Gr / Mustard Yel — ½L		½L	½L	Med Lt Gray / Ext Texture
Med Yel-Grn / Olive Yello — MV	Green-Yellow Shadow	MV	MV	Middle Gray / Max Texture

Munsell blue is known by photographers as cyan. Cyan color-printing filters are almost identical to the high-chroma samples of the Munsell blue constant hue chart (see fig. C-20). Cyan blue contains a small proportion of green, distinguishing it from purple blue, which contains a large proportion of purple. Cyan blue does not appear as green as the color blue green, however, because blue green contains a much larger proportion of green. This color is also known as turquoise and peacock blue. It is similar to blue sky under certain atmospheric conditions. Examination of the Munsell purple blue, cyan blue, and blue green samples is necessary to distinguish visually the three colors and to memorize their appearance. Cyan blue is almost equally distributed on each side of middle value on the Munsell chart. Automobiles, nature subjects, cosmetics, home furnishings, clothing, jewelry, peacock feathers, and package labels contain this color. The color names provide clues to correct exposure.

*Step 2L: **Whitish Baby Blue**.* Bluish white and very light blue are both versions of light baby blue with a faint trace of green in them.

*Step 1½L: **Baby Blue**.* Low-chroma light bluish gray is reproduced on Step 1½L. Light cyan, light greenish blue, and light aqua blue are all versions of baby blue.

*Step 1L: **Dark Baby Blue**.* Listed in order of increasing chroma, light grayish blue, pale blue, haze blue, smoke blue, aquamarine, light greenish blue, and brilliant greenish blue are all versions of dark baby blue that should be exposed on Step 1L.

*Step ½L: **Very Light Blue Sky**.* Bluish gray and pale blue are two low-chroma names for cyan blue at this value. Both contain considerable gray. Light greenish blue, aquamarine, and beryl blue are color names for cyan blue on this

step. Sky will be very light on Step ½L, making this the lightest value for blue sky, except for horizon sky in some pictures.

Step MV: Light Blue Sky. Middle bluish gray, blue fog, and slate turquoise are examples of low-chroma cyan blue on Step MV. Strong greenish blue, bright peacock blue, and turquoise blue will be correctly exposed according to the meter reading. A Step MV blue sky will seem light in value compared to other subjects.

Step ½D: Medium Blue Sky. Low-chroma cyan blue at this value is known as dark bluish gray or dark cyan gray. Moderate greenish blue, deep peacock blue, strong greenish blue, olympic blue, and vivid cyan are correctly exposed on this step. This is one of the best three steps for sky.

Step 1D: Dark Blue Sky. Low-chroma colors include dark grayish blue, dark greenish blue, shadow blue, and dusky cyan. Deep greenish blue, similar to dark blue sky, is the highest chroma sample present on the Munsell chart for Step 1D. This step is used for shadows and dark blue sky. No blending of blue sky with evergreens or other dark colors will occur on this step.

Step 1½D: Very Dark Blue Sky. This step is for exposing shadows of lighter cyan blue subjects. Color names for cyan at this step include midnight blue and indigo, both of which are slightly greenish.

Step 2D: Blackish Blue Sky. This step is frequently used for dark shadows and blackish cyan blue subjects. It is not recommended for exposure of daytime sky because it produces blackish blue. Step 2D and darker steps may be used for night sky if sufficient light illuminates other objects to prevent them from blending into the sky. Skyscrapers with many room lights turned on would be clearly visible against a black sky, even if the building itself blended into the sky.

EXPOSURE EXAMPLE: CYAN BLUE, GREEN, RED, AND OLIVE GREEN

The cactus blossom in figure C-21 was photographed in sunshine with a cyan blue poster board behind the flower to simulate sky. A foil reflector illuminated the interior of the blossom, softening the shadows. Single-value spot readings were obtained of the "sky," vivid red petals, and olive green areas in sunlight and shadow. Because blue sky can be exposed at any of several appropriate values, exposure was based on choosing the best reproduction of red and olive. The meter reading of the dark olive shadow was aligned with Step 1½D on the value-selector chart. This indicated that the vivid red petals would be exposed on Step ½D, which

12-1 Data form and value-selector chart excerpt for figure C-21.

			Colors and Color Values of Objects	Step			
Dk Baby Blu / Med Lavend	Viv Yel-Grn / Dark Yellow	1L	Blue "Sky"	1L	1L	Light Gray Consid Text	Dark Pink Dk Pur-Pink
V Lt Bl Sky / Dk Lavender	Dk Viv Y-Gr / Mustard Yel	½L		½L	½L	Med Lt Gray Ext Texture	Coral Red Lt Red-Pur
Lt Blue Sky / Lt Viv Pur	Med Yel-Grn / Olive Yello	MV◀		MV ▶	MV	Middle Gray Max Texture	Crimson Red Med V Red-P
Med Blu Sky / Viv Purple	Dk Yel-Grn / Light Olive	½D	Red Petals	½D	½D	Med Dk Gray Ext Texture	Bright Red Viv Red-Pur
Dk Blue Sky / Dk Viv Pur	Olive Green / Med Olive	1D	Olive Green Cactus	1D	1D	Dark Gray Consid Text	Vivid Red Dk Red-Pur
V Dk Bl Sky / V Dk Purple	Dk Olive Gr / Dark Olive	1½D	Dark Olive Shadows	1½D	1½D	V Dk Gray Adeq Text	Maroon V Dk Red-P

is described on the chart as bright red. The sky would automatically fall on Step 1L. This exposure resulted in desaturated colors, conveying the delicacy of the blossom. Acceptable exposure would also have resulted at one step darker, but the impression of delicacy in the flower would decrease with darker exposure.

EXPOSURE EXAMPLE: CYAN BLUE, WHITE, BLACK, AND GRAY

The cyan-colored automobile in figure C-22 was photographed after a snowfall. The picture was composed, then meter readings were obtained of the snow, cyan blue paint, gray headlight, black tire, and black grille. These colors were written on the stair-step data form on lines corresponding to the meter readings. The scene encompassed fourteen stair-steps, far surpassing the ability of the film to retain texture in both the white snow and the black areas.

12-2 Data form and value-selector chart excerpt for figure C-22.

		Colors and Color Values of Objects	Step	Step				
Baby Blue / Lt Lavender	1½L	Snow in Sunlight	1½L		1½L	White-Gray / Adeq Text	Lt Viv Org / Light Beige	
Dk Baby Blu / Med Lavend	1L	Snow in Shadow	1L		1L	Light Gray / Consid Text	Viv Orange / Med Beige	
V Lt Bl Sky / Dk Lavender	½L	Cyan on Side, Orange	½L		½L	Med Lt Gray / Ext Texture	Dk Viv Org / Dark Beige	
Lt Blue Sky / Lt Viv Pur	MV	Cyan on Side, Headlight	MV		MV	Middle Gray / Max Texture	Burnt Org / Lt Brown	
Med Blu Sky / Viv Purple	½D	Cyan on Front of Car	½D		½D	Med Dk Gray / Ext Texture	Dk Burnt Or / Med Brown	
Dk Blue Sky / Dk Viv Pur	1D		1D		1D	Dark Gray / Consid Text	Dk Org-Brn / Dark Brown	
V Dk Bl Sky / V Dk Purple	1½D		1½D		1½D	V Dk Gray / Adeq Text	V Dk Org-Br / Choc Brown	
Blk-Blu Sky / Blksh-Purpl	2D		2D		2D	Text Black / Min Texture	Blk-Org-Brn / Blkish Brn	
	2½DB		2½DB		2½DB	Pure Black / No Texture	All colors will be reproduced textureless black on Steps 2½DB, 3DB and darker steps.	
	3DB	Black Tire	3DB		3DB	Opaque Blk / No Texture		
			3½DB					
			4DB					
			4½DB					
		Black Grill	5DB					

It was noted that the cyan was high chroma, middle value, rather than blackish or pale, and therefore should be exposed on a middle value. The value-selector chart was positioned under the data form with the three cyan readings centered around Step MV. Moving the chart up and down, the changing value and texture effects on the snow were evaluated, and a final position was chosen. Any attempt to retain texture in the black areas was abandoned. Centering the cyan readings around Step MV resulted in snow exposure on Steps 1 ½L and 1L.

This selection of values retained excellent texture in the snow while preserving its "white" appearance. The cyan was exposed on steps that corresponded to the

highest chromas of cyan as classified by Munsell. The contrast range between the snow and black areas is indicated on the data form. Exposing the black grille on Step 5DB is the same as if readings had positioned it on Step 3DB. If this picture had been exposed by positioning the white snow and black grille equal distances from middle value, the picture would have been seriously overexposed. The snow would have been positioned on Steps 3LW or 3½LW; the black grille on Steps 3DB or 3½DB. Neither subject would have retained texture.

B rown is not classified by Munsell as one of the ten basic colors. It is, however, such an important color to photographers that it must be described separately. All browns are actually low-chroma versions of red, orange, and yellow. Depending upon the basic hue, browns of the same value look quite different. Red, orange, and yellow all have versions of brown at Step MV and in the L steps. The majority of D-step browns are within the basic hue of orange. Skin tones of various racial groups are present among brown samples. The chroma variation of brown is minimal, as indicated in the accompanying diagrams from the Munsell charts. Look for the color samples in the color reproductions of red, orange, and yellow charts in this book (figs. C-8, C-11, and C-14).

 Step 2L: Whitish Beige. Brownish white, peach gray, peach tint, very light buff, and very light beige are all examples of brown on Step 2L. This step can be used for highlights on darker brown surfaces.

 Step 1½L: Light Beige. Pale brown, brownish pink, very light brown, dust, light beige, putty, flax brown, and skin brown are all color names for exposure on Step 1½L. Highlighted areas of Caucasian skin should be exposed on this step.

 Step 1L: Medium Beige. Color names appropriate for brown at this value include light brown, flax brown, brownish pink, skin beige, dark buff, old ivory, and pale brown. Caucasian skin is found within these brown samples.

 Step ½L: Dark Beige. At this value colors typically known as brown include light grayish brown, sandalwood, sand, dark beige, light brown, and dull rose. Shaded Caucasian skin can be exposed on Step ½L, as can highlights of darker-skinned people.

 Step MV: Light Brown. Low-chroma grayish brown is similar to weathered wood and sand. Medium-chroma light brown is a rich color because its basic color is orange. Reddish gray is a brick brown. Olive brown is from the yellow chart. Step

ELEVEN-STEP GRAY SCALE

STEP	Munsell Chroma Notations

Munsell Chroma Notations column headers: /1 /2 /4 /6 /8

STEP
2½LW
Munsell 9.5/

2L
Munsell 9/

1½L
Munsell 8/

1L
Munsell 7/

½L
Munsell 6/

MV
Munsell 5/

½D
Munsell 4/

1D
Munsell 3/

1½D
Munsell 2/

2D
Munsell 1.25/

2½DB
Munsell .5/

* *

* Munsell charts contain no chips at 2D. Color slide
film will reproduce blackish colors on Step 2D.

13-1 Rectangles representing the gray scale and brown samples selected from the
Munsell yellow red chart. Compare to colored chips in same position on yellow
red chart, figure C-8.

ELEVEN-STEP GRAY SCALE

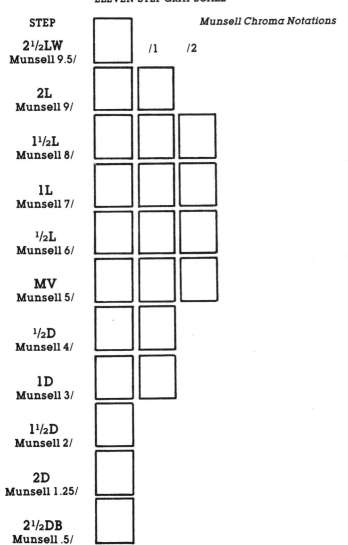

STEP		*Munsell Chroma Notations*	
2½LW Munsell 9.5/		/1	/2
2L Munsell 9/			
1½L Munsell 8/			
1L Munsell 7/			
½L Munsell 6/			
MV Munsell 5/			
½D Munsell 4/			
1D Munsell 3/			
1½D Munsell 2/			
2D Munsell 1.25/			
2½DB Munsell .5/			

13-2 Rectangles representing the gray scale and brown samples selected from the Munsell red chart. Compare to colored chips in same position on red chart, figure C-11.

ELEVEN-STEP GRAY SCALE

STEP		Munsell Chroma Notations

2½LW
Munsell 9.5/ /1 /2

2L
Munsell 9/

1½L
Munsell 8/

1L
Munsell 7/

½L
Munsell 6/

MV
Munsell 5/

½D
Munsell 4/

1D
Munsell 3/

1½D
Munsell 2/

2D
Munsell 1.25/

2½DB
Munsell .5/

13-3 Rectangles representing the gray scale and brown samples selected from the Munsell yellow chart. Compare to colored chips in same position on yellow chart, figure C-14.

MV is the point of departure in the stair-step exposure system. If the meter reading is followed without modification when exposing the light browns and beige colors of the L steps, their appearance will be darkened to approximate the descriptions for this step. If the chocolate and walnut browns of the D steps are exposed at middle value, their appearance will be lightened to Step MV descriptions.

Step ½D: Medium Brown. No brown samples from the yellow chart occur in the D steps. Brown samples present at Step ½D are from the orange and red charts, including brownish gray, moderate brown, strong brown, light walnut, earth brown, copper brown, rust brown, reddish gray, chocolate gray, and rose brown.

Step 1D: Dark Brown. Grayish brown, dark brown, cinnamon brown, walnut stain, dull reddish brown, burnt russet, chocolate maroon, and garnet brown are all samples of brown that should be exposed on Step 1D.

Step 1½D: Chocolate Brown. Only orange has brown samples at Step 1½D and darker. Very dark brown, chocolate brown, and dark walnut are versions of brown at this step frequently seen in furniture. These color names suggest exposure on Step 1½D. This is also a shadow value for lighter brown.

Step 2D: Blackish Brown. Exposure of brown at this step will result in blackish brown. Shaded portions of brown that are exposed on Step 2D will retain minimal texture.

EXPOSURE EXAMPLE: BEIGE, BROWN, DARK BROWN, AND BLACK

Cliff Palace (fig. C-23), an ancient Indian ruin in Mesa Verde National Park in Colorado, illustrates a variation of brown values caused by light being reflected against the walls at various angles. Consequently, although the rock itself has little variation of values, there is nevertheless a wide contrast between the brown values caused by sunlight and shadows. A compromise exposure was required to retain minimum texture in two vertical walls, resulting in loss of texture in the shadow of the overhanging cliff.

13-4 Data form and value-selector chart excerpt for figure C-23.

	Colors and Color Values of Objects	Step	Step			
2L	Beige Wall	2L		2L	Off-White / Min Texture	Wh Orange / Whit Beige
1½L	Beige Walls in Distance	1½L		1½L	White-Gray / Adeq Text	Lt Viv Org / Light Beige
1L		1L		1L	Light Gray / Consid Text	Viv Orange / Med Beige
½L		½L		½L	Med Lt Gray / Ext Texture	Dk Viv Org / Dark Beige
MV	Brown Wall on Right	MV		MV	Middle Gray / Max Texture	Burnt Org / Lt Brown
½D		½D		½D	Med Dk Gray / Ext Texture	Dk Burnt Or / Med Brown
1D		1D		1D	Dark.Gray / Consid Text	Dk Org-Brn / Dark Brown
1½D		1½D		1½D	V Dk Gray / Adeq Text	V Dk Org-Br / Choc Brown
2D	Cliff Ceiling Shadow	2D		2D	Text Black / Min Texture	Blk Org-Brn / Blkish Brn
2½DB	Cliff Ceiling Shadow	2½DB		2½DB	Pure Black / No Texture	All colors will be reproduced textureless black on Steps 2½DB, 3DB and darker steps.
3DB	Small Shadows	3DB		3DB	Opaque Blk / No Texture	

After the picture was composed, readings were taken of several areas. The contrast encompassed eleven stair-steps. The value-selector chart was positioned under the data form so that the reading of the lightest wall was aligned with Step 2L. The heavily textured brown wall on the right side of the picture was on Step MV. Light beige walls in the distance were exposed on Step 1½L. The meter reading of the shadow under the cliff indicated it would be blackish brown on Step 2D. Smaller shadows, on Steps 2½DB and 3DB, were untextured black. Exposure of one small green area was not important to the overall picture. Its value was determined by the contrast range between it and other values.

EXPOSURE EXAMPLE: BROWN, GRAY, AND WHITE

The major problem in photographing figure C-24 was that the deer would not stay in that position very long, requiring that exposure be rapidly determined. Those who have worked with the stair-step system and are familiar with its steps can rapidly determine exposure by eliminating use of the data forms. After quickly taking readings of two snow areas and the shaded brown of the deer, the meter dial was rotated to expose the light area of snow on Step 1½L. By doing this with the meter dial, time was not lost completing the forms. The arrow on the meter dial pointed at the EVS number from which the camera settings were selected. Brown hide in the sun was on Step 1D. Shaded brown hide was on Steps 1½D and 2D.

13-5 Data form and value-selector chart excerpt for figure C-24.

	Colors and Color Values of Objects	Step			
1½L	Snow in Lower Right	1½L	1½L	White-Gray / Adeq Text	Lt Viv Org / Light Beige
1L		1L	1L	Light Gray / Consid Text	Viv Orange / Med Beige
½L		½L	½L	Med Lt Gray / Ext Texture	Dk Viv Org / Dark Beige
MV		MV	MV	Middle Gray / Max Texture	Burnt Org / Lt Brown
½D		½D	½D	Med Dk Gray / Ext Texture	Dk Burnt Or / Med Brown
1D	Brown Deer in Sun	1D	1D	Dark Gray / Consid Text	Dk Org-Brn / Dark Brown
1½D	Brown Deer in Shadow	1½D	1½D	V Dk Gray / Adeq Text	V Dk Org-Br / Choc Brown
2D	Brown Deer in Shadow	2D	2D	Text Black / Min Texture	Blk-Org-Brn / Blkish Brn

EXPOSURE EXAMPLE: BEIGE AND BROWN SKIN TONES

Flesh tones of all races are included among the various samples of brown. Flesh tones of the racial groups include the following colors: off-white, very light beige, light beige, beige, dark beige, light brown, brown, dark brown, yellowish brown, reddish brown, blackish brown, and black. Selection of the proper exposure step for each individual's skin color is important. Correct matching of light source and type of film is also important if unwanted color casts and complicated filtration problems are to be avoided. Use daylight film when photographing people outdoors. Fill-in flash will help illuminate eye sockets when harsh lighting is present.

Daylight film may also be used indoors if blue floodlights are used. Indoor color slide film, combined with 3200°K or 3400°K photoflood lights, is recommended. If outdoor pictures are taken in the shade or under cloudy skies, decamired R-1½ or R-3 filters will counteract the bluishness in the shaded light.

Roundness of the face, body, and hands causes light to be reflected in different directions, and this must be considered when exposure is determined. That part of the skin that comprises the largest proportion of flesh is to be exposed on the proper step for that racial group. For example, the skin of most Caucasians is to be exposed on Step 1L. Highlight areas may fall on Step 1½L or 2L, and shadows may fall on Steps ½L, MV, or ½D. Exceptions to these exposures occur in creative portraiture and specialized modeling procedures. If the photographer is not certain of the proper exposure for a particular model, the Kodak 18 percent gray card will serve as a valuable tool. The gray card is positioned beside the face at an angle to the light identical to the angle of the majority of the skin, and a meter reading is obtained on the gray card. This reading will be middle value, which in most instances will expose the various skin colors on the proper step. In the case of black-skinned people, a meter reading of the skin is recommended to compare to the gray card reading to assure texture will be visible. The reader is referred to many fine books on modeling and portraiture for information about lighting techniques, posing, choice of lenses, and creative portraiture.

In figure C-25 the hands must receive correct exposure or the picture will be ruined. Sunlight on the right hand was reflected at the camera, making it lighter than the left hand. Sunlight on the left hand was reflected in a different direction. The yellow letters were too small to read, even with a spot meter, without disturbing the man's work. Any step for the brown sign, except black, was considered acceptable. The shadow in the upper right corner was considered insignificant because it contained no important subjects. Therefore, exposure of the shadow could fall on any step, including blackish brown or black.

When the meter reading of the right hand was positioned on Step 1L, the reading on the left hand fell on Step MV. Other areas of skin fell on Step ½L. These were considered acceptable values for skin that was tanned. All these steps would preserve texture in the skin. The brown sign fell between Steps 1½D and 2D. The yellow letters and black watch band provided contrasting accents of color. Note that the yellow and black are properly exposed.

13-6 Data form and value-selector chart excerpt for figure C-25.

1½L	Colors and Color Values of Objects	Step	1½L	White-Gray Adeq Text	Lt Viv Org Light Beige
1L	Right Hand	1L	1L	Light Gray Consid Text	Viv Orange Med Beige
½L	Small Skin Areas	1½L	½L	Med Lt Gray Ext Texture	Dk Viv Org Dark Beige
MV	Left Hand	MV	MV	Middle Gray Max Texture	Burnt Org Lt Brown
½D		½D	½D	Med Dk Gray Ext Texture	Dk Burnt Or Med Brown
1D		1D	1D	Dark Gray Consid Text	Dk Org-Brn Dark Brown
1½D	Brown Sign	1½D	1½D	V Dk Gray Adeq Text	V Dk Org-Br Choc Brown
2D	Brown Sign	2D	2D	Text Black Min Texture	Blk Org-Brn Blkish Brn

GREEN 14

\mathbf{M}any greens in nature are darker than middle value, requiring photographers to adjust the exposure meter reading to obtain correct exposure. Green is also found in home furnishings, clothing, food, and automobiles. You should train yourself with the Munsell charts to distinguish between light green, middle green, and dark green (fig. C-26), and to differentiate between green, green yellow, and blue green.

*Step 2L: **Whitish Green**.* This is the lightest step on which significant hue is retained in green or any other color. Step 2L green includes very light green, very pale green, greenish white, mint lime, pastel green, and pale emerald.

*Step 1½L: **Light Green**.* Designations for green at this value include smoke green and pale green. Light green, light brilliant green, and very light emerald are medium-chroma color names. High-chroma samples include brilliant green and vivid green.

*Step 1L: **Light Kelly Green**.* Listed in order of increasing chroma, pale green, dusky green, brilliant green, light kelly green, vivid green, and light emerald are correctly exposed on this step.

*Step ½L: **Kelly Green***: Green reaches maximum chroma on the Munsell chart on Steps ½L, MV, and ½D. Greenish gray and fog green are synonyms for low-chroma green. Meadow green is a common medium-chroma color in nature. Vivid greens include brilliant green, emerald, kelly green, and Killarney green.

*Step MV: **Dark Kelly Green**.* Grayish green is a low-chroma version of green that could be called slate green or sagebrush green. Strong green on Step MV is also known as bright emerald or dark kelly green. Exposure according to the meter reading is indicated for correct reproduction. This step is the point of departure for exposure of other green values. Because of exposure meter design, the versions of green listed for the L steps will be reproduced at Step MV if the meter reading of the sample is followed. To obtain lighter green, the meter reading must be

adjusted. All of the green designations listed for the D steps will change to middle value if the reading is not modified.

Step ½D: **Pepper Green.** The lowest chroma greens at this value are known as dark grayish green, dusky green, and jade green. Higher chroma greens include dark Killarney green, deep emerald, and pepper green.

Step 1D: **Hunter Green.** Low-chroma green at this value is a dark grayish green that could be called dark spruce. Dark greens, such as hunter green, are in the middle of the chroma scale on Step 1D. Higher chroma green on this step is known as dark emerald or dark vivid green. Step 1D can be used as a shadow value for lighter greens.

Step 1½D: **Forest Green.** Green has higher chroma at dark values than some other colors, as indicated by comparing the length of the chroma scales for Step 1½D on the Munsell charts. Dark grayish green and dusky dull green are low-chroma color names on Step 1½D. Dark green, forest green, and pine green should be exposed on Step 1½D.

Step 2D: **Blackish Green.** Green at this value can be described as dark grayish green, dusky dark green, dark forest green, and blackish green. Hue is minimal on this blackish value. This step is a shadow value that can be used for very dark green subjects. It is the darkest step on which green or any other hue should be exposed if hue and texture are to be retained.

EXPOSURE EXAMPLE: GREEN AND BLUE

A small tree provided a frame for Long's Peak in Rocky Mountain National Park in Colorado (fig. C-27). Metering through the polarizer enabled exposure of the sky to be precise from the top to the bottom of the format and prevented the green and blue from blending. Four colors were read with the meter: light brown rock, green tree, blue sky, and shadows. The value-selector chart and data form were positioned with blue sky at the top of the format aligned with Step 1D. This choice was made because Step 1D blue sky assured separation between blue sky and dark green. The lower sky was exposed on Step ½D. Small areas of light brown rock in the foreground were on Step 1½L. Spot readings of the evergreen branches were obtained and aligned with Step ½D because of the contrast range between sky and branches. Shadows within the evergreen branches could not blend with the Step 1D blue sky. The areas of snow were too small to determine exposure.

14-1 Data form and value-selector chart excerpt for figure C-27.

			Colors and Color Values of Objects *	Step			
Baby Blue Lt Lavender	Pastel Turq Light Green	1½L	Beige Rock	1½L	1½L	White-Gray Adeq Text	Lt Viv Org Light Beige
Dk Baby Blu Med Lavend	Bright Turq Lt Kelly Gr	1L		1L	1L	Light Gray Consid Text	Viv Orange Med Beige
V Lt Bl Sky Dk Lavender	Vivid Turq Kelly Green	½L		½L	½L	Med Lt Gray Ext Texture	Dk Viv Org Dark Beige
Lt Blue Sky Lt Viv Pur	Turq-Green Dk Kelly Gr	MV		MV	MV	Middle Gray Max Texture	Burnt Org Lt Brown
Med Blu Sky Viv Purple	Deep Turq Pepper Grn	½D	Evergreens, Sky	½D	½D	Med Dk Gray Ext Texture	Dk Burnt Or Med Brown
Dk Blue Sky Dk Viv Pur	Dk Blue-Grn Hunter Grn	1D	Polarized Blue Sky	1D	1D	Dark. Gray Consid Text	Dk Org-Brn Dark Brown
V Dk Bl Sky V Dk Purple	V Dk Bl-Grn Forest Grn	1½D		1½D	1½D	V Dk Gray Adeq Text	V Dk Org-Br Choc Brown
Blk-Blu Sky Blksh-Purpl	Blk-Blu-Grn Blksh-Green	2D	Shadows	2D	2D	Text Black Min Texture	Blk Org-Brn Blkish Brn

Blue green has the shortest chroma scales of the ten basic hues. It is also the only one of the ten basic hues in which maximum chroma is reached on four values (fig. C-28). Blue green is frequently called turquoise, aqua, jade, or teal. It is a common color for alpine lakes filled with glacial silt and is also present in some types of evergreens, in jewelry, clothing, automobiles, and home furnishings.

Step 2L: Whitish Blue-Green. Step 2L is reserved for exposure of whitish blue greens such as very pale blue green, very light blue green, and very light aqua green.

Step 1½L: Pastel Turquoise. Very light turquoise green, pale aqua green, and pastel turquoise green occur on Step 1½L. Higher chroma versions include brilliant blue green, bright aqua green, and bright jade green.

Step 1L: Bright Turquoise. Maximum chroma for blue green is reached on Steps 1L, ½L, MV, and ½D. Designations for Step 1L blue green include pale blue green, light blue green, aqua, aqua green, and turquoise green. Brilliant blue green, bright turquoise, vivid blue green, and vivid turquoise are names for high-chroma versions.

Step ½L: Vivid Turquoise. This is one of the values at which blue green reaches maximum chroma. Versions of this hue at Step ½L are designated pale blue green at a low chroma. Light blue green, sulfate green, brilliant blue green, turquoise, jade green, vivid blue green, and vivid turquoise are names for the high-chroma versions.

Step MV: Turquoise Green. Step MV color names include grayish blue green, moderate blue green, aquamarine, and sprite. High-chroma versions are called dark aqua, turquoise green, vivid blue green, and vivid turquoise. Any of these will be correctly exposed according to the meter reading, because they are middle-reflectance versions of blue green.

Step ½D: Deep Turquoise. Medium grayish blue green, green slate, dark jade green, dark sulfate green, deep turquoise, and teal green are colors that should be exposed on this step. This is the darkest step on which aqua can be reproduced.

Step 1D: Dark Blue Green. Dark grayish blue green, dark teal, dark blue green, dark turquoise, and some types of evergreen shrubbery are correctly exposed on this step.

Step 1½D: Very Dark Blue Green. The chroma scale for blue green is quite short at this value, indicating that the samples will have gray in them. Very dark grayish blue green, very dark teal, and very dark blue green are present at this value.

Step 2D: Blackish Blue Green. Very dark blue green and dark spruce are synonyms for blackish blue green exposed on Step 2D.

EXPOSURE EXAMPLE: BLUE GREEN, DARK GREEN, GRAY, AND WHITE

Peyto Lake is one of the spectacular waterscapes in the Canadian Rockies (fig. C-29). A camera position six inches above the ground was selected. Using a superwide-angle 25mm lens to encompass the entire lake, several flowers were composed below one arm of the lake. Meter readings were taken of the white and gray clouds, blue green water, bluish mountains, and evergreen forest. The forest occupied a large enough proportion of the format to require that it retain its green color and texture. High-value clouds complicated exposure because of the wide contrast between them and the forest.

The value-selector chart was moved up and down under the data form while the meter readings were evaluated. If evergreens were exposed on Step 2D, the clouds would vary from Step MV to 2L. Shadows on the green forest occupied an important proportion of the format. Step 2L clouds accounted for a small proportion of the format. The majority of clouds ranged from gray cloud base on Step ½L to lighter clouds on Steps 1L and 1½L. All these values were envisioned as acceptable.

15-1 Data form and value-selector chart excerpt for figure C-29.

			Colors and Color Values of Objects	Step	Step		
Wh Baby Blu / Whit Lavend	Whit Bl-Grn / Whit Green	2L	Small White Cloud Areas	2L		2L	Off-White / Min Texture
Baby Blue / Lt Lavender	Pastel Turq / Light Green	1¼L	Large Cloud Masses	1½L		1½L	White-Gray / Adeq Text
Dk Baby Blu / Med Lavend	Bright Turq / Lt Kelly Gr	1L	Large Cloud Masses	1L		1L	Light Gray / Consid Text
V Lt Bl Sky / Dk Lavender	Vivid Turq / Kelly Green	½L	Gray Clouds, Sunny Lake	½L		½L	Med Lt Gray / Ext Texture
Lt Blue Sky / Lt Viv Pur	Turq-Green / Dk Kelly Gr	MV	Distant Bluish Mountains	MV		MV	Middle Gray / Max Texture
Med Blu Sky / Viv Purple	Deep Turq / Pepper Grn	½D		½D		½D	Med Dk Gray / Ext Texture
Dk Blue Sky / Dk Viv Pur	Dk Blue-Grn / Hunter Grn	1D	Shaded Water	1D		1D	Dark Gray / Consid Text
V Dk Bl Sky / V Dk Purple	V Dk Bl-Grn / Forest Grn	1½D	Sunny Evergreens	1½D		1½D	V Dk Gray / Adeq Text
Blk-Blu Sky / Blksh-Purpl	Blk-Blu-Grn / Blksh-Green	2D	Shaded Evergreens	2D		2D	Text Black / Min Texture
		2½DB	Small Black Shadows	2½ DB		2½DB	Pure Black / No Texture

Ideally, the clouds should have been darker and the evergreens one step lighter, but this could not be done. If the mass of forest had been darkened to obtain darker clouds, hue and texture in the trees would disappear. If the forest had been exposed lighter to provide more texture and hue, the white clouds would have lost significant detail and changed their mood. If this picture had larger proportions of white and smaller proportions of dark values, less exposure would have been acceptable.

The exposure of the forest and clouds determined that the sunlit portion of the lake would fall on Step ½L. Shaded areas of the lake fell on 1D. Both retained the lake's distinctive blue green color. In this example blue green was allowed to fall on steps determined by the contrast range between shadows and clouds. In a different picture, exposure of the blue green might have to be the first priority. In this scene, however, the blue green is very close to the actual color of the lake. The mountains in the distance were exposed on Step ½L. Had this scene been exposed in the automatic-exposure meter "point and shoot" manner, desaturation or overexposure would have resulted, ruining the picture. This would have occurred because the predominance of dark values would have been raised from their dark value to middle value, much too light for correct exposure.

Purple is the color of royalty, found in clothing worn by kings and queens. It also has religious significance and is included as part of the interior decoration of churches and cathedrals. Choir robes are often purple or a variation of purple. It is also used for household furnishings, clothing, automobiles, and stained glass windows. Flowers, fruits, and vegetables, including eggplant, prunes, and boysenberries, have colors found on the Munsell purple chart (see fig. C-30). Color names for purple that signify light, middle, or dark values provide important clues to correct exposure.

Step 2L: Whitish Lavender. This step should be reserved for very light colors. Purplish white, very light purple, pale lilac, and very light lavender result from exposure on Step 2L.

Step 1½L: Light Lavender. Very pale purple, light lavender, orchid, and similar colors are correctly exposed at this value or will result from exposure of darker purples on this step. Higher chroma samples include very light purple and brilliant purple.

Step 1L: Medium Lavender. Light purplish gray, pale purple, and dull lavender are low-chroma colors at this value. At higher chroma levels, light purple, medium lavender, brilliant purple, violet, and vivid purple are present.

Step ½L: Dark Lavender. On this step purplish gray and pale purple are low-chroma samples. From middle to high chroma, light purple, lilac, dark lavender, brilliant purple, violet, and vivid purple are color names for Step ½L purple.

Step MV: Light Vivid Purple. This step is the point of departure in the stair-step system Low-chroma designations for purple on Step MV include purplish gray and grayish violet. The higher chroma samples include amethyst purple, strong purple, pansy violet, light vivid purple and bright violet.

Step ½D: Vivid Purple. Purple reaches its maximum chroma on this step. Low-chroma grayish purple is similar to shadow lilac, slate violet, or lavender. Vivid purple at Step ½D can be described as imperial purple.

Step 1D: Dark Vivid Purple. The following color names and designations are listed in order of increasing chroma for this step: dark grayish purple, dark slate violet, eggplant, dark vivid purple, plum, prune, deep purple, petunia violet, and royal purple.

Step 1½D: Very Dark Purple. Step 1½D is a shadow value to be used for lighter samples of purple in shade. Any purple exposed on Step 1½D will be reproduced as very dark purple.

Step 2D: Blackish Purple. Versions of purple that can be reproduced on this step include blackish purple, very dark purple wine, and burgundy. These colors are almost black and retain minimal texture. This step is also used for shadows.

EXPOSURE EXAMPLE: PURPLE, ORANGE, AND WHITE

The ceiling of the United States Air Force Academy Chapel can be interpreted with saturated or desaturated colors. This is done by making several exposures one stair-step apart. Not all subjects lend themselves to this type of individual interpretation; some, such as those found in nature, require accurate color reproduction. In figure C-31 the photographer decided to interpret the scene in the L steps, rather than in dark values, because light values convey a feeling of radiance, whereas dark values are emotionally heavy. The contrast range of the scene encompassed six stair-steps, which were positioned on the range from Step MV to Step 2½LW. This required modification of the meter reading. An averaging meter would have recommended that the six-step range be positioned around middle value, an acceptable exposure, but one that would produce an emotionally heavier scene.

16-1 Data form and value-selector chart excerpt for figure C-31.

		Colors and Color Values of Objects	Step	Step		Pure White / Off-White etc.	Orange	Pink
	2½LW	Ceiling Windows	2½ LW		2½LW	Pure White / No Texture		
Wh Baby Blu / Whit Lavend	2L	Ceiling Windows	2L		2L	Off-White / Min Texture	Wh Orange / Whit Beige	White Pink / Wh Pur Pink
Baby Blue / Lt Lavender	1½L	Ceiling Windows	1½L		1½L	White-Gray / Adeq Text	Lt Viv Org / Light Beige	Baby Pink / Purple-Pink
Dk Baby Blu / Med Lavend	1L	Purple Ceiling Areas	1L		1L	Light Gray / Consid Text	Viv Orange / Med Beige	Dark Pink / Dk Pur-Pink
V Lt Bl Sky / Dk Lavender	½L	Mass of Purple Ceiling	½L		½L	Med Lt Gray / Ext Texture	Dk Viv Org / Dark Beige	Coral Red / Lt Red-Pur
Lt Blue Sky / Lt Viv Pur	MV	Small Purple Areas	MV		MV	Middle Gray / Max Texture	Burnt Org / Lt Brown	Crimson Red / Med V Red-P

C-31 Exposure of purple, orange, and white shown in this color slide reproduction of United States Air Force Academy chapel ceiling.

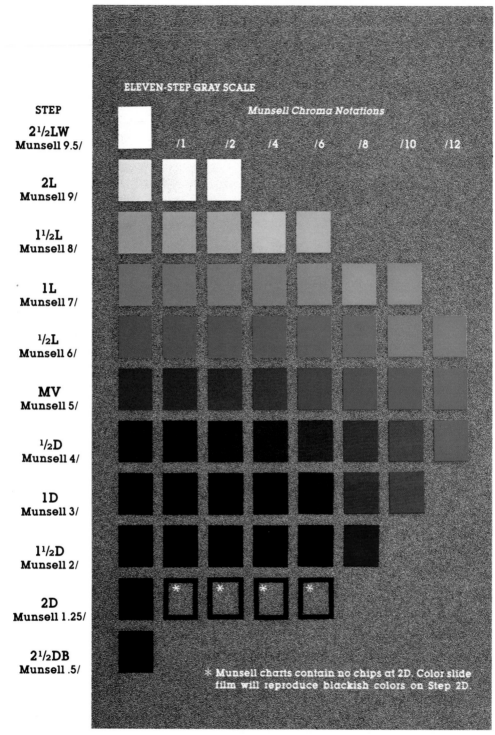

Munsell constant-hue chart 5RP red purple with eleven-step gray scale
added as left column. (From *Munsell Book of Color*, reproduced courtesy
of Munsell Color)

C-33 Exposure of red purple, blue, and black shown in this color slide reproduction of "The Soul of the Organ."

C-34 Exposure of red purple, green, and off-white shown in this color slide reproduction of tiny cactus blossom.

C-35 Sacrifice of shadow texture shown in this color slide reproduction of Central City lamp.

36 Exposure of building interiors shown in this color slide reproduction of mission chapel interior, light version.

C-37 Twilight photography shown in this color slide reproduction of Expo '74 twilight.

C-38 Color slide reproduction of snowshoe rabbit photographed in bluish shadow to illustrate effect of orange overlay (top) on part of picture.

C-39 Color slide reproduction of montage combining statue and sunset.

40 Color slide reproduction of montage "The Supreme Sacrifice."

41 Double exposure on different areas of film shown in this color slide reproduction of Cox Jeweler sign and alarm clock gears.

C-42 White double-exposed on colors is shown in this color slide reproduction of "Springtime in the Rockies."

C-43 Double exposure of colors on other colors is shown in this color slide reproduction of flowers and log cabin at Capitol City, Colorado.

C-44 Black titling on color slide shown in this color slide reproduction of "Rick Hypes Presents." (Photograph by Richard Hypes)

C-45 White titling on color slide, produced by double exposure and duplication, shown in this color slide reproduction of "Text Compiled."

C-46 Color slide reproduction of underexposed, bluish "Abandoned Cabin in the Aspens."

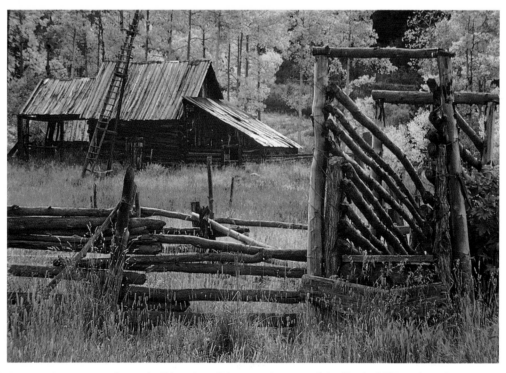

C-47 Corrected exposure shown in this color slide reproduction of duplicated "Abandoned Cabin in the Aspens."

RED PURPLE (MAGENTA) 17

The color that photographers know as magenta is classified by Munsell as red purple. Magenta is one of the basic colors used for color balance in photographic color print making. It is found in flowers, fruit, clothing, home furnishings, automobiles, and glassware. Red purple is also a religious color, as indicated by its use in stained glass windows, choir robes, and church interiors. An evaluation of the Munsell chart reveals that the chips are almost equally distributed on each side of middle value (fig. C-32). The color names vary from pink to burgundy.

*Step 2L: **Whitish Purple Pink**.* This step should be reserved for very light colors. Magenta at this value is light purple pink.

*Step 1½L: **Purple Pink**.* Pale purple pink, brilliant purple pink, and baby purple pink are versions of Step 1½L magenta.

*Step 1L: **Dark Purple Pink**.* Dull lavender, moderate purple pink, rose pink, strong purple pink, and dark purple pink should be exposed on this step.

*Step ½L: **Light Red Purple**.* Red purple reaches maximum chroma on Steps ½L, MV, and ½D. Pale magenta, dull violet, dark purple pink, dull rose, deep purple pink, and light red purple are all color names appropriate for red purple on this value.

*Step MV: **Medium Red Purple**.* Low-chroma versions of red purple at middle value include slate violet, grayish red purple, and brown violet. The amount of gray in these colors accounts for their muted effect. Moderate purplish red, plum purple, strong purplish red and rose violet are color names for higher chroma versions of magenta on Step MV.

*Step ½D: **Vivid Red Purple**.* Low-chroma grayish purple can be called brown violet. Strong red purple, rose violet, vivid red purple, and deep magenta are samples of higher chroma red purple at this value.

Step 1D: *Dark Red Purple.* Dark grayish purple at this value resembles dark prune or deep eggplant. Dark red purple could be called plum violet or garnet. Deep red purple is a high-chroma version of fuschia red.

Step 1½D: *Very Dark Red Purple.* Color names for this step include very dark red purple, burgundy, royal violet, raisin, and magenta rose.

Step 2D: *Blackish Red Purple.* Raisin black, blackish burgundy, and blackish red purple are all Step 2D versions of red purple.

EXPOSURE EXAMPLE: RED PURPLE, BLUE, AND BLACK

In photographing figure C-33, two 500-watt slide projectors were used to illuminate the trompette pipes in a pipe organ. A magenta filter was placed in front of one projector lens and a blue filter in front of the other projector lens to provide color on the silver pipes. Exposure was determined for the desired color values and texture in the shadows. Exposure alternatives allowed three acceptable pictures with three different interpretations. Not all subjects lend themselves to this variety of creative exposure. Some objects, such as nature studies, require precise exposure. The contrast range encompassed nine steps if the tiny pink highlights were included, seven steps if these highlights were ignored.

17-1 Data form and value-selector chart excerpt for figure C-33.

		Colors and Color Values of Objects		Step		
Wh Baby Blu / Whit Lavend	2L	Small Purple Pink Areas 2L		2L	Off-White / Min Texture	White Pink / Wh Pur Pink
Baby Blue / Lt Lavender	1½L		1½L	1½L	White-Gray / Adeq Text	Baby Pink / Purple-Pink
Dk Baby Blu / Med Lavend	1L		1L	1L	Light Gray / Consid Text	Dark Pink / Dk Pur-Pink
V Lt Bl Sky / Dk Lavender	½L		½L	½L	Med Lt Gray / Ext Texture	Coral Red / Lt Red-Pur
Lt Blue Sky / Lt Viv Pur	MV	Red-Purple Organ Pipes MV		MV	Middle Gray / Max Texture	Crimson Red / Med V Red-P
Med Blu Sky / Viv Purple	½D	Blue Organ Pipes ½D		½D	Med Dk Gray / Ext Texture	Bright Red / Viv Red-Pur
Dk Blue Sky / Dk Viv Pur	1D		1D	1D	Dark Gray / Consid Text	Vivid Red / Dk Red-Pur
V Dk Bl Sky / V Dk Purple	1½D		1½D	1½D	V Dk Gray / Adeq Text	Maroon / V Dk Red-P
Blk-Blu Sky / Blksh-Purpl	2D	Shadows 2D		2D	Text Black / Min Texture	Blk-Maroon / Blk-Red-Pur

EXPOSURE EXAMPLE: RED PURPLE, GREEN, AND OFF-WHITE

A tiny cactus blossom was illuminated with sunlight in figure C-34. An aluminum foil reflector softened the shadows. Spot-meter readings were taken through a +10 portrait lens of the red purple, shaded green, and sunny green areas. The value-selector chart was positioned with the shaded green aligned with Step 2D. Checking color values of the green and red purple readings indicated that these colors would be accurately reproduced. The red purple was on Step 1D. The sunny green was on Step MV. The spines were off-white accents against the green. If the reading of a through-the-lens meter had been followed, this picture would have received one more f/stop of light because the meter would have averaged the val-

17-2 Data form and value-selector chart excerpt for figure C-34.

			Colors and Color Values of Objects	Step				
~~Turq-Green~~ (Dk Kelly Gr)	Med Yel-Grn Olive Yello	MV	Green in Sunlight	MV	MV	~~Middle Gray~~ (Max Texture)	Crimson Red Med V Red-P	
Deep Turq Pepper Grn	Dk Yel-Grn Light Olive	$\frac{1}{2}$D		$\frac{1}{2}$D	$\frac{1}{2}$D	Med Dk Gray Ext Texture	Bright Red Viv Red-Pur	
Dk Blue-Grn Hunter Grn	Olive Green Med Olive	1D	Red-Purple Blossom	1D	1D	~~Dark Gray~~ (Consid Text)	~~Vivid Red~~ (Dk Red-Pur)	
V Dk Bl-Grn Forest Grn	Dk Olive Gr Dark Olive	1$\frac{1}{2}$D		1$\frac{1}{2}$D	1$\frac{1}{2}$D	V Dk Gray Adeq Text	Maroon V Dk Red-P	
~~Blk Blue-Grn~~ (Blksh-Green)	~~Blk-Olive-G~~ Blksh Olive	2D	Shaded Green	2D	2D	~~Text Black~~ (Min Texture)	Blk-Maroon Blk-Red-Pur	

ues to middle value, rather than exposing them on the correct dark step. The resulting picture would have been ruined because of excessive exposure.

ADVANCED AND CREATIVE COLOR SLIDE EXPOSURE

III

USING THE STAIR-STEP EXPOSURE SLIDE RULE

The exposure slide rule combines the features of the value-selector chart and the data form into one easy-to-use instrument. Once you learn the stair-step system by using the data forms and value-selector chart, you can move on to using the slide rule. You must remember the subjects and colors in the scenes you photograph when using the slide rule, rather than recording them on data forms. You may, however, wish to use data forms for the first few pictures taken with the exposure slide rule, until you become familiar with it. The slider is moved left and right through the stator as color values and textures are examined. This is the equivalent of moving the value-selector chart up and down under the data form. The slider is turned end over end or turned over in order to use all of the rows. One sub-row of numbers is used when working on a particular photograph. A range of numbers in one row of holes is selected on the basis of the range of meter readings of the scene. For example, if the range of the scene encompasses EVS 10 to 16 (or 1/125 to 1/4 second, or f/11 to f/1.5), that sub-row of numbers is selected for choosing the color values for exposure determination. Four sub-rows of numbers are visible at a time through the holes. In nearly all other respects, instructions for using the exposure slide rule are identical to those for the use of the value-selector chart and the data forms.

1. Define the perimeters of the format to determine the proportionate sizes of colors. Select the lens to be used.
2. Determine if polarization is needed to darken the sky or eliminate reflections.
3. Obtain spot readings of several single-value colors within the format, including those that make up the largest proportion of the format and those in the main subject.
4. Write the colors on the stair-step data form on lines corresponding with the meter readings if desired, or make mental notes of the lightest and darkest areas if the data form is not used.

5. Position the slider so that the range of EVS numbers (or f/stops or shutter speeds) from the lightest to the darkest areas of the scene is visible in the holes of the stator. Work with only one series of numbers in one of the rows of holes. Position the slider in the following manner:
 a. Select the row on the slider that contains the range of numbers encompassed by the contrast of the scene.
 b. Position the slider so that the range of numbers is approximately equal on each side of Step MV.
6. Adjust the slider right and left to obtain the best compromise of colors, highlights, shadows, and textures to select the best exposure. The size of each colored and textured area must be considered in proportion to the format. Compare the colors in the scene with the descriptions on the stator. Evaluate readings of other colors.
7. Enter the steps selected from the slide rule on the data form if desired.
8. The EVS number (or f/stop or shutter speed) that is visible in the Step MV hole of the slide rule will be used to determine the camera settings. Set the EVS number on the meter so that the meter arrow points at it. If you are using the f/stop rotation procedure, set the lens f/stop on the f/stop that appears in the Step MV hole of the stator. If you are using the shutter-speed rotation technique, set the shutter speed on the setting indicated in the Step MV hole of the stator.
9. Choose the best combination of f/stop and shutter speed for the picture, based upon the requirements of depth of field and motion control. Write the camera settings on the data form, if it is being used.
10. Set the camera shutter and f/stop and take the picture.
11. After processing, evaluate the slide.
12. Memorize the appearance of the colors, textures, highlights, and shadows at the various steps.

The slide rule works easily and quickly; it can be used to photograph fast-moving sports, wildlife in motion, and subjects in changing light conditions. The increased exposure accuracy will make the learning process more than worth your effort. You may discontinue using the exposure slide rule after learning the steps for all values and textures. Then you will be able to use only the meter dial to determine exposure, as demonstrated in chapter 13.

CORRECT EXPOSURE OF HIGH-CONTRAST SCENES

Scenes that have high contrast of reflectance present difficult exposure problems for color slide photographers because color slide film can reproduce color and texture only within a limited range. When the contrast range of a scene exceeds nine stair-steps, the film must be exposed for loss of hue and texture in either the dark or light values or both. By using the value-selector chart or exposure slide rule, you can envision exposure compromises as acceptable or not acceptable. If compromises are not acceptable, you may be able to recompose the picture and change the proportions of values to reduce the amount of unacceptable area. When learning to photograph high-contrast scenes, variation of exposures by bracketing may be indicated if the photographic assignment cannot be easily repeated. After the photographer learns to precisely envision the result of several exposure possibilities, bracketing can be reduced or eliminated.

EXPOSURE EXAMPLE: SACRIFICE OF SHADOW TEXTURE

Central City, Colorado, is a restored ghost town in which many of the old buildings and relics have been preserved. Gaslights are attached to many of the buildings in the town. Figure C-35 was composed into a vertical format because of the shape of the light. Four meter readings were taken, and colors were written on the stair-step data form. The scene encompassed eleven steps. Color photographers have occasionally been misled into placing the highlights and shadows of a high-contrast scene equidistant from middle value. If this had been done in this example, the picture would have been seriously overexposed. The large mass of light beige would have been reproduced as untextured white.

Using the color names on the value-selector chart, the data form was positioned with the light beige wall on Step 1½L. This can also be done with the exposure slide rule. The contrast range between the wall and the darkest shadow caused the shadow to fall on Special Step 3½DB. This step is not included on the value-

19-1 Data form and value-selector chart excerpt for figure C-35.

		Colors and Color Values of Objects	Step	Step			
Lt Viv Y-Gr / Viv Yellow	1½L	*Beige Wall*	1½L		1½L	White-Gray (Adeq Text)	Lt Viv Org (Light Beige)
Viv Yel-Grn / Dark Yellow	1L		1L		1L	Light Gray / Consid Text	Viv Orange / Med Beige
Dk Viv Y-Gr / (Mustard Yel)	½L	*Olive Door Frame*	½L		½L	Med Lt Gray (Ext Texture)	Dk Viv Org / Dark Beige
Med Yel-Grn / Olive Yello	MV◄		MV		►MV	Middle Gray / Max Texture	Burnt Org / Lt Brown
Dk Yel-Grn / Light Olive	½D		½D		½D	Med Dk Gray / Ext Texture	Dk Burnt Or / Med Brown
Olive Green / Med Olive	1D		1D		1D	Dark.Gray / Consid Text	Dk Org-Brn / Dark Brown
Dk Olive Gr / Dark Olive	1½D	*Shadow on Beige*	1½D		1½D	V Dk Gray (Adeq Text)	V Dk Org-Br (Choc Brown)
Blk-Olive-G / Blksh Olive	2D		2D		2D	Text Black / Min Texture	Blk-Org-Brn / Blkish Brn
	2½DB		2½DB		2½DB	Pure Black / No Texture	
	3DB		3DB		3DB	Opaque Blk / No Texture	
		Black Shadow	3½ DB				

selector chart or exposure slide rule because Step 3DB represents the darkest practical value of the film. By indicating Step 3½DB, the actual contrast range of the scene is apparent. Sacrificing hue and texture in the shadow was a better compromise for this picture than giving up texture and color in the wall. The proportions of colors and the importance of subjects helped the photographer decide how to make the required compromise and obtain an acceptable slide.

EXPOSURE EXAMPLE: SACRIFICE OF HIGHLIGHT, SHADOW TEXTURE, AND HUE

The Firehole River Falls in Yellowstone National Park in Wyoming (fig. 19-2) encompasses a range of fifteen stair-steps when it is illuminated by sunlight. This range far exceeds the ability of color slide film to retain texture and hue. The excessive contrast in this scene is the result of sunlight reflected by glaring white water, combined with black canyon shadows.

The data form and value-selector chart were used to help the photographer envision the result of several possible exposures. If the center of interest had been in the shadow, the exposure would have to illuminate that shadow. The large mass of white water was the center of interest, however. This meant that considerable texture in the dark values could be sacrificed. A small, exceptionally light area of white water was exposed on Special Step 3LW with loss of texture. Readings of the remainder of the water areas were aligned on the value-selector chart with steps ranging down to 1L. Green water was on Step ½L. Evergreens may be exposed as light as Step ½D. In this example the lightest evergreens in sunlight were exposed on Step 1½D; darker evergreens, on Steps 2D and 2½DB. The evergreens made up a significant proportion of the format, but hue and texture had to be sacrificed in order to expose the water on acceptable values. The granite cliffs would be black on Special Step 3½DB.

The resulting slide does not appear to have any overexposed areas because the eye accepts the white water as correctly exposed. It ranges from Step 1L to

19-2 Sacrifice of highlight, shadow texture, and hue shown in this black-and-white version of color slide of Firehole River Falls.

19-3 Data form and value-selector chart excerpt for figure 19-2.

			Colors and Color Values of Objects	Step	Step		
Use Steps 2½LW, 3LW, and lighter steps for white textureless highlights in wide contrast scenes whose dark areas require color or texture.		3LW	Small White Area	3	LW	3LW	Glare White No Texture
		2½LW	Small White Area	2½	LW	2½LW	Pure White No Texture
Whit Bl-Grn / Whit Green	Whit Yel-Gr / White Yel	2L	Large White Area	2L		2L	Off-White Min Texture
Pastel Turq / Light Green	Lt Viv Y-Gr / Viv Yellow	1½L	Large White Area	1½L		1½L	White-Gray Adeq Text
Bright Turq / Lt Kelly Gr	Viv Yel-Grn / Dark Yellow	1L	Green Water	1L		1L	Light Gray Consid Text
Vivid Turq / Kelly Green	Dk Viv Y-Gr / Mustard Yel	½L	Green Water	½L		½L	Med Lt Gray Ext Texture
Turq-Green / Dk Kelly Gr	Med Yel-Grn / Olive Yello	MV	Water	MV		MV	Middle Gray Max Texture
Deep Turq / Pepper Grn	Dk Yel-Grn / Light Olive	½D	Water	½D		½D	Med Dk Gray Ext Texture
Dk Blue-Grn / Hunter Grn	Olive Green / Med Olive	1D	Green Grass	1D		1D	Dark Gray Consid Text
V Dk Bl-Grn / Forest Grn	Dk Olive Gr / Dark Olive	1½D	Evergreens	1½D		1½D	V Dk Gray Adeq Text
Blk Blu-Grn / Blksh-Green	Blk-Olive-G / Blksh Olive	2D	Evergreens, Shadows	2D		2D	Text Black Min Texture
Use Steps 2½DB, 3DB, and darker steps for black textureless shadows in wide contrast scenes whose highlights require color and texture.		2½DB	Shadows, Evergreens	2½	DB	2½DB	Pure Black No Texture
		3DB	Shadows, Evergreens	3	DB	3DB	Opaque Blk No Texture
			Shadows on Cliffs	3½	DB		

3LW. The untextured white areas on Steps 2½LW and 3LW occupy such small proportions of the format that they do not appear overexposed, even though some detail is missing. At the other extreme, black shadows occupy a large proportion of the picture, but just enough illuminated places lay within the shadows to make them acceptable.

Correct Exposure of High-Contrast Scenes | 97

TIME EXPOSURE ACCURACY 20

Time exposures have long been a favorite type of creative photography because of the unusual effects that can be achieved. In addition, many subjects are too dark for instantaneous exposure. In some situations flash pictures may not be permitted or may not be practical because the distances exceed the ability of the flash to illuminate the subject. By enabling more light to reach the film, time exposures solve these problems. Underexposure has been a common problem in time exposures because reciprocity failure makes films lose sensitivity. The chart in figure 20-1 explains how to correct for loss of film sensitivity when taking pictures that exceed two seconds. Make a copy of the chart, tape it to your equipment, and refer to it whenever exposures exceed two seconds. Use this chart in combination with the stair-step exposure system to expose colors on the desired step.

UNDERSTANDING RECIPROCITY FAILURE

When taking pictures with instantaneous shutter speeds, photographers may choose many combinations of shutter speeds and f/stops, all of which provide the film with the same amount of light. The dial on the meter indicates the interchangeability of shutter speeds and f/stops that result in identical exposures. For example, 1/30 at f/8 is the same amount of light as 1/60 at f/5.6, and the same as 1/125 at f/4. This is *reciprocity* or *reciprocity success* in action.

If reciprocity means to be the equivalent, and to return in equal amounts, reciprocity failure may be defined as return in different amounts. Because of the reciprocity failure characteristics of film, five seconds at f/8 will not expose the film the same as ten seconds at f/11, although the exposure meter dial indicates it will be the same exposure. According to one film's reciprocity failure characteristics, eighteen seconds at f/11 will expose the film the same as five seconds at f/8. With this much difference in reciprocity, it should be obvious why underexposure occurs with

20-1 Reciprocity failure correction chart.

MR	CE	MR	CE	MR	CE	MR	CE	MR	CE
2S =	2S	9S =	16S	17S =	37S	40S =	2M	4M =	23M
2½S =	3S	10S =	18S	18S =	40S	45S =	3M	4½M =	27M
3S =	4S	11S =	21S	19S =	42S	1M =	3½M	5M =	31M
4S =	5½S	12S =	24S	20S =	45S	2M =	9M	5½M =	33M
5S =	7S	13S =	27S	25S =	60S	2½M =	13M	6M =	36M
6S =	9S	14S =	29S	30S =	80S	3M =	17M	6½M =	40M
7S =	11S	15S =	32S	35S =	99S	3½M =	20M	7M =	50M
8S =	13S	16S =	34S						

MR indicates meter reading S indicates seconds
CE indicates corrected exposure M indicates minutes

time exposures. Exposure meters make no allowances for reciprocity failure in the film. The photographer must, therefore, make adjustments for reciprocity failure. The reciprocity failure chart simplifies these adjustments.

The chart was based on the reciprocity failure curve of a well-known color-slide film. We have used the chart extensively for many years with all of the well-known color-slide films. Although every brand and speed of film has its own reciprocity failure characteristics, we have found that these variations do not seem to be significant. The time of the corrected exposures has been rounded off to the nearest second. Reciprocity failure begins with exposures exceeding two seconds. The code letters used on the chart have the following meanings: MR = Meter Reading; CE = Corrected Exposure, S = Seconds; and M = Minutes.

USING THE CHART

1. Compose the picture.
2. Focus the camera lens.
3. Determine the required depth of field and choose the largest lens aperture that will provide the desired depth of field.

OR

Determine the desired length of exposure based upon the following factors:
 a. Long exposure: required for a subject such as a freeway interchange at night to obtain tracings of many headlights and taillights.
 b. Long exposure: scene requires small f/stop to obtain adequate depth of field.
 c. Short exposure: shallow depth of field requirement permits large aperture.
 d. Short exposure: use of telephoto lenses that increase possibility of camera motion.
4. Take a meter reading using either of the methods that follow.
 a. Obtain the meter reading (MR) timing for a predetermined aperture established in step 3.
 b. Select the aperture for the predetermined MR time that was established in step 3.
5. Apply stair-step exposure system techniques by exposing colors on appropriate steps.
6. Using the reciprocity failure correction chart, convert the MR time in the left column to the corrected exposure (CE) time in the right column, after considering the following factors:
 a. If the corrected exposure time fits the requirement of step 3, proceed to step 7.
 b. If the corrected exposure time is too long and must be shortened, return to the MR column of the chart, cut the time in half, and read the corresponding CE time. If this newly corrected time is satisfactory, open the lens aperture one f/stop and proceed to step 7. If the exposure is still too long, repeat this step again or make other modifications as required before proceeding to step 7.

7. Adjust the lens aperture. The shutter will usually be on *B* (bulb) or *T* (time). Use a locking cable release with cameras that do not have the *T* setting.
8. Expose the film, using a watch or timer.
9. Write the exposures on the data form for later evaluation.

BRACKETING TIME EXPOSURES

Varying exposures provides different picture effects. When reciprocity failure is involved, bracketing time exposures is very different from bracketing instantaneous exposures. If you ignore reciprocity failure, you would bracket a meter reading of sixteen seconds according to the times on the meter dial, namely, four, eight, sixteen, thirty-two, and sixty-four seconds. The photographer who is aware of reciprocity failure will compare each of these MR times to the CE times on the chart. The resulting exposure bracket would be six, thirteen, thirty-four, eighty-five seconds, and three and one-half minutes. This example illustrates the large difference between MR and CE times. Note that as the MR times increase, the CE times increase at a much faster rate. Using the chart to determine bracketing times will help you come close to making a correct exposure. Keep records of the time exposures and write the data on the slide mount after processing.

EXPOSURE EXAMPLE: BUILDING INTERIORS

The stair-step exposure system, combined with the reciprocity failure correction chart, will help you obtain correct exposures on color slide film under conditions of minimal light. The interior of an old Spanish mission chapel in California (fig. C-36) was so dark that it was difficult for the visitor to see its beauty. Correctly exposed photographs, however, revealed the colors, sculpturing, mosaics, and textures. A meter reading of the lightest area in the room read five on the EVS scale. The front wall was so dark that it read EVS three. No readings could be obtained of the dark wooden railings, pulpit, and shadows.

One or two readings, combined with the use of the stair-step exposure calculator or exposure slide rule, are sufficient to obtain satisfactory exposure. The delicately patterned pale yellow wall adjacent to the pulpit was exposed on Step 1 1/2L

20-2 Data form and value-selector chart excerpt for figure C-36, dark version.

		Meter	Colors and Color Values of Objects				Step			
Date			Misc.			Filter	R3			
Lt Viv Y-Gr / Viv Yellow	1½L	10 1/4 / 4½ /1.5	Yellow Wall				1½L	1½L	White=Gray / Adeq Text	Lt Viv Org / Light Beige
Viv Yel-Grn / Dark Yellow	1L	9½ 1/3 / 4 /1.2	Yellow Wall				1L	1L	Light Gray / Consid Text	Viv Orange / Med Beige
Dk Viv Y-Gr / Mustard Yel	½L	9 1/2 / 3½ f/1					½L	½L	Med Lt Gray / Ext Texture	Dk Viv Org / Dark Beige
Med Yel-Grn / Olive Yello	MV	8½ 3/4 / 3	Front Wall				MV	MV	Middle Gray / Max Texture	Burnt Org / Lt Brown
Dk Yel-Grn / Light Olive	½D	8 1 sec / 2½	Too Dark to Meter				½D	½D	Med Dk Gray / Ext Texture	Dk Burnt Or / Med Brown
Olive Green / Med Olive	1D	7½ 1½ s. / 2	" " " "				1D	1D	Dark Gray / Consid Text	Dk Org-Brn / Dark Brown
Dk Olive Gr / Dark Olive	1½D	7 2 sec / 1½	" " " "				1½D	1½D	V Dk Gray / Adeq Text	V Dk Org-Br / Choc Brown
Blk-Olive-G / Blksh Olive	2D	6½ 2½ s. / 1	" " " "				2D	2D	Text Black / Min Texture	Blk-Org-Brn / Blkish Brn

20-3 Data form and value-selector chart excerpt for figure C-36, light version.

Meter	Colors and Color Values of Objects	Step	Step		
Date	Misc.		Filter **R3**		
2½LW · 10 ¼ / ④ /1.5	*Whitish Yellow Wall*	**2½LW**	2½LW · Pure White (No Texture)		
Whit Yel-Gr / White Yel · 2L · 9½ ⅓ / ④ f/1.2	*Whitish Yellow Wall*	**2L**	2L · Off-White (Min Texture)	Wh Orange / Whit Beige	
Lt Viv Y-Gr / Viv Yellow · 1½L · 9 ½ / 3½ f/1		**1½L**	1½L · White-Gray (Adeq Text)	Lt Viv Org / Light Beige	
Viv Yel-Grn / Dark Yellow · 1L · 8¼ ¾ / ③	*Front Wall*	**1L**	1L · Light Gray (Consid Text)	Viv Orange / Med Beige	
Dk Viv Y-Gr / Mustard Yel · ½L · 8 1 sec / 2½	*Too Dark to Meter*	**½L**	½L · Med Lt Gray (Ext Texture)	Dk Viv Org / Dark Beige	
Med Yel-Grn / Olive Yello · MV · 7½ 1½ s. / 2	" " " "	**MV**	MV · Middle Gray (Max Texture)	Burnt Org / Lt Brown	
Dk Yel-Grn / Light Olive · ½D · 7 2 sec / 1½	" " " "	**½D**	½D · Med Dk Gray (Ext Texture)	Dk Burnt Or / Med Brown	
Olive Green / Med Olive · 1D · 6½ 2½ s. / 1	" " " "	**1D**	1D · Dark Gray (Consid Text)	Dk Org-Brn / Dark Brown	
Dk Olive Gr / Dark Olive · 1½D · Evaluation:	" " " "	**1½D**	1½D · V Dk Gray (Adeq Text)	V Dk Org-Br / (Choc Brown)	
Blk-Olive-G / Blksh Olive · 2D	" " " "	**2D**	2D · Text Black (Min Texture)	Blk-Org-Brn / (Blkish Brn)	
2½DB	" " " "	**2½DB**	2½DB · Pure Black (No Texture)		

and the decorated front wall on Step MV for the first exposure. This positioning of the data form and value-selector chart was chosen because Step 1 ½L is one of the ideal steps for yellow. The dark areas that could not be read with the meter fell on undetermined values in the D steps. Because of the possibility that the dark shadows and brown wood might not be sufficiently illuminated, the second exposure was one f/stop lighter. This is the exposure shown in figure C-36. The pale yellow wall was exposed on Step 2½LW, which in the resulting slide has a very faint trace of yellow. The front wall was exposed on Step 1L. It was estimated that this would be the maximum permissible exposure because a colored area was exposed on Step 2½LW, usually reserved for white. The dark areas in the resulting slides were sufficiently illuminated.

High-speed color slide film required exposure times of four and thirteen seconds for each of the pictures. Because of reciprocity failure, an exposure time of thirteen seconds actually resulted in only twice as much exposure as that of four seconds. Daylight film was used because no artificial lighting was present. Because absence of direct sunlight causes bluishness, a decamired R-3 filter was used to provide warmth. The lens aperture of f/11 provided the necessary depth of field; this had to be taken into consideration when determining exposure time. A tripod was used to prevent camera motion.

EXPOSURE EXAMPLE: TWILIGHT PHOTOGRAPHY

Expo '74, a world's fair in Spokane, Washington, provided the setting for a different type of available-light photography. Figure C-37 was taken shortly after sundown when the buildings became silhouetted against the early evening sky. Four meter readings were obtained: horizon sky, middle sky, top sky, and silhouetted buildings. This was done to assure that the buildings and sky would not blend. Sky areas read from EVS four to EVS seven. No reading could be obtained of the black

Object	Step	Meter	Colors and Color Values of Objects	Step	Step		Description
Wh Baby Blu / Whit Lavend	2L	12½ 1/22 / (7)/3.5	Horizon Sky	2L		2L	Off-White Min Texture
Baby Blue / Lt Lavender	1½L	12 1/15 / 6½ f/2.8		1½L		1½L	White-Gray Adeq Text
Dk Baby Blu / Med Lavend	1L	11½ 1/12 / 6 f/2.5		1L		1L	Light Gray Consid Text
V Lt Bl Sky / Dk Lavender	½L	11 1/8 / 5½ f/2		½L		½L	Med Lt Gray Ext Texture
Lt Blue Sky / Lt Viv Pur	MV	10½ 1/6 / (5)/1.8	Middle of Format Sky	MV		MV	Middle Gray Max Texture
Med Blu Sky / Viv Purple	½D	10 1/4 / 4½ f/1.5		½D		½D	Med Dk Gray Ext Texture
Dk Blue Sky / Dk Viv Pur	1D	9½ 1/3 / (4)/1.2	Dark Sky at Top	1D		1D	Dark Gray Consid Text
V Dk Bl Sky / V Dk Purple	1½D	9 1/2 / 3½ f/1		1½D		1½D	V Dk Gray Adeq Text
Blk-Blu Sky / Blksh-Purpl	2D	8½ 3/4 / (3)	(Lowest Meter Reading)	2D		2D	Text Black Min Texture
	2½DB	8 1 sec / 2½		2½DB		2½DB	Pure Black No Texture
	3DB	7½ 1½ s. / 2	Estimated Black Value	3DB		3DB	Opaque Blk No Texture

silhouettes, indicating that the silhouettes were darker than EVS three, the lowest reading possible on the meter being used. The blueness of the dark top sky could be retained on Step 1D. This would result in at least a difference of two-f/stops between the sky and the silhouette, which would be darker than Step 3DB. With the sky on Step 1D, the horizon sky was on Step 1L. The values were envisioned by using the value-selector chart. The sky values encompassed a range from Step 2L to 1D.

No exposure meter readings were made of the streetlights. A cross-star filter accentuated these lights. Exposure determination must be done rapidly when photographing twilight because the light fades quickly. Camera settings were determined on the basis of the meter number EVS 5 on the Step MV line of the data form. The meter dial indicated six seconds at f/11. This was adjusted to nine seconds according to the CE time on the reciprocity failure correction chart, preventing underexposure. A tripod was used to hold the camera steady for the nine-second time exposure.

CREATIVE OVERLAY AND MONTAGE PHOTOGRAPHY

21

The creation of spectacular effects and special moods has often been accomplished by montage and overlay techniques, which involve the addition of another color slide, another type of film, or a piece of transparent material to the original slide. The additional film or material is taped into the slide mount with the original slide. The effect is that of making a sandwich with multiple slices of ham and cheese. The only limits to the number of film layers are when the slide becomes too thick to fit in the projector or too dark to be visible on the screen. If the montage is too thick for the projector, duplication is recommended. An overlay consists of one or more pieces of film or other transparent material, each of which has a uniform density. A montage consists of two or more films superimposed, each of which has a variety of values, colors, or both. A variety of replacement mounts is available at camera stores for making these "sandwiches."

Slides photographed for montages usually require more exposure than would otherwise be considered correct, because layers of slides result in a darker final picture. In the past the major difficulty with these techniques arose because no precise, simple, and practical procedures existed for determining exposure. The photographer had no choice but to estimate the amount of overexposure. The stair-step exposure system, however, permits accurate exposure of film for montages and overlays.

OVERLAY

An overlay modifies colors in the slide with which it is combined. The overlay may, therefore, be used to darken the photograph. For example, a piece of unexposed black-and-white film may be processed and combined with an overexposed slide to make it appear properly exposed. Positioning it so the color slide is on

21-1 Black-and-white version of color slide showing Castle geyser with overlay on the left portion of the picture.

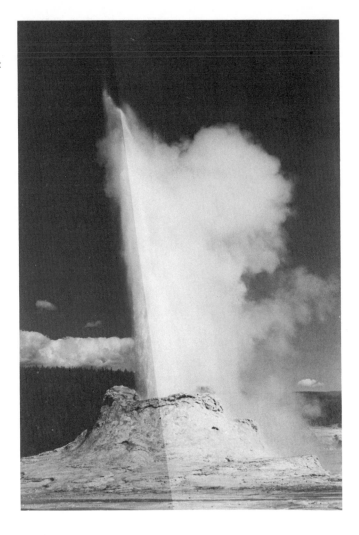

the side of the "sandwich" nearest the screen and the gray overlay nearest the projector bulb prevents unwanted diffusion of light caused by the overlay.

The stair-step system test exposures of the black, white, and gray cards discussed in chapter 2 may be used for overlay. For example, if a slide that has an average density of Step 1L is combined with a Step 2½LW frame exposed from the gray, black, or white cards, the overall lightness of the slide will be reduced to an average of Step MV. This is equivalent to exposing the picture one f/stop darker.

Using fine-grain black-and-white film that has been exposed out of focus for various shades of gray will produce a less expensive neutral-density overlay than color film will. Expose the film out of focus to assure that no unwanted texture from the cards will be present in the film to mar the final picture. By carefully exposing and developing the black-and-white film, you can obtain the desired stair-step values.

It should be obvious that overlay slides from gray-card transparencies or from black-and-white film add gray to the colors. In most slides the gray will not be objectionable. Exceptions are high-chroma yellow and high-chroma orange, which

will be degraded by the addition of gray because the overlay reduces both value and chroma.

Overlay slides may also be used to change colors. For example, Step 2L slides of blue sky or blue cards may be used to counteract a yellow or yellow orange cast. If the slides have a bluish cast because they were taken in deep shade, Step 1L, 1½L, or 2L photographs of out-of-focus orange or yellow orange poster paper will counteract the bluishness. Figure C-38 shows an example of this. Take pictures for this purpose and keep them cataloged in a slide file. Select complementary color overlays to counteract unwanted color casts. View the slide through the overlay to determine whether the desired effect has been achieved. Check to be sure that the overlay does not combine with any other colors in the slide to create an undesirable effect (for example, a blue overlay over a red object will produce purple). Save rejected overlay slides for later usage. An alternative to slides is theatrical gelatin filters, but only the pale ones are suitable.

MONTAGE

A montage consists of two or more films taped together in the slide mount. Each film in the group has a variety of values and/or colors, as compared to an overlay, which has a uniform density or color. For example, clouds, fog, sunsets, or a moon can be montaged with harbor scenes or windblown trees to create the effect of atmospheric conditions. The use of Kodalith, Diazochrome, 3M Color Key, and other materials are also common ways to make montages. It is possible to obtain opaque black silhouettes by montaging, especially when using Kodalith, Kodak Technical Pan Film (processed in Kodak D-19), and Kodak High Contrast Copy Film.

STAIR-STEP EXPOSURE SYSTEM OVERLAY AND MONTAGE DATA FORM

The stair-step exposure system form in figure 21-2 will assist you in making accurate exposures for both montages and overlays. It has three major columns, one for each of the two slides to be combined and a third column for the combined density effect of the two superimposed films. When a completed slide is to have more than two films bound together, tape as many forms side by side as is necessary to calculate the combined densities. Light levels for the *Meter* column and step assignments are obtained in the manner described throughout this book, except that most pictures will require more exposure than normal to compensate for the additional color density that results from sandwiching two slides. You will have to learn this process to some degree through trial and error, but you can file rejected slides for possible use at a later time in other montages. The *Step plus Step* column indicates the combined density of the superimposed values. It is essential to know the density in stair-step terms when slides are combined if the envisioned result is to be obtained.

OVERLAY AND MONTAGE CALCULATOR CHART

The calculator chart will help you plan exposures for overlay and montage. It enables you to determine the effect of superimposed steps in advance. Exposures lighter than Step 3LW have not been included because the darkening effect becomes imperceptible above that level. Step 3LW is the maximum practical transparency of the film for montage purposes. Read the chart like a distance table on a map. The numbers outside the heavy black lines are followed to the point where they intersect. For example, reading the Step 1D column vertically to the point

21-2 Stair-step exposure system data form for double exposures, overlays, and montages.

STAIR-STEP EXPOSURE SYSTEM DATA FORM
(for double exposures and montages)

Subject #1			Subject #2			
Place			Place			
Date			Date			
Film ASA			Film ASA			
Shutter Speed			Shutter Speed			
Lens f/stop			Lens f/stop			
Lens			Lens			
Filters			Filters			Step Plus Step
Meter	Step	Colors	Meter	Step	Colors	

Evaluation

	1D	½D	MV	½L	1L	1½L	2L	2½LW	3LW
3LW	1½D	1D	½D	MV	½L	1L	1½L	2L	2½LW
2½LW	2D	1½D	1D	½D	MV	½L	1L	1½L	
2L	2D	1½D	1D	½D	MV	½L	1L		
1½L	2½DB	2D	1½D	1D	½D	MV			
1L	2½DB	2D	1½D	1D	½D				
½L	2½DB	2D	1½D	1D					
MV	2½DB	2D	1½D						
½D	2½DB	2D							
1D	2½DB								

where it intersects with the horizontal row at Step ½D reveals that Step 1D + ½D = 2½DB. By tracing the horizontal MV row to the point it intersects with the vertical MV column, the chart reveals that Step MV + MV = 1½D. Combining two Step 2L values results in Step 1L. The chart contains more than fifty different combinations of montaged values.

The montage exposure calculator chart may also be used to determine the combined density of three or more films. First, determine the combined density of two values in the manner described. For example, Step 1L + Step 1L = Step ½D. If another Step 1L is added to this montage, the result will be Step 2D. In other words, Step 1L + 1L = ½D + 1L = 2D. The combined density of three Step 2L values is calculated in the following manner: Step 2L + 2L = 1L, then 1L + 2L = MV.

The data in the montage calculator was determined using the thirteen gray-card exposure frames described in chapter 2. First, various combinations of the thirteen frames were superimposed. Meter readings were obtained by transmitted light, and these readings were then compared to the transmitted-light readings of the thirteen single-value frames. This determined the nearest step in the exposure system. The information on the chart could have been provided in increments smaller than one-half f/stops, but this would have made the table too complicated and cumbersome to be useful. Rounding off to the nearest step resulted in seemingly illogical combinations, such as 1½L + ½D = 2D and also ½D + ½D = 2D. Seemingly illogical combinations would not be present if the data were broken down into tenths of f/stops, but camera settings cannot be made this precisely. Other examples of illogical combinations are apparent on the chart, but these are accurate when rounded off to the nearest one-half f/stop.

PHOTOGRAPHING THE MOON FOR MONTAGED LANDSCAPES AND WATERSCAPES

The moon can be montaged with selected slides to create a nighttime effect. The moon is photographed at dusk when the sky is very light blue and there is little contrast between the moon and the sky. The sky is exposed on steps ranging from 1D to 1½L, which automatically exposes the moon on steps ranging from 1L to 2½LW. These ranges provide enough variety in density to match the various densities of sky in the second film of the montage. The moon should be photographed with telephoto lenses as long as 800mm. By using exposure variations, combined with different sizes of moons because of the use of different telephoto lenses, and by positioning the moon in different locations on the film, an entire thirty-six-exposure roll of film can be used.

21-4 Black-and-white version of moon for montage.

21-5 Black-and-white version of Patrick's Point for montage.

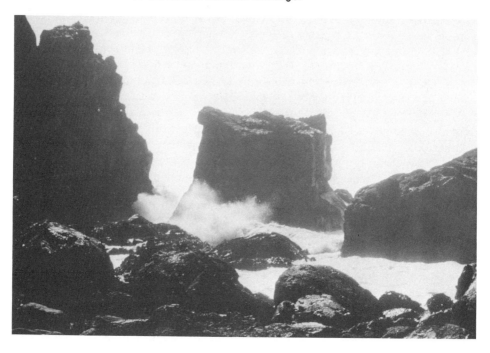

The sky in the second part of the montage should be exposed on any step from ½D to 2½LW. The use of the montage calculator will assist in determining expo-

sures. Montaged moon scenes that have a superimposed value of the moon on steps ranging from 1D to 1L will retain sufficient texture in the moon if the original moon was exposed on Step 2L or darker. The scene to be superimposed should be silhouetted, or nearly silhouetted, if the effect is to appear realistic.

PHOTOGRAPHING SILHOUETTES FOR MONTAGE AND OVERLAY

"Moon Over Patrick's Point" (fig. 21-6) is dark and moody, conveying what it was like to watch the surf on a night with a full moon. The moon was photographed with a 300mm telephoto lens and exposed on Step 2L against a Step 1L sky near

21-6 Black-and-white version of Patrick's Point and moon in montage.

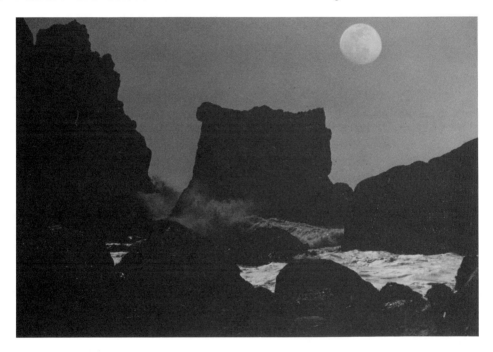

21-7 Montage data form excerpt for figure 21-6.

Subject #1 Surf			Subject #2 Moon			
Place California			Place Colorado			Step Plus Step
Meter	Step	Colors	Meter	Step	Colors	
	3LW	Surf		1L	Sky	½L
	2L	↑		2L	Moon	1L
	2L	Sky		1L	↑	MV
	1½L	↓		1L	/	½D
	MV	↑		1L	Sky	1½D
	½D	Rocks		1L	/	2D
	1D	↓		1L	↓	2½D

dusk. The surf picture's sky (fig. 21-5) was exposed on Step 2L; the shaded rocks on Steps MV, ½D, and 1D; and the surf on Step 3LW. When the two slides were combined, the superimposed skies were reduced to Steps MV and ½D. The blue sky in the moon picture was superimposed on the rocks, lowering them in value to a range encompassing Steps 1½D to 2½DB. The sky in the surf picture darkened the moon to Step 1½L. The black-and-white reproductions match the values in the original slide as closely as possible.

The Monument Valley silhouette (fig. 21-8) was photographed shortly before sunrise. Meter readings of the sky resulted in a range of values from Step ½D at the top to Step 3LW at the horizon. The silhouette is textureless black at Step 3DB or darker. The moon was photographed with a 300mm lens several months later at another location. The montage data form for the picture was completed with the multivalue Monument Valley scene in the left column and the single-value sky with the moon in the right column. The superimposed values represent readings of the same areas of each slide. By using the montage calculator chart, the results of both

21-8 Black-and-white version of Monument Valley.

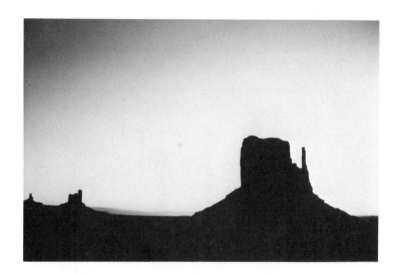

21-9 Black-and-white version of moon montaged with Monument Valley.

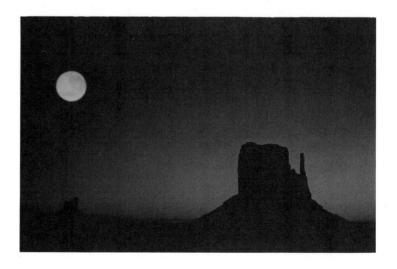

21-10 Montage data form excerpt for figure 21-9.

Subject #1 Monument Valley, Ariz.			Subject #2 Moon California			Step Plus Step
Lens			Lens			
Filters			Filters			
Meter	Step	Colors	Meter	Step	Colors	
	3LW ↑			½D ↑		1D
	2½LW			½D Sky		1½D
	2L			½D ↓		1½D
	2L	Sky		2L Moon		1L
	1½L			½D ↑		2D
	1L			½D		2D
	½L			½D Sky		2D
	MV			½D		2D
	½D ↓			½D		2D
	3DB Butte			½D ↓		3DB

exposures can be envisioned. The sky value in the montage ranges from blackish blue Step 2D to dark blue sky on Step 1D. The Step 2L moon montaged with an area of Step 2L sky resulted in a moon value of Step 1L.

PHOTOGRAPHING CLOUDS FOR MONTAGE

The same Monument Valley silhouette can be made into a totally different montage by using a cloud scene (fig. 21-2). An irregular line of very bright clouds and sun rays was exposed on Steps ranging from 3LW to 1D. The clouds can be montaged with the Monument Valley silhouette the way they were taken, or they can be reversed. Well-known scenes, such as Monument Valley, should not be reversed, however. The sky value in the Monument Valley picture (fig. 21-8) ranged from Step ½D at the top to Step 3LW at the horizon. Combined with the cloud scene (fig. 21-11), the sky and cloud values were reduced to a range from Step 1½L to 2D. The silhouettes are 3DB black or darker.

Notice the manner in which the values of the Monument Valley scene are written on the data form. The lightest values are at the top and become darker as the bottom of the form is approached. Compare this with the mixture of values for the cloud picture, which is in the center column. This mixture occurs because overlapping areas of each picture must align with each other to obtain the "*Step plus Step*" values in the montage. Note that the "*Step plus Step*" column is also a mixture of values.

21-11 Black-and-white version of clouds for montage.

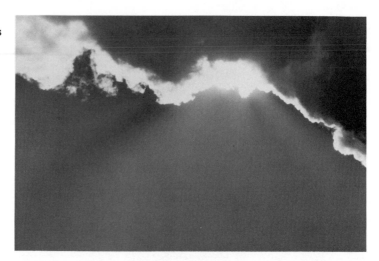

21-12 Black-and-white version of clouds montaged with Monument Valley silhouette.

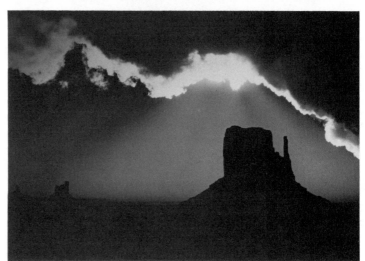

21-13 Montage data form excerpt for figure 21-12.

Subject #1 **Monument** Place **Valley, Ariz.**			Subject #2 **Clouds** Place **California**			
Date			Date			Step Plus
Meter	Step	Colors	Meter	Step	Colors	Step
	3LW	↑		1D	↑	1½D
	2½LW			MV	Clouds	½D
	2L			3LW	↓	1½L
	1½L	Sky		MV	Sky	1½D
	1L			½D	↑	2D
	MV			3LW	Clouds	½D
	½D	↓		3LW	↓	1D
	3DB	↑		½L	↑	3DB
	3DB	Butte		MV	Sky	3DB
	3DB	↓		½D	↓	3DB

112

PHOTOGRAPHING SUNSETS FOR MONTAGE

Take several pictures of sunset clouds that have potential for montage, varying the exposures. Each one can then be used for montage with other pictures. Ideal values for sunset montage range from Steps 1D to 3LW. The sunset in figure 21-14 for example, has a large center area and one corner exposed on Step 1L. Three corners are darker, with values ranging from Step 1D to ½D.

The Pioneer Woman statue (fig. 21-15) was photographed at Ponca City, Oklahoma, on an overcast afternoon. The anticipated sunset did not occur. The white sky was exposed on Step 3LW, permitting texture to show in the darkest area of the statue on Step ½D. Other parts of the statue ranged from Steps 1L to MV. This combination of values assured that a montage would be possible. The sunset cloud was illuminated from the left, as was the statue. The large center of the sunset provided an area into which the statue could be positioned. This also permitted the picture to have three dark corners, with the Pioneer Woman looking into the one light corner (fig. C-39). The combined values of the montage gave the statue values ranging from Steps ½D to 2½DB. The upper right and lower left corners are on Steps 1½D and 1D, preserving texture and hue. The light orange area in front of the statue is on Step ½L. The arrangement of clouds darkened all areas surrounding the statue, concentrating the viewer's attention on the outlines of the statue. Referring to the montage calculator chart enables the photographer to select values that will result in the envisioned montage.

21-14 Black-and-white version of sunset cloud.

21-15 Black-and-white version of pioneer woman statue.

21-16 Montage data form excerpt for figure C-39.

Subject #1 Sunset			Subject #2 Statue			Step Plus Step
Place Colorado			Place Oklahoma			
Meter	Step	Colors	Meter	Step	Colors	
	1L	Center		3L	White	½L
	1L	↓		1L	Statue	½D
	1L	Up. Left		3L	white	½L
	½L	↑		MV	Statue	1½D
	½L	Center		3L	white	MV
	MV			3L	↓	½D
	MV	↙		½D	Statue	2D
	½D	Up. Right		3L	↑	1D
	1D	Low. Left		3L	white	1½D
	1D	Low. Right		3L	↓	1½D
	1D	↙		½D	Statue	2½D

SUPERIMPOSING WHITE AND COLORS ON WHITE AND ALIGNING SHADOWS

"Cross-Country Skier" (fig. 21-19) is an example of the montage of two white snow scenes, each of which contains additional values and colors. The snow with the skier (fig. 21-17) was exposed on Step 3LW and the snow with the skis (fig. 21-18) on Step 1½L. These values combined to Step 1L, ideal for pictures in which snow fills more than 75 percent of the format. The Step ½D blue coat montaged with Step 1½L snow became Step 2D. Orange skis were changed from Step ½L to MV. The shadows

21-17 Black-and-white version of skier.

were nearly aligned. Lighting should appear to come from the same direction on the images in both frames to align the shadows. Close alignment of shadows is an important consideration when composing montages.

21-18 Black-and-white version of pair of skis in snow.

21-19 Black-and-white version of "Cross-Country Skier" montage.

21-20 Montage data form excerpt for figure 21-19.

Subject #1 *Skier*	Subject #2 *Skis*	Step Plus Step
Place *Colorado*	Place *Colorado*	
3LW Snow	1½L Snow	1L
3LW Snow	½L Skis	MV
½D Coat	1½L Snow	2D

USING DIFFUSED LIGHT TO ELIMINATE SHADOW ALIGNMENT PROBLEMS

Taking pictures for montages under diffused light eliminates the necessity to align shadows. Certain picture combinations may require that all parts of the montage be taken in diffused light. This is because if one part of the picture has pronounced shadows, all parts should have shadows. Both frames of the montage in figure 21-23 were photographed in diffused light. The large mass of sand surrounding the cowboy (fig. 21-21) was exposed on Step 1½L, lighter than for a picture not

21-21 Black-and-white version of cowboy for montage.

21-22 Black-and-white version of sand dune for montage.

planned for montage. The second part of the montage (fig. 21-22) contained a foreground of logs, a background of sand dunes, and a middle area of flat beige sand. The flat area was exposed on Step 1½L to create the proper montaged value when combined with figure 21-21. If it were not to be combined in a montage, this sand would be exposed on Step MV. The calculator chart indicates that two Step 1½L densities will become Step MV (1½L + 1½L = MV). The darker values of both slides provide accents in the montage and all appears to be correctly exposed.

21-23 Black-and-white version of cowboy and dunes montage.

21-24 Montage data form excerpt for figure 21-23.

Subject #1 Cowboy			Subject #2 Dunes			
Place Utah			Place Colorado			Step Plus Step
Meter	Step	Colors	Meter	Step	Colors	
	1½L ↑			1L ↑		½D
	1½L			½L ↑		1D
	1½L	Beige		MV	Shadows	1½D
	1½L	Sand		½D		2D
	1½L			1D ↓		2½D
	1½L ↓			1½L ↑		MV
	1L ↓			1½L ↑		½D
	½L ↑			1½L	Beige	1D
	MV	Shadows		1½L	Sand	1½D
	½D			1½L		2D
	1D ↓			1½L ↓		2½D

SUPERIMPOSING SEVERAL COLORS

"The Supreme Sacrifice" (fig. C-40) illustrates the superimposition of beige, yellow, red, white, blue, purple, and gold. The first frame of the montage (fig. 21-25) was photographed on the side of a Bank of America building in Redding, California.

21-25 Black-and-white version of "America" for montage.

21-26 Black-and-white version of telegram for montage.

The lighting on the building came from the upper right. The large mass of tan was ideal for montage and was exposed on Step 2L. The letters and the flag values were exposed accordingly. When a large area, such as this wall, is what the second slide will show through, this background slide must be exposed on Steps 2L, 2½LW, or 3LW. These exposures provide minimal density and detail, thus preventing the background slide from interfering with the slide to be montaged with it.

The telegram and purple heart were photographed when a friend was notified that his son had been killed in action (fig. 21-26). The purple heart was carefully positioned on the telegram to conceal the name. This emphasized the words "America . . . has asked me to express deep regret that your son died" The dominating word *America* covered the top part of the telegram. The flag helps tell the story.

The yellow telegram was exposed on Step 2L. The combined 2L + 2L, equaling 1L, was an appropriate value for the picture. The combination of the tan building and yellow telegram resulted in an appropriate blend of the two colors. The colors of the flag were retained despite superimposition of the Step 2L beige wall. Selective focusing reduced attention to words on the bottom line.

21-27 Montage data form excerpt for figure C-40.

Subject #1 Telegram			Subject #2 Bank Wall			
Place Colorado			Place California			Step Plus Step
Meter	Step	Colors	Meter	Step	Colors	Step
	2L	Yellow		2L	Beige	1L

PHOTOGRAPHING MULTIPLE EXPOSURES THE EASY WAY

<div style="text-align: right">**22**</div>

Multiple exposure is another way to create unusual photographic effects. Multiple exposure differs from montage in that two or more pictures are taken on one frame of film. Multiple exposure requires greater precision than montage: if one part of a montage is wrong, the montage may be taken apart and each film saved for new montage combinations; if any exposure in the multiple exposure is wrong, the picture is usually ruined and must be discarded. Time, planning, and careful selection of each exposure are therefore essential. Because making multiple exposures involves exposing the film to light more than once, the picture becomes progressively lighter with each new exposure. This is different than montage, in which successive layers increase the density of the final picture. Thus, a major advantage of multiple exposure over montage is the ability to add images in the dark or unexposed areas of the film—for example, repeated exposures of fireworks in a black sky. Additional images must be added in the lighter areas of a montage, as was illustrated in chapter 21.

If properly done, multiple exposures and montages have equal impact on an audience. Moon scenes, for example, can be done by montage, as previously detailed, or by double exposure. Using double exposure, a night scene of lights on a bridge framing the lights of a city skyline may be photographed at dusk when the sky is exposed on Step 1D or 1½D if the black outline of the bridge and buildings is to be visible against the sky. If you do not want the black bridge and buildings to show, use Step 2D or darker for the sky. The moon can be double-exposed into the sky later by photographing only the moon from a black sky. A telephoto lens will enlarge the moon, enhancing the resulting picture. The moon must be carefully positioned in the photograph to prevent overlap with any other objects in the scene. The black sky surrounding the moon in the second exposure will not change the original exposure.

Any 35mm camera can be used to make films for montage, but to make multiple exposures, the camera must be mechanically capable of double exposure. Double or multiple exposures must be photographed in sequence without advancing the film. This makes it desirable to have another camera body available so that you may take other pictures while waiting for the opportunity to complete the multiple exposure.

In the past, photographers have had to guess at how much to reduce exposure when making multiple exposures because there has been no accurate or practical information about what happened to areas of film that received additional amounts of light from the second or third exposure on the same frame. A common practice was to reduce the exposure by one f/stop for each part of a double exposure. Photographers were frequently disappointed when this was not satisfactory. The stair-step exposure system provides accurate and practical information about multiple exposures on one frame of film. The multiple-exposure calculator, combined with the value-selector chart, determines the correct exposure to produce the envisioned picture. Taking double exposures is very easy on some cameras, complicated on others, and impossible with still others. Consult the camera manual or your camera dealer to learn if you can do it and how it is done. Otherwise, the only limitations are your creativity and the amount of time you want to spend.

There are three alternatives when making double exposures:

1. No reduction of exposure from normal in either part of the double exposure.
2. No reduction of exposure from normal in one part of the picture. The other part receives less exposure.
3. Both exposures must be less than normal. The same three alternatives apply to making double exposures by slide duplication.

THE MULTIPLE-EXPOSURE CALCULATOR CHART

The multiple-exposure calculator chart (fig. 22-1) is read in the same manner as the montage chart. The numbers outside the heavy black lines indicate stair-step combinations that, when exposed together, produce the steps or values at the intersection of those columns and rows inside the heavy black lines. The chart contains approximately forty-five different combinations. Choose the step on which important masses are to be reproduced, then select the combinations of steps at which each of the subjects must be exposed. Next, select the camera settings that will

22-1 Stair-step system multiple-exposure calculator chart.

	2D	1½D	1D	½D	MV	½L	1L	1½L
2L 1½L	2½LW 2L	2½LW 2L	2½LW 2L	2½LW 2L	2½LW 2L	2½LW 2L	2½LW 2L	3LW 2½LW
1L ½L	1½L 1L	1½L 1L	1½L 1L	1½L 1L	1½L 1½L	1½L 1½L	1½L	
MV ½D	½L MV	½L ½L	½L ½L	½L ½L	1L			
1D 1½D	½D 1D	MV ½D	½L					
2D 2½DB	1½D 2D							

achieve the envisioned picture. Double exposures are calculated in the following manner: Step 2D + MV = ½L. Notice that the combination results in a lighter value than either of the individual values. This is the reverse of montaging, in which the combination results in a darker value. Multiple exposures can also be calculated from the chart; for example, a triple exposure of Step 2D equals Step 1D: 2D + 2D = 1½D, then 1½D + 2D = 1D.

How the Multiple-Exposure Calculator Chart Was Devised

A series of double exposures was made using the gray card as the subject. For example, one exposure of the gray card was on Step 2D, then a second exposure on the same frame was Step 1D, completing the exposed frame. Then the film was advanced to the next frame, which was exposed at Step 1D, then re-exposed at Step 1D, completing another double-exposed frame. This process continued until all of the stair-step combinations had been photographed. When the rolls of film were returned from the processor, each frame was compared to the frames of the thirteen-step transparency scale described in chapter 2. The calculator chart was made from an analysis of that data. The results were rounded off to the nearest step to make the chart easy to use and to fit within the terminology of the stair-step exposure system. Smaller increments of f/stops could have been provided but would have made the chart more difficult to use without significantly improving the photographic results.

STAIR-STEP EXPOSURE SYSTEM DOUBLE-EXPOSURE DATA FORM

The same special data form used for montage exposures (fig. 21-2) will help you calculate the effect of double exposures. The form is used in combination with the multiple-exposure calculator and the value-selector chart. The values for the first exposure are written on the form just as they are on the other stair-step forms, with lightest values at the top. Occasionally the same step is entered more than once because of overlapping values in the second picture.

EXPOSURE EXAMPLES: DOUBLE EXPOSURES USING A BLACK BACKGROUND

Black areas of film are unexposed. In the following example, the black shadows of night leave large areas of unexposed film in which multiple images can be positioned. A single freeway was photographed at night with overlapping images of several exposures. The effect becomes that of a bustling city, rather than a single curve on a freeway. Figure 22-2 shows the Mission Valley freeway in San Diego, California, photographed from a nearby hill. Seven different focal-length lenses were used to photograph the freeway curve. The freeway was positioned in a different place in the format for each lens. Each exposure was calculated as if it were the only exposure because of the large masses of unexposed black. Superimposed lights were allowed to add light to themselves. The original scene looks like the upper left corner of the picture, in which there is a single curve of the freeway. The data form for multiple exposures is not used in this type of picture because overlapping exposures are limited to very small areas of white light.

The picture of the Cox Jewelers sign combined with the gears of an old alarm clock (fig. C-41) is an example of two related objects double-exposed onto different areas of the same frame of film. A sketch was made of the format to indicate the area filled by the sign. The clock gears were exposed on the area that remained unexposed after the jewelry store sign was photographed. The clock

22-2 Multiple exposure with black background shown in black-and-white version of San Diego Freeway.

gears were photographed using two slide projectors for spotlights; a red filter placed on the lens of one, a yellow filter on the lens of the other. The camera was on a tripod so that f/22 could be used to obtain maximum depth of field. Stair-step exposure system techniques were employed with both parts of the picture to obtain correct colors. Meter readings were taken of the red, yellow, and shaded red areas of the old clock, using a spot meter. Yellow was aligned with Steps 1½L and 2L, with some areas of yellow on Special Step 1¾LY. Red in direct light was exposed on Step MV and shaded red on Step 1D. A time-exposure shutter speed was selected because of minimum available light and the small f/22 aperture. Underexposure was avoided by increasing the length of the shutter speed according to the reciprocity failure correction chart.

EXPOSURE EXAMPLES: WHITE DOUBLE-EXPOSED ON COLORS

"Springtime in the Rockies" (fig. C-42) combines the white seedball of a dandelion superimposed against a very dark blue sky with a mountain scene in southwestern Colorado picturing a large field of yellow wildflowers. We chose a composition with a mass of blue sky in the upper right corner. Polarization, darkened the sky to Step 1½D, providing a dramatic contrast with the white seedball. After the scenic was photographed, the camera was adjusted for double exposure, then placed on a tripod. A textureless black card was held behind the white seedball. It was moved and tilted until it cast a shadow on itself but not on the seedball. The shaded black card assured an extremely black background of unexposed film. If sunlight were permitted to strike the black card, the background might not be black

22-3 Double-exposure data form excerpt for figure C-42.

Subject #1 Landscape Place S.W. Colorado			Subject #2 Seed Ball Place S.W. Colorado			Step Plus Step
Meter	Step	Colors	Meter	Step	Colors	
	2L	Clouds		3DB	↑	2L
	1½L	↓		3DB		1½L
	1L	↑		3DB		1L
	½L			3DB	Black	½L
	MV	Misc		3DB		MV
	½D			3DB		½D
	1D	↓		3DB	↓	1D
	1½D	Sky		1½L	↑	2L
	2D	Green		1½L	White	2L
	2½D	Shadows		1½L	↓	2L
	1½D	Sky		3DB	↑	1½D
	2D	Green		3DB	Black	2D
	2½D	Shadows		3DB	↓	2½D

enough and texture and specks of dust from the card might show in the final picture. The sunlit seedball was then exposed on the same frame as the scenic. Exposure was on Step 1½L, which, when double-exposed on the Step 1½D blue sky, lightened the seedball to Step 2L.

EXPOSURE EXAMPLE: COLORS DOUBLE-EXPOSED ON OTHER COLORS

A more complicated example of double exposure with overlapping areas of light and dark values is illustrated by an abandoned cabin at the ghost town of Capitol City, located high in the Colorado Rockies (fig. C-43). Yellow flowers were double-exposed onto black, beige, dark brown, and green, increasing the complexity of the exposure problem. This overlap required different reductions of the exposure for both pictures. The double-exposure calculator and value-selector chart were used to obtain the best compromise. The cabin was photographed with one-half f/stop less exposure than normal because exposure of the yellow flowers on appropriate values could not be achieved without darkening the cabin by one-half f/stop. Meter readings were taken of the cabin and the flowers before making this decision. The tan roof had to be darkened to retain yellow in the flowers to be exposed on the roof. The combination of a Step MV roof and Step ½L yellow flower resulted in a final flower value of Step 1½L, a correct value for yellow.

The group of flowers was photographed against a shaded black card as described in the previous example. The yellow flowers were exposed on Step ½L, one f/stop darker than normal. It was planned that the additional light from the cabin would raise their value to Steps 1L and 1½L. Reducing the exposure of the flowers, rather than the exposure of the cabin, was preferable because the flowers

22-4 Double-exposure data form excerpt for figure C-43.

Subject #1 Cabin			Subject #2 Flowers			Step Plus Step
Meter	Step	Colors	Meter	Step	Colors	
	MV	Tan		½L	Yellow	1½L
	MV	Roof		3DB	Black	MV
	½D	Brown		½L	Yellow	1L
	⅓D	Logs		3DB	Black	½D
	1D	Green		½L	Yellow	1L
	1D			3DB	Black	1D
	1½D	Cabin		3DB		1½D
	2D	Front		3DB		2D
	2½D	Shadows		3DB		2½D

made up a small portion of the format, whereas the cabin scene encompassed the entire format. If the cabin had received one f/stop less light and the flowers one-half f/stop less light, the final effect would have been underexposure. The reduction of exposure in the scene that comprises a major proportion of the format should be less than that of the element that occupies a smaller proportion of the format.

Note the manner in which the double-exposure form (fig. 22-4) is completed. The first exposure proceeds down the form from light to dark, although two lines must be given to each of several objects because they overlap both flowers and shadow. Information for the second exposure is entered on lines that correspond to objects from the first exposure that are superimposed. This results in a mixture of values in the second and third columns. Three colors plus black are overlapped in this example. Each of these areas is included in the *Step plus Step* column to indicate the final result of the double exposure of colors, as well as the exposure of colors on black. The multiple-exposure form is not positioned on top of the value-selector chart during this process because of the mixture of steps. The step codes are compared to the descriptions on the chart.

Photographing Multiple Exposures the Easy Way | 125

TITLE PICTURES
FOR PROGRAMS

An unending list of groups desire programs of educational, inspirational, and recreational value, including churches, service clubs, schools, universities, lodges, art associations, camera clubs, and charitable organizations. Camera club councils, organizations that combine several camera clubs in a geographic area, sponsor conventions at which a variety of programs are presented. The Photographic Society of America, a worldwide organization of camera clubs, amateur photographers, and professional photographers, sponsors several regional conventions in the United States each year, in addition to its annual international convention. Well-prepared programs with high-quality pictures and informative commentary are appreciated by all of these organizations. The addition of appropriate music adds a dimension that cannot be achieved in any other way. Title slides provide the finishing touch for these types of presentations.

Montage, double-exposure, and duplication techniques (chapters 21, 22, and 25) may be used to make title pictures for programs. The procedures require using color slide film, or combining black-and-white film with color slides. High-contrast films can be used to make black titles to be montaged with color slides. Color slide titles can be made with white letters using double-exposure techniques. Photographs of black letters against a white background can be montaged with the color slide. Black, white, and colored letters that stick to any surface are sold at stationery stores. Photographers skilled at lettering can make their own titles on white paper. Three-dimensional movie titling sets are available at camera stores. The letters must be large enough to be easily and quickly read by the audience. They should not be proportionately smaller than the examples in this chapter.

BLACK LETTERS FOR COLOR SLIDES

Black letters may be montaged on white or very light colored areas in slides. The title slide "Rick Hypes Presents Trails and Pathways of the West" (fig. C-44)

illustrates the use of black letters montaged over two light-colored areas of a picture. The sky reflected in the water had to be light enough to prevent the letters from blending with the blue water. The letter, word, and phrase layout were carefully planned to fit within the allotted spaces in the slide. The letters were photographed against textureless white paper. The color slide film was then montaged with the color slide scenic film to complete the title slide.

The title slide "Colorado—Where Nature Splashed Her Paints" (fig. 23-1), illustrates positioning of the title in a white area. Using a photographic enlarger or slide projector to focus the slide on a five-by-eight-inch textureless white card will help in positioning the letters precisely. The image is projected on the card, and quarter-inch pressure-sensitive, black vinyl letters are positioned within the allotted picture area. If larger cards are used, proportionately larger letters must also be used if the letters are to be legible in the final result. The letters are then photographed on color slide film. The white paper background is exposed on Steps 2L, 2½LW, or 3LW to permit the superimposed title to show through the title picture.

Another method of making montaged black titles is to photograph white letters against a solid black background, using high-contrast film. These films will reverse the values. The white letters must be attached to textureless black paper or textureless matte board. High-contrast films have a totally clear film base, permitting the colored slide to show through the film without reducing its values. Ordinary black-and-white film has a gray dye in the film base, which will darken the slide. The film base of color slide film is not as clear as high-contrast films. When using Kodak High Contrast Copy Film for this purpose, reduce the ASA by one-half, double the length of development time, and bracket exposures with five exposures in one-half f/stop increments. The increased exposure and development increases the con-

23-1 Black title on white background shown in this black-and-white version of "Colorado—Where Nature Splashed Her Paints."

trast and enhances the result. Follow the exposure and development instructions when using Kodak Technical Pan Film developed in Kodak D-19 high-contrast developer. Kodalith must be exposed and developed without modification of instructions. When making titles with all of these films, bracket the ASA with five exposures in one-half f/stop increments, develop the five exposures, select the best, and finish the remainder of the titles with one exposure of each card using the best of the bracketed exposures.

WHITE LETTERS ON COLOR SLIDES

White letters can be photographed on color slides in several ways. The easiest is to put white letters on a color print made from one of your slides, then copy the picture on slide film. Expose the film according to stair-step principles. One-fourth-inch letters on a five-by-eight-inch print will produce easily readable titles. Colored letters may also be used.

White letters can also be added to color slides with double-exposure and duplication techniques. First, choose a slide in which the white titles will fit against a dark background, preferably a single-value or single-color area. Never overlap white letters against a light or white background because the letters will merge into the background. In the title slide "Text Compiled by George and Carol Hypes" (fig. C-45), the white letters stand out against the Step 2½DB black shadows and ½D and 1D red rock.

White letters can be obtained in two ways. Clear letters on high-contrast film can be double-exposed onto color slide film that contains the picture. The letters are exposed on Special Step 3LW or lighter to show completely through the picture's colors. The opaque black of Kodalith and the nearly opaque black of Kodak Technical Pan Film prevent other areas of the color slide from receiving any exposure. If Kodak High Contrast Copy Film is used in this way, it is necessary to use two layers in order to obtain the opaque background. Kodalith has the disadvantage of containing pinholes that must be covered with a solution of Kodak Opaque Black. This work must be done with an extremely small brush.

The second way to obtain white letters is to double-expose white letters that have been attached to a textureless black background. Most construction paper is not suitable for this purpose because it has texture and is dark gray rather than black. Untextured black matte board is best for this purpose. The white letters should be exposed so that the *Step plus Step* result will be Step 1½L or lighter. Consult the multiple-exposure chart to determine the correct exposure.

A variation of this method is to attach the white letters to a piece of glass. The glass is positioned over a box painted black on the inside. The black paint, combined with side lighting of the letters, will prevent the background of the letters from receiving any illumination. This technique is superior to using black paper because it assures that no texture from the black background is visible in the slide. The white letters should be exposed on Special Steps 3LW or 4LW to make them stand out dramatically from the dark colors in the slide. Be certain the glass is clean and free from lint. Lint will appear as white dots in the final picture. Figure C-45 was photographed by duplication and double-exposure, using white letters on glass.

When on location in the field, scenes may be selected for title slides. The scene is photographed, then the titles are arranged and double-exposed on the scene. This procedure avoids the problems of slide duplication. The double-exposure calculator chart may be used to obtain the correct exposure. The black box will permit exposure on Special Steps 3LW or 4LW, resulting in the best quality.

SLIDE EVALUATION PROCEDURES

Transmitted-light and reflected-light evaluation procedures have been developed to analyze those slides you photographed before adopting the stair-step exposure system. These two procedures will help you evaluate whether your pictures have been correctly or incorrectly exposed. By understanding exposure errors made in the past and by understanding why certain pictures were correctly exposed, you will be able to improve the quality of your photographs. If photographic projects can be repeated, what you learn from your evaluation will help you prevent repetition of errors and will help assure repetition of success. The transmitted-light and reflected-light procedures are equally effective, but the reflected-light procedure is easier to use.

STAIR-STEP EXPOSURE SYSTEM EVALUATION DATA FORM

A data form similar in layout to the other stair-step exposure system forms will assist you in evaluating colors in slides (fig. 24-1). A standardization procedure requires that the light source and its distance from the slide or from the screen be stated. Whenever slides are evaluated, this distance must remain the same. There is a column for stair-steps, including Special Steps 3LW and 3DB. These two steps are on the form because overexposed and underexposed slides will be evaluated. Step 3LW is the maximum practical transparency of the film and Step 3DB is the maximum practical blackness. When slides are viewed by intense transmitted light in this type of evaluation, texture and hue that is not apparent when projected normally on a screen may be visible. Texture and hue may also be visible in the reflected-light evaluation process because of the closeness of the projector to the reflecting surface.

EVALUATION BY TRANSMITTED LIGHT

The thirteen gray-card slides described in chapter 2 are used in the standardization procedure. A piece of opal glass is secured in a freestanding frame in

STAIR-STEP EXPOSURE SYSTEM DATA FORM
(Slide Evaluation)

Place

Date

Subject

Film

ASA

Light Source for Evaluation

Bulb-to-Film Distance

Slide-to-Posterboard Distance

Frame Size on Projection Screen

Type of Screen Surface

Miscellaneous

Step	Meter	Colors and Color Values of Objects
3LW		
$2\frac{1}{2}$LW		
2L		
$1\frac{1}{2}$L		
1L		
$\frac{1}{2}$L		
MV		
$\frac{1}{2}$D		
1D		
$1\frac{1}{2}$D		
2D		
$2\frac{1}{2}$DB		
3DB		

Evaluation

24-2 Slide evaluation equipment setup.

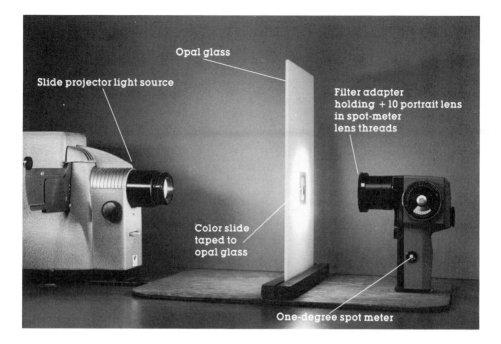

Opal glass

Slide projector light source

Filter adapter
holding +10 portrait lens
in spot-meter
lens threads

Color slide
taped to
opal glass

One-degree spot meter

front of the slide projector. Position the slide projector to throw its beam of light into a circle about three inches in diameter on the opal glass; the projector bulb will be about twelve inches from the opal glass. The color slide should be fully and evenly illuminated. A slide projector is used for this purpose because it throws a very strong, narrow beam of light. The projector fan dissipates the heat produced by the light, preventing the opal glass from breaking.

Turn off the room lights to prevent unwanted light from influencing the meter readings. Tape the Step 3DB slide to the opal glass and obtain a meter reading using a spot meter equipped with a +10 portrait lens. Attach the +10 portrait lens to the meter with a filter adapter and retaining ring. This enables the meter lens to focus on a circle one-eighth inch in diameter. If this technique is attempted without focusing the spot-meter lens on the slide, the results will be erratic and useless because single-value colors must be read. If no reading on the Step 3DB slide can be obtained because the slide is too dark, move the projector closer to the opal glass until a reading is possible. Obtain readings of each of the other twelve gray-card slides. Enter these readings in the *Meter* column for the step each slide represents. These readings will not be consistently one-half f/stop apart as might be expected; do not be concerned about these variations. Enter the standardization information on the evaluation form for each slide. Enter the light source and the bulb-to-film distance on the data form.

Tape the slide to be evaluated on the opal glass. Illuminate it with the projector light from the same distance as in the standardization procedure. Take meter readings with the spot meter and the +10 lens of major single-value colors. Write these colors or descriptions of the objects on the line appropriate to their meter reading. For example, an object that receives the same meter reading as the Step

STAIR–STEP EXPOSURE SYSTEM DATA FORM
(Slide Evaluation)

Place **Bodie, California**

Date **October, 1967**

Subject **Main Street of Ghost Town**

Film

ASA

Light Source for Evaluation **500 Watt Slide Projector**

Bulb-to-Film Distance **18"**

Slide-to-Posterboard Distance

Frame Size on Projection Screen **Four feet by Six Feet**

Type of Screen Surface **Glass Beaded Screen**

Miscellaneous

Step	Meter	Colors and Color Values of Objects
3LW		
2½LW		
2L		
1½L		
1L	11½	"White" Building
½L	10¾	Bricks in Sun
MV	10	Clouds, Tin Roof
½D	9¼	Clouds, Brown Road
1D	8	Sky in Middle of Format
1½D	7¼	Bricks in Shade, Mountain
2D	6½	Shaded Red Bricks
2½DB	6	Sky at Top of Format
3DB		

Evaluation **Total Picture is too dark, including sky. Evaluation indicates one f/stop lighter would have made sky blue rather than black.**

MV slide will be written on the Step MV line. A color that gives the same reading as the Step 2L slide is to be written on the Step 2L line. Repeat this procedure for all significant colors in the slide. By comparing the results with the steps, you can spot errors and correct them the next time you photograph a similar scene.

EVALUATION BY REFLECTED LIGHT

In this procedure standardization slides and slides to be evaluated will be projected on white poster board or on a projection screen. The projector-to-reflected-surface distance is determined by the distance required to obtain a reading of the Step 3DB slide. Write this distance on the form. Take meter readings of all thirteen test slides from the same distance and enter each reading on the form. These standardization readings must be entered on each form for each slide to be evaluated. The metering distance must remain the same because light intensity varies with distance. Project the slide to be evaluated. The projector must be the same distance from the reflecting surface as it was for the standardization procedure. Take spot-meter readings of major single-value colors within the picture. The portrait lens is not necessary because the image produced by reflected light is much larger than that produced by transmitted light. Write the colors on lines appropriate to their value step. For example, a color that provides the same reading as Step 1D gray will be entered on Step 1D. Figure 24-3 shows a sample exposure data form filled in as we recommend.

EVALUATING SLIDES PROJECTED ON THE SCREEN

Place the slide to be evaluated in the projector and project it on the screen. The projector and screen should be those you regularly use. The size of the slide on the screen must be the size that is usually projected. Use of different equipment and projection of a different size will alter the results of the evaluation. When the slide is projected, make notes of your visual observations on the bottom of the form. No meter is used. Indicate which colors are overexposed, desaturated, underexposed, saturated, and correctly exposed.

ANALYZING THE RESULTS

Comparisons between the screen evaluation and the transmitted-light evaluations or the reflected-light evaluations can now be made. Write down these comparisons. Make recommendations on how to improve the slide if it were to be taken again. Note how exposure of colors would be modified. Position the value-selector chart under the evaluation form and decide upon improved exposure of various colors. If all colors and objects except sky were correctly reproduced, the recommendation might include using a polarizer to darken the sky or not using it to obtain a lighter blue sky. If shadows do not show sufficient texture, increased exposure would correct this. If shadows are too light, they would be darkened by less exposure.

COLOR SLIDE DUPLICATION **25**

Making high-quality duplicate slides is a technical, complex, time-consuming process. It is not an activity for the impatient or casual photographer. This chapter describes in detail the techniques, materials, equipment, and procedures required for precision stair-step exposure and color correction that will produce excellent duplicates.

There are many advantages for the photographer who can duplicate color slides. Overexposure and underexposure can be precisely corrected by duplication. Color casts can be removed, introduced, or intensified by duplication. Creative slides can be made Montages can be duplicated, then disassembled and reused for other montages. Horizontal or vertical sections of slides can be changed to full-frame transparencies. Areas of slides can be darkened or lightened. Black-and-white negatives can be made from color slides by the techniques that follow.

If sharp focusing is a requirement in the duplicate the original slide must be sharply focused and show no evidence of camera motion. Poor definition of lines in the original will increase in the duplicate slide. This problem is compounded when sections of slides are enlarged. Color slide duplicating film is recommended because contrast will not be increased as it would be with ordinary films. Increased contrast causes loss of texture in shadows and highlights and complicates accurate exposure determination. Ordinary slide film is suitable for duplication with extremely low contrast slides.

EQUIPMENT AND SUPPLIES FOR COLOR SLIDE DUPLICATION

Color Correction Filters

Economical color correction (CC) filters may be purchased in different sizes at photography stores. Color printing (CP) filters can also be used. These filters are

not used in the conventional way on the camera lens because they are not optically perfect; photographing through them will introduce unwanted distortion into the duplicate slide. These filters instead will change the color of the light source by being positioned between the light source and the slide to be copied.

The filter sets include three primary colors: yellow, cyan, and magenta. All hues can be made with these three colors. They are combined to make three filter combination grids: cyan-yellow, yellow-magenta, and magenta-cyan. The filters are graded according to density or depth of color and range from CC 05 or less to CC 50 or more for each color. CC 05 is very light. Typical sets contain six filters for each of the three colors, graded as follows: CC 05, CC 10, CC 20, CC 30, CC 40, and CC 50. Any combination in CC 05 increments up to CC 155 can be produced in each color by superimposing the filters. For example, to get CC 95 yellow, the CC 50, CC 40, and CC 05 yellow filters would be superimposed. The standard procedure is to use one or two colors for color correction. The addition of a third color causes a neutral-density effect, reducing the amount of light available for duplication. A Wratten 2B filter is used with duplicating film to absorb ultraviolet light. This filter, or its equivalent, is included in most color printing filter sets. Unfortunately, the polaroid filter cannot be used to darken skies in duplicate slides. The only use of the polarizer in duplication is as a neutral-density filter.

Slide Projector for Light Source

We recommend using a 300-watt or a 500-watt slide projector as the duplication light source for several reasons. It is a highly efficient light source that projects a concentrated beam of light brighter than any other photographic bulb with the exception of some electronic flash units. Minimal filtration is required because it is approximately color balanced at 3200° K (Kelvin), the same as duplicating film. (Kelvin ratings are a method of measuring the color temperature of heated objects, in this case, lights used in photography, and their relationship to films.) Slide projectors dissipate bulb heat with their fans. The most important reason for recommending the slide projector is that meter readings that assure precision exposure according to stair-step principles can be obtained.

Camera, Bellows, Lens, and Meter for Duplication

We recommend that a single-lens reflex camera be equipped with a bellows that will permit focusing on an area as small as eight millimeters by twelve millimeters. This will allow you to crop slides. The camera's 50mm lens can be used on the bellows. Although most 50mm camera lenses are curved-field lenses, the use of f/8, f/11, and smaller apertures will assure corner-to-corner sharpness. The camera lens focusing ring should always be set at infinity for duplication to help minimize problems associated with curved-field lenses. If you have a flat-field lens, such as an enlarging lens, we recommend that you use it. An enlarging lens can be easily adapted to the focusing bellows by mounting it on a metal body cap. Hire a machinist to cut the proper-size hole precisely in the middle of the body cap. This unit then mounts on the front of the bellows like a camera lens.

A one-degree spot meter equipped with a +10 portrait lens will take close-up meter readings of one-eighth-inch circles of the original slide in the duplicator. This technique is the same as that described in chapter 24. The meter will be held close to the slide as shown in figure 24-2.

The camera must either be attached to the duplicator or mounted on a

tripod. We recommend attaching it to the duplicator for precision alignment because composition is critical to less than one millimeter. Time exposures will be required.

The Slide Duplicator

A slide duplicator you purchase or one you make can be used with a single-lens reflex camera. It must be capable of using a slide projector for a light source. The annotated bibliography in the back of this book contains an extensive reading list for homemade duplicating equipment. We designed and built a plywood box to duplicate slides. The inside of the box is painted glossy white. The slide projector is positioned on a shelf inside the open back of the box. Both sides of the box have holes that permit access to the filter holder. These holes also allow the insertion of small cardboards to darken or lighten areas of the slide.

The front board of the box has a three-inch-diameter hole through which light reaches the slide to be duplicated. Opal glass is secured to the back of this board, covering the hole. Opal glass is the finest diffuser for this purpose because it produces a brilliant white background against which the slide is photographed. One inch should be left between the opal glass and the slide to be copied to assure that no texture from the glass will be reproduced in the slide. A manual changer from a slide projector is attached to the front of the box in a position that permits light to come through the opal glass and the hole. Any grooved device that permits the slide to be moved horizontally is satisfactory. Filters are positioned in a slot next to the opal glass on the projector side of the glass.

25-1 Slide duplication setup (two views).

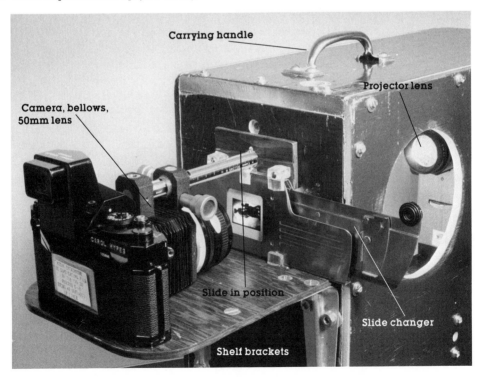

Carrying handle

Projector lens

Camera, bellows, 50mm lens

Slide in position

Slide changer

Shelf brackets

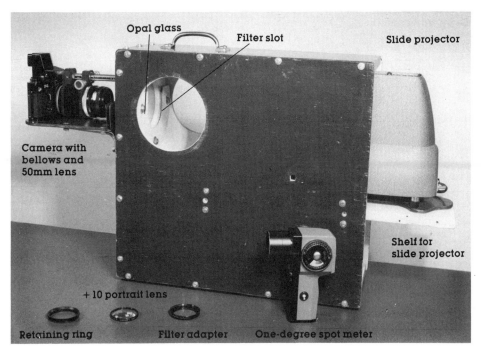

Opal glass — Filter slot — Slide projector — Camera with bellows and 50mm lens — Shelf for slide projector — + 10 portrait lens — Retaining ring — Filter adapter — One-degree spot meter

A shelf is bolted to the front of the box with shelf brackets. This shelf was positioned with a carpenter's square at a ninety-degree angle to the front of the box. The angle was adjusted precisely with washers between the board and the brackets because the brackets were not exactly square. This angle must be exact to assure that the slide to be copied and the film in the camera are parallel for critical focus and precise alignment of picture sides.

The camera and bellows are attached to this board with a one-fourth-inch wing nut and a washer. The camera slides smoothly back and forth on the board because the bolt moves in a slot in the board. A focusing rail on the bellows would accomplish the same purpose. Focusing is accomplished by moving the camera and bellows as a unit. Reproduction size is determined by bellows extension. Camera position and bellows extension work together to achieve precise focusing at the desired reproduction size. When the focusing and composing are completed, the wing nut is tightened to hold the camera in position.

The camera is always used horizontally in this duplicator. Slides are positioned sideways to make vertical pictures. Putting the slides in the changer right side up, upside down, or sideways achieves the desired cropped composition.

Rubber feet are attached to the bottom of the box to protect furniture and stabilize the unit. A carrying handle completes the duplicator.

Stair-step Exposure System Slide-Duplicating Form

A form has been designed to use the stair-step system when duplicating slides (fig. 25-3). The information entered on this form will guide you in assigning correct color values. There are spaces to write location and subject of the original picture, the name of the film, ASA, and the filter modification for that emulsion. There is a space to enter the basic filter pack for the combination of light source and film

25-3 **Stair-step exposure system data form for duplicating color slides.**

STAIR-STEP EXPOSURE SYSTEM DATA FORM FOR DUPLICATING COLOR SLIDES

Place		Frame Number			
		Light to Film Distance			
Subject		Correction Filter			
Date		Correction Filter			
Film		Correction Filter			
Emulsion Correction		Bellows Extension			
ASA Film Speed		Effective ASA Film Speed			
Light Source		Shutter Speed			
Basic Filter Pack		f/Stop Setting			

Gray-Scale Steps	Meter	Colors and Color Values	Step	Step	Step
3LW					
$2\frac{1}{2}$LW					
2L					
$1\frac{1}{2}$L					
1L					
$\frac{1}{2}$L					
MV					
$\frac{1}{2}$D					
1D					
$1\frac{1}{2}$D					
2D					
$2\frac{1}{2}$DB					
3DB					

Evaluation of Filtration

Evaluation of Exposure

being used. In the three vertical columns on the right side of the form, enter the color correction filters actually used to take the picture. This filtration may or may not be the same as the basic filter pack. For maximum exposure accuracy, readings should be taken with the filters in position in the duplicator. The three columns permit three variations of filtration to be written on the form.

Bellows extension influences exposure; the amount of extension should therefore be recorded. The length of the picture in millimeters indicates the amount of extension, which is then divided into the film speed. We recommend changing the film ASA to an effective ASA for easier exposure determination. The length of the picture area to be copied and the film speed factors are as follows:

Length of picture area to be copied	Film-speed exposure factor
(full frame) 36 mm	4×
27 mm	6×
18 mm	8×
14 mm	12×
9 mm	16×

If the duplicating film speed is eight and the length of the picture area to be copied is 36mm, then the exposure factor is four, resulting in an effective ASA of two. If the section of the original slide to be copied is 18mm long, the exposure factor will be eight and the ASA of the film will change from eight to one. This measuring principle applies to any millimeter-length lens used on the camera.

Depth of field is very critical when duplicating slides. Therefore, it is advisable to use f/8 or smaller. When photographing full-frame duplicates at 4× bellows extension, depth of field at f/8 is one millimeter. Depth of field is three millimeters at f/22. Depth is significantly reduced when photographing sections of slides. Enter the f/stop on the data form.

The light-source-to-film distance influences exposure. It must be recorded if the same result is to be reproduced later or if modifications must be made. It is recommended that a standardized distance be used with the slide projector. Our projector-bulb-to-camera-film distance is twenty-eight inches. This was determined by positioning the projector as close as possible to the opal glass but not so close that vignetting occurred in the slide to be copied. The bottom of the data form contains blanks for evaluating exposure and filtration in the duplicate slide.

Miscellaneous Equipment

A light box that has even illumination is used for comparing the slides. A cable release will help prevent camera motion. A compass, ruler, protractor, and a pen will be needed to make charts similar to those in this chapter. A timing device for time exposures will also be needed.

COLOR CORRECTION PRINCIPLES AND PRACTICES

Selecting the Filter Pack

The filter pack for one brand of 3200° K duplicating film and a 500-watt slide projector light source is CC 25 cyan plus CC 45 yellow. This may vary with your film, projector, and processing. The procedure by which this filtration was determined can be used to find the filter pack for any other film and light source combination. A

projector bulb has a color temperature of approximately 3200° K, which is the color temperature of the duplicating film we used. If the color temperature of the bulb is the same as the color temperature of the film, no color correction filters may be necessary. Therefore, a bracketed filtration was selected that surrounded the point of no color correction.

The circular filtration grid combines filter combinations with the ten basic Munsell colors. Each box represents a filter combination, although for this experiment only nineteen combinations are used. This chart includes sections from all three filter grids: yellow-cyan, cyan-magenta, and magenta-yellow. A picture that contained a white area was selected for duplication. The white area in the duplicate would clearly indicate any unwanted color cast. This type of initial experiment will save film later. The following filtration bracket was used, as is shown in the circular filtration grid:

25-4 **Circular filtration grid with selected filter combinations to determine a filter pack.**

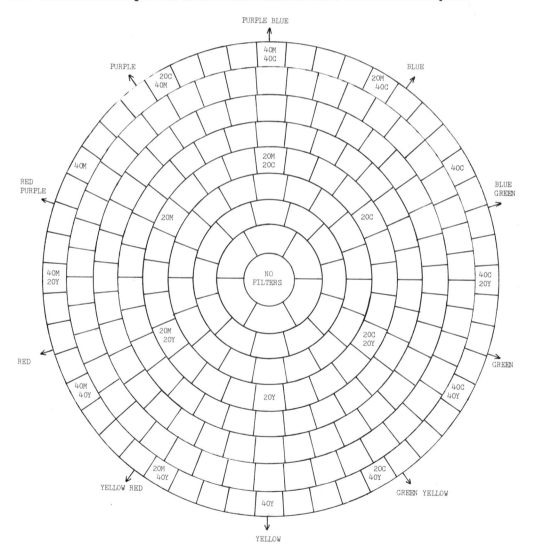

1.	no color correction filters	11. CC 20 yellow plus CC 40 magenta
2.	CC 20 yellow	12. CC 40 magenta
3.	CC 20 yellow plus CC 20 magenta	13. CC 40 magenta plus CC 20 cyan
4.	CC 20 magenta	14. CC 40 magenta plus CC 40 cyan
5.	CC 20 magenta plus CC 20 cyan	15. CC 20 magenta plus CC 40 cyan
6.	CC 20 cyan	16. CC 40 cyan
7.	CC 20 cyan plus CC 20 yellow	17. CC 40 cyan plus CC 20 yellow
8.	CC 40 yellow	18. CC 40 cyan plus CC 40 yellow
9.	CC 40 yellow plus CC 20 magenta	19. CC 20 cyan plus CC 40 yellow
10.	CC 40 yellow plus CC 40 magenta	

The filter combinations form two circles around the point of no filtration. After the film was processed, each slide was positioned on a light box and compared to the original. Eighteen of the pictures had color casts ranging from moderate to extreme. The picture taken with the CC 20 cyan plus CC 40 yellow was almost perfect. This duplicate had a minor magenta color in what was supposed to be white snow. Therefore, to locate the precise filter pack, the minor amount of magenta had to be removed from the CC 20 cyan plus CC 40 yellow combination. A filtration bracket was selected, and the original photograph was duplicated again with the following filters:

1.	CC 20 cyan plus CC 40 yellow	4. CC 30 cyan plus CC 55 yellow
2.	CC 25 cyan plus CC 45 yellow	5. CC 35 cyan plus CC 50 yellow
3.	CC 30 cyan plus CC 50 yellow	6. CC 35 cyan plus CC 55 yellow

This series of exposures removed the magenta by adding cyan and yellow. Yellow plus cyan is green, which is the complementary color of the unwanted magenta. When these slides were compared to the original on a light box, the precise color filtration was CC 25 cyan plus CC 45 yellow. The slides that had been exposed beyond this filtration had snow that was increasingly green. The snow in the properly filtered duplicate was as white as in the original slide. The other colors were also identical to the original colors. Therefore, the filter pack for the slide projector light source and the 3200° K duplicating film was CC 25 cyan plus 45 yellow for that emulsion.

25-5 Excerpt from filtration grid color wheel illustrating removal of magenta by addition of green yellow. Note the location of the filter pack in the middle of the circle from which ten Munsell colors radiate.

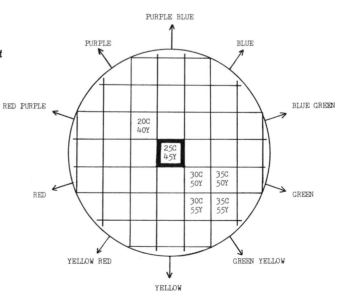

A filtration grid color wheel illustrates the positioning of the filter pack in the center of the circle (fig. 25-6). This grid visually illustrates what filter selection will do to the duplicate. Duplicating additional pictures and comparing them to the originals will verify that the correct filter pack has been selected. White areas in these test slides will allow you to easily identify the color of any color shift. When the color shift is blended with other colors, it is difficult to determine the precise color of the shift.

25-6 **Completed filtration grid color wheel with ten Munsell colors radiating from the filter pack in the middle of the circle.**

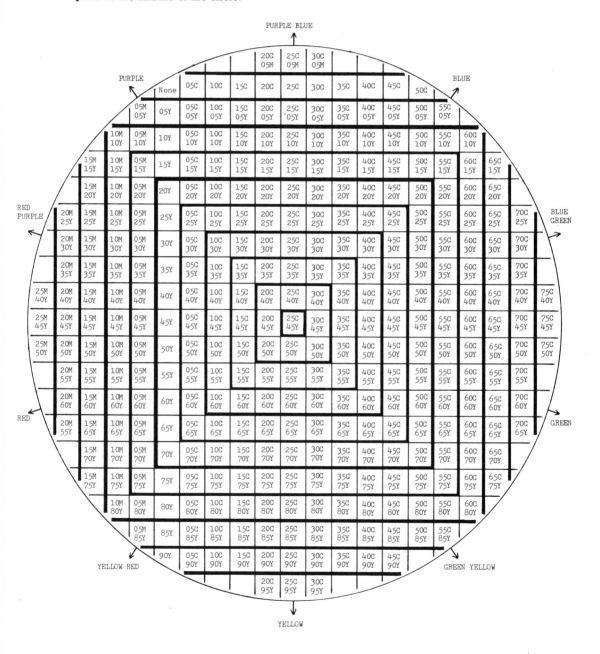

Determining Color Shifts and Their Intensity

Examine the grids inside the filtration grid color wheel. This chart indicates the positioning of ten Munsell colors and their relationship to a filter pack. The filter pack is enclosed by heavy black lines in the center of the circle. The circle indicates the usual limits of both corrective and creative filter combinations, although the grid can be extended beyond the circle. The filter pack in the center of the circle will be different for various emulsions and for other combinations of film and light source. Study the filter combinations to determine which ones produce changes as indicated by the positioning of the ten Munsell colors. The heavily outlined boxes indicate progressive amounts of change in filtration from the filter pack in the center.

Changes in color casts become progressively more intense as filter combinations increase in distance in any direction from the filter pack in the center of the circle. When making duplicate slides, the intensity of the color will shift in the direction of the color name toward which filter combinations are selected. Examination of the grid inside the color circle illustrates specifically how to select the proportions of cyan and yellow by choosing filter combinations within the grid.

It will be helpful to make copies of the blank filtration grid color wheel (fig. 25-7). Write or type in the filter combinations that surround the filter pack you will use. The grid should include as many combinations as illustrated because these represent the limits of filtration commonly used for correction and creative intensification of color. Use the color circle and the ten color names to assist you in determining the direction of change.

Color Filtration Changes Caused by Time Exposures and Processing

Color shifts may occur with duplicating film when time exposures exceed fifteen seconds. Consult the reciprocity failure correction chart for exposures that exceed two seconds. The correct filtration change for various long exposures can be determined by the procedures that have been described. If you keep the exposures under fifteen seconds, however, this will not be necessary.

Processing of duplication film should always be done by the same reliable laboratory. Variations in filtration requirements may result from processing by different laboratories. This variation may be as much as CC 20 or more in any direction from the filter pack.

Evaluation of the Filter Pack Experiments

When the film is returned from the processing laboratory, the duplicates and the original are placed on a light box for side-by-side comparison. Cover the remaining area of the light box to reduce glare. Accurate comparison cannot be done by projection on a screen. If you use one projector, your eyes will not distinguish minor color variations as you change from slide to slide. If you use two projectors, optical differences between the projectors may make precise comparison impossible. The light box also allows you to examine numerous pictures simultaneously. Select the slide that is correctly exposed and has the colors closest to those in the original. Write this information on the evaluation section of the data form. Using slides that are too dark or too light will complicate selection of the correct filter pack.

All of the experimental pictures should be saved and studied carefully to learn the effect of various degrees of filtration and exposure. This information is then

25-7 Blank filtration grid color wheel to copy and write in filter combinations. Filter pack is to be written in the center box.

used to help make color corrections and exposures in pictures that have unwanted color casts, erroneous exposures, or other defects that can be corrected by duplication. For example, pictures taken in shade or on cloudy days that are excessively blue can be corrected by filtration when duplicating.

FILTRATION EXAMPLES

These examples illustrate filtration in different directions and intensities from the filter pack. An excerpt of the filtration grid color wheel accompanies each example.

Correction of Unwanted Color Cast: Extreme Bluishness

The snowshoe rabbit described in the montage chapter was photographed in deep shade. It was illuminated only by a dark blue sky, resulting in an extremely blue color cast. The blue color cast can be corrected by overlay or by duplication. The filter pack for the slide projector and duplicating film was CC 25 cyan plus CC 45 yellow for that emulsion. Exposure of the rabbit on duplicating film with CC 25 cyan plus CC 45 yellow resulted in the same excessive bluish cast as in the original. To correct for bluishness caused by overcast or shaded light, filter choices are made along a line drawn from the filter pack toward yellow red and red. The line is created by positioning the ten Munsell colors around the filter pack as shown in the filtration grid color wheel. The following filter combinations eliminated the bluishness and restored the brown in the rabbit and soil.

25-8 Excerpt from filtration grid color wheel illustrating the removal of extremely bluish color cast from the rabbit picture by adding yellow red to the filter pack. The filter pack is inside the heavy black lines. The ten Munsell colors radiate from the filter pack.

Filter combinations	Results
CC 25 cyan plus CC 45 yellow	Bluishness as in the original
CC 15 cyan plus CC 60 yellow	Bluishness eliminated but picture is gray overall
CC 05 cyan plus CC 65 yellow	Brown partially restored
CC 05 cyan plus CC 80 yellow	Brown partially restored
CC 05 magenta plus CC 75 yellow	Brown fully restored
CC 10 magenta plus CC 65 yellow	Brown fully restored, best color reproduction

Correction of Unwanted Color Cast: Minor Bluishness

The montage of the skier described in the montage chapter was bluish, though not as bluish as the rabbit. Although the bluishness in the montage is within acceptable limits, it can be completely removed by duplication; the montage then can be disassembled and made into other montages. This blue color cast was present because of the reflection of blue sky on the snow in both films of the montage. The chart illustrates that much less color correction was needed here than for the rabbit. The elimination of blue in this montage was accomplished by adding small amounts of red and yellow red to the filter pack. The following filter combinations were used.

Filter combinations	Results
CC 25 cyan plus CC 45 yellow	Same amount of blue as in original
CC 15 cyan plus CC 50 yellow	No bluishness, snow is white
CC 20 cyan plus CC 55 yellow	No bluishness, snow is white
CC 10 cyan plus CC 65 yellow	Overcorrection results in orange snow

25-9 Excerpt from the filtration grid color wheel illustrating removal of unwanted blue from the montage of the skier by addition of red and yellow red to the filter pack. The filter pack is outlined with dark black lines. The ten Munsell colors radiate from the filter pack.

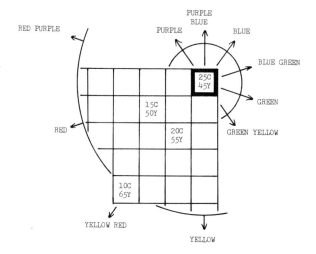

Correction of Unwanted Color Cast: Red Purple (Magenta)

A picture taken at Mount Lassen National Park in California was on a film emulsion that contained too much magenta. If the magenta could be removed by duplication, the picture would have colors that viewers would regard as normal. The following filter combinations achieved the results indicated.

Filter combinations	Results
CC 25 cyan plus CC 45 yellow	Same red purple cast as in the original slide
CC 35 cyan plus CC 50 yellow	Red purple removed, colors restored to normal

25-10 Excerpt from filtration grid color wheel illustrating removal of unwanted magenta from Mount Lassen picture by adding green.

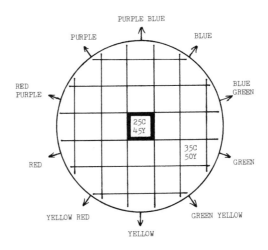

Correction of Unwanted Color Cast: Reddish Orange

The sand dunes and cowboy montage described in the montage chapter was made by combining two beige sand pictures. When the montage was project-

25-11 Excerpt from filtration grid color wheel illustrating the removal of unwanted reddish orange from the sand dune montage by adding blue and blue green to the filter pack.

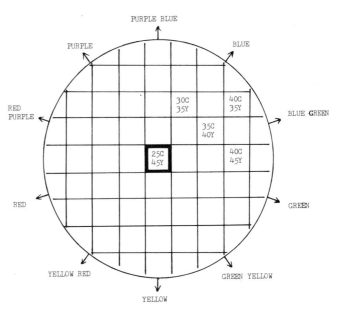

ed on the screen, the colors were acceptable, although warm in color. When compared side by side with other sand dune pictures on a light box, the montage had a reddish orange color cast, which could be removed by duplication. Beginning with the filter pack, selections were made on the grid between the filter pack and the (cyan) blue and blue green arrows. This would counteract the unwanted color cast. The following filter combinations achieved the results indicated.

Filter combinations	Results
CC 25 cyan plus CC 45 yellow	Color cast as in the original
CC 35 cyan plus CC 40 yellow	Color cast removed, beige restored
CC 30 cyan plus CC 35 yellow	Color cast removed, beige restored
CC 40 cyan plus CC 35 yellow	Overcorrection results in bluish sand
CC 40 cyan plus CC 45 yellow	Overcorrection results in blue green sand

Correction of Unwanted Color Cast: Yellowish Orange

The head of George Washington at Mount Rushmore National Memorial in South Dakota was photographed at night while it was illuminated for the evening program. The resulting picture was yellowish orange. Although this was an acceptable color rendition, the photographer wanted to enlarge the head of Washington by duplication and remove the color cast at the same time. The enlargement would fill the frame of the slide. The following combinations of filters illustrate the progressive elimination of the unwanted yellowish orange color.

Filter combinations	Results
CC 25 cyan plus CC 45 yellow	Same color cast as in original
CC 25 cyan plus CC 30 yellow	Extremely yellowish orange
CC 40 cyan plus CC 35 yellow	Excessive yellow still present

25-12 Excerpt from filtration grid color wheel illustrating removal of yellowish orange from Mount Rushmore night scene by addition of blue and blue green to the filter pack.

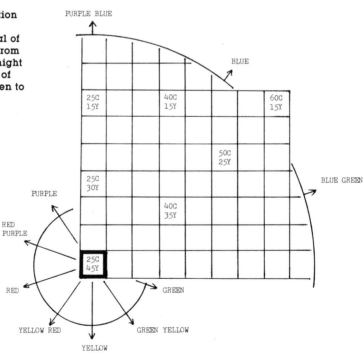

Filter combinations	Results
CC 25 cyan plus CC 15 yellow	Slightly yellowish orange
CC 50 cyan plus CC 25 yellow	Yellowish orange still present
CC 60 cyan plus CC 15 yellow	Color cast eliminated
CC 40 cyan plus CC 15 yellow	Color cast eliminated, best version

Addition of Color Cast for Creative Effect

The Monument Valley and cloud scene described in the montage chapter offers a variety of creative possibilities. The original montage contains a range of blue in the sky, a very faint yellow red line along the horizon, gray and white in the cloud, and black silhouettes. The picture is acceptable in that version because it portrays an atmospheric condition that could have actually occurred. By duplicating the montage with a series of exposures filtered in the direction of red, yellow, and yellow red, brilliant sunrise effects were achieved. Too much filtration resulted in some unacceptable versions. Note that two filter combinations were selected from the yellow-magenta section of the grid. After duplicating this montage in various color versions, the montage was disassembled and each of the original films was combined with other subjects to create additional montages for duplication. The following filter combinations resulted in pictures that had intensified red, orange, and yellow.

25-13 Excerpt from filtration grid color wheel illustrating how the Monument Valley sunrise was created by intensifying the amount of red and yellow red in several exposures.

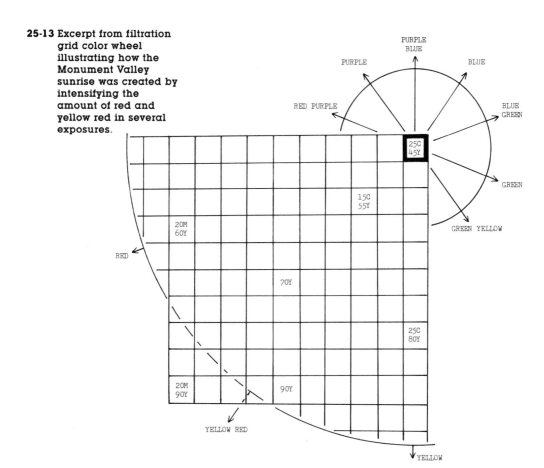

Filter combinations	Results
CC 25 cyan plus CC 45 yellow	Identical to original montage
CC 15 cyan plus CC 55 yellow	Less bluishness
CC 25 cyan plus CC 80 yellow	Less bluishness, slightly yellow version
CC 70 yellow	Beautiful yellow version
CC 90 yellow	Slightly orange version
CC 20 magenta plus CC 90 yellow	Brilliant orange version
CC 20 magenta plus CC 60 yellow	Overdone, excessively reddish

Filter Selection for Different Emulsions

The instruction sheet with each roll of duplicating film indicates starting point recommendations for filtration. For example, Kodak Ektachrome SE Duplicating Film Special Order SO-366 has a starting point recommendation of CC 35 yellow and CC 35 cyan when using a tungsten 3200° K light source. Filter adjustments for each emulsion are printed on the side of the yellow film box in a white rectangle. As described in this chapter, experimentation determined that a filter combination of CC 45 yellow and CC 25 cyan resulted in accurate filtration for the emulsion in that box when using a slide projector for the light source. There will usually be a difference between the standardized 3200° K light used by the manufacturer and your projector light. The difference in filtration between the standard 3200° K light and your projector bulb is important to know because it will simplify filter selection when changing from one emulsion to another. This difference in color correction can be determined as follows.

Starting point recommendation	CC 35 yellow and	CC 35 cyan
emulsion adjustment	+CC 05 yellow and	CC 00 cyan
Recommendation for 3200°K bulb		
for that emulsion	CC 40 yellow and	CC 35 cyan
Correct filtration determined by		
experimentation	CC 45 yellow and	CC 25 cyan
Recommendation for 3200°K light source	−CC 40 yellow and	CC 35 cyan
Filter adjustment for projector bulb	CC 05 yellow and	−CC 10 cyan

With the filtration difference established, filtration for each succeeding roll of film is determined in the following manner.

Starting point recommendation	CC 35 yellow and	CC 35 cyan
Correction for projector bulb	+CC 05 yellow and	−CC 10 cyan
	CC 40 yellow and	CC 25 cyan
Recommended emulsion correction	+CC 05 yellow and	CC 00 cyan
Filtration to be used	CC 45 yellow and	CC 25 cyan

When the next roll of the same brand of film is purchased, it may be from a different emulsion batch. The new filtration is determined in the same manner.

Starting point recommendation	CC 35 yellow and	CC 35 cyan
Correction for projector bulb	+CC 05 yellow and	−CC 10 cyan
	CC 40 yellow and	CC 25 cyan
Recommended emulsion correction	−CC 40 yellow and	+CC 10 cyan
Filtration to be used	CC 00 yellow and	CC 35 cyan

This new filter pack is written in the center of a new blank filtration grid color wheel. The remainder of the grid is completed according to this new filter pack.

DETERMINING EXPOSURE FOR COLOR SLIDE DUPLICATION

Single-Value Meter Readings with Filters in Duplicator

The exposure calculation process is similar to the procedures described throughout this book, namely, exposure of colors on the proper steps. For duplication, the one-degree spot meter is equipped with a +10 portrait lens to take close-up meter readings of the slide in one-eighth-inch-diameter circles. This makes it possible to obtain single-value readings of individual colors in the slide. Through-the-lens meters obtain averaged readings that will result in exposure errors. For maximum accuracy, readings should be taken with the color-correction filters in position between the light source and the opal glass. The value-selector chart and duplication data form will assist you in determining exposure. Meter readings and exposures should be done in a darkened room because extraneous room light will change the readings and degrade the results. Maximum exposure accuracy and precision reproduction of colors, values, and textures will result from using color slide duplicating film rather than ordinary slide film.

Time Exposures

Duplicating film has an extremely low ASA that will require time exposures. Using a 300-watt or 500-watt slide projector, these exposures may vary from one-half second to fifteen seconds or longer. Most of the exposures, however, will be in the range from one to five seconds. Use the reciprocity failure correction chart in chapter 20 to make adjustments for time exposures that exceed two seconds. A stopwatch, darkroom timer, or wristwatch may be used to time the exposures if the camera does not have a built-in timer for the exposure times used.

Comparison to Gray-Scale Slides for Precision Exposure

It was recommended in chapter 1 that thirteen exposures be made of the Kodak 18 percent gray card. The exposure range was from Step 3LW to Step 3DB. The values of the slides to be duplicated will be compared to these gray-scale values and exposed accordingly. First, determine the filtration for the picture to be duplicated. Place these filters in the filter holder of the duplicator. Beginning with the Step 3LW gray-scale transparency, place the gray-scale slides in the duplicator and take meter readings of each of them. Each reading is written on the data form in the "Meter" column corresponding with the step of the gray-scale slide being metered. For example, the reading of the Step MV gray-scale slide is written on the form in the *Meter* column beside the *MV* in the *Gray-Scale Steps* column.

Next, meter readings are taken of the major colors in the slide to be duplicated. If an identical reproduction is desired, Step MV is entered in the *Step* column on the same line as the gray-scale Step MV. Camera settings are selected according to the meter dial where Step MV is assigned.

Precision darkening or lightening of the duplicate can be accomplished by placing Step MV above or below the *Gray-Scale Steps* MV and exposing accordingly. The value-selector chart will assist you in assigning proper color values. If the

½L	13.1	Lightest Brown Sand	½L
MV	12.5	Brown Sand	MV
½D	11.8	Brown Sand	½D
1D	11.1		1D
1½D	10.4		1½D
2D	9.5	Dark Brown Shadow	2D

Evaluation of Exposure
Exposure identical to original

25-14 Data form excerpt illustrating exposure on steps identical to the original slide.

25-15 Excerpt from data form illustrating exposure one-half f/stop lighter than original slide.

½L	12.6	Lightest facial area	1L
MV	12.0		½L
½D	11.3	Cheek	MV
1D	10.6		½D
1½D	9.9		1D
2D	9.1	Shoulder Area	1½D
2½DB	8.2		2D
3DB	7.4		2½D
	6.6	Black Sky	3DB

Evaluation of Exposure
One step lighter as planned because original is slightly dark

½L	13.1	Light Gray Fog	MV
MV	12.5		½D
½D	11.8		1D
1D	11.1	Shadow of tree	1½D
1½D	10.4		2D
2D	9.5	Dark Rock	2½D

25-16 Excerpt from data form illustrating exposure one step darker than the original slide.

25-17 Excerpt of data form illustrating how to obtain an exposure two steps (one f/stop) lighter than the original slide.

MV	11.5	Moon	1L
½D	10.9	Moon and Sky	½L
1D	10.2	Water	MV
1½D	9.5		½D
2D	8.7	Rocks	1D
2½DB	7.9	Rocks	1½D
3DB	7.1	Rocks	2D
	6.1	Rocks	2½D

Evaluation of Exposure
JUST RIGHT!
ONE STOP LIGHTER

picture is to be lightened by one stair-step (one-half f/stop), the assigned Step MV is written on the first line below the gray-scale MV.

If the picture is to be darkened by one stair-step, the assigned Step MV is written on the first line above the gray-scale MV. If the duplicate is to be darkened by one f/stop, MV is written on the second line above the gray-scale MV. Camera settings are selected according to the meter dial on the line where Step MV is assigned. If the duplicate is to be lightened by one f/stop (two stair-steps), MV is written on the second line below the gray-scale MV.

One exception to the gray-scale comparison procedure occurs when the values of the slide to be duplicated are all at Step 2D or darker. This may occur in severely underexposed slides and extremely dark montages. Expose the slide by obtaining meter readings of it, then positioning the value-selector chart under the data form to select colors and values as described throughout this book. Keep records of the exposure information. If your first attempt to duplicate extremely dark slides is not as accurate as you desire, correct the exposure of these slides or montages on the second attempt. If all of the readings of an overexposed slide are at Step 2L or above, it probably will not be possible to obtain a satisfactory duplicate, although an attempt should be made.

Standardization Chart

Readings of the gray-scale slides were plotted on graph paper, producing a chart that simplifies the gray-scale comparison procedure and saves time. As discussed in the slide evaluation chapter, readings of the gray-scale slides by transmitted light are not one-half f/stop apart, even though that is the way they were exposed. In addition, a range encompassing twenty-one stair-steps from Step 4LW (clear film) to Step 6DB was plotted on the graph to provide data to duplicate severely overexposed slides and extremely dark montages. With this chart you can satisfactorily duplicate montages that would appear black on the screen.

The lines on the graph were logarithmic in shape because of progressive differences in transmitted-light readings between the very light steps and the very dark steps. This means that the lines at the upper steps were curved and the lines at the dark end of the graph were straight. The numbers on the chart reflect the curve. Note that the differences between the readings for the light steps are much smaller

25-18 Standardization chart to simplify entries in the data form *Meter* column.

	A	B	C	D	E	F	G	H	I	
4LW	12.2	12.7	13.2	13.7	14.2	14.7	15.2	15.6	16.0	4LW
3½LW	12.0	12.5	13.0	13.5	14.0	14.5	15.0	15.4	15.8	3½LW
3LW	11.8	12.3	12.8	13.3	13.8	14.3	14.8	15.2	15.6	3LW
2½LW	11.5	12.0	12.5	13.0	13.5	14.0	14.5	14.9	15.3	2½LW
2L	11.1	11.6	12.1	12.6	13.1	13.6	14.1	14.6	15.0	2L
1½L	10.6	11.1	11.7	12.1	12.6	13.2	13.6	14.2	14.6	1½L
1L	10.1	10.6	11.1	11.6	12.1	12.6	13.1	13.8	14.1	1L
½L	9.6	10.1	10.6	11.1	11.6	12.1	12.6	13.1	13.6	½L
MV	9.0	9.5	10.0	10.5	11.0	11.5	12.0	12.5	13.0	MV
½D	8.4	8.9	9.4	9.9	10.4	10.9	11.3	11.8	12.3	½D
1D	7.8	8.3	8.8	9.3	9.8	10.2	10.6	11.1	11.6	1D
1½D	7.2	7.6	8.1	8.6	9.0	9.5	9.9	10.4	10.8	1½D
2D	6.6	7.0	7.5	7.9	8.3	8.7	9.1	9.5	9.9	2D
2½DB	6.0	6.4	6.7	7.2	7.5	7.9	8.2	8.6	9.0	2½DB
3DB	5.3	5.7	6.0	6.4	6.2	7.1	7.4	7.7	8.0	3DB
3½DB	4.5	4.8	5.1	5.5	5.8	6.1	6.6	7.0	7.3	3½DB
4DB	3.7	4.0	4.3	4.6	4.7	5.2	5.4	5.6	5.8	4DB
4½DB	3.0	3.2	3.4	3.7	3.8	4.2	4.4	4.6	4.8	4½DB
5DB	2.2	2.4	2.5	2.7	3.0	3.2	3.4	3.6	3.7	5DB
5½DB	1.4	1.5	1.6	1.8	2.0	2.2	2.4	2.7	3.0	5½DB
6DB	.7	.8	.9	1.0	1.2	1.4	1.6	1.8	1.9	6DB

than for the dark steps. By using graph paper, it was possible to obtain meter readings in one-tenth of an f/stop, as indicated on the chart. For practical use, select readings rounded off to the nearest one-fourth or one-half f/stop.

There are nine vertical columns of readings on the chart, lettered from *A* to *I*. These represent variations in transmitted-light readings resulting from placement of various densities of filter combinations in the duplicator. After the filters are in position, read the Step MV gray-scale slide. Find that meter reading on the Step MV line of the chart. Then write the meter readings on the data form in the *Meter* column for the indicated steps. This procedure makes it unnecessary to read all of the gray-scale slides each time a slide is to be duplicated. In addition, readings are provided for montages that have areas as dark as Step 6DB.

Example: *Correction of Underexposure and Bluishness*

"Abandoned Cabin in the Aspens" (fig. C-46) was photographed under dark, cloudy lighting conditions. The slide was accidentally underexposed approximately two f/stops because the camera settings were erroneously adjusted. The aspen trees were too dark in value and contained a bluish cast caused by cloudy lighting. Underexposure reduced the chroma of the yellow leaves. The roof of the cabin and the log fence had a bluish cast caused by lack of direct sunlight. The following filter combinations progressively removed the bluish cast.

Filter combinations	Results
CC 25 cyan plus CC 45 yellow	Identical to bluish original
CC 05 cyan plus CC 65 yellow	Slightly magenta but acceptable
CC 15 cyan plus CC 75 yellow	Excellent removal of bluishness
CC 10 cyan plus CC 95 yellow	Best version, total removal of bluishness

25-19 Excerpt from filtration grid color wheel illustrating removal of bluishness by addition of yellow and yellow red to the filter pack for figure C-46.

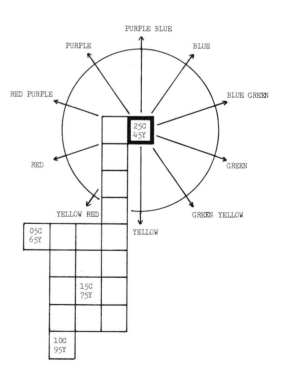

To determine the correct exposure for the duplicate, the CC 10 cyan and CC 95 yellow filters were placed in the slide duplicator filter slot. A meter reading was taken of the Step MV gray-scale slide. This reading was 12, which appears in column G on the standardization chart. Column G readings for the various steps were written on the data form in the *Meter* column. The slide to be copied was positioned in the duplicator. Meter readings were taken of the following colors and subjects in the slide: yellow leaves and grass, porch and house roof sections, shadow on the side of the house, and the shaded green bush in the lower right corner. The subject of each of these single-value readings was written on the data form on the line corresponding to its reading. For example, the reading on the shaded side of the building was

25-20 Excerpt from data form illustrating filtration and exposure of figure C-46.

STAIR-STEP EXPOSURE SYSTEM DATA FORM FOR DUPLICATING COLOR SLIDES

Place *Southwestern Colorado*	Frame Number	*12*	
	Light to Film Distance	*28"*	
Subject *Abandoned Cabin*	Correction Filter	*10 C*	
Date	Correction Filter	*85Y*	
Film	Correction Filter	*—*	
Emulsion Correction *+ CC 05 Yel*	Bellows Extension	*4 ×*	
ASA Film Speed *8*	Effective ASA Film Speed	*2*	
Light Source *Projector*	Shutter Speed	*24 s*	
Basic Filter Pack *25C 45Y*	f/Stop Setting	*11*	

Gray Scale Steps	Meter	Colors and Color Values	Step	Step	Step
(MV)	*12.0*		*2L*		
½D	*11.3*		*1½L*		
1D	*10.6*	*Porch Roof*	*1L*		
1½D	*9.9*	*Yellow, Roof*	*½L*		
2D	*9.1*	*Yellow*	*(MV)*		
2½DB	*8.2*	*Shadow*	*½D*		
3DB	*7.4*		*1D*		
	6.6	*Shaded Green*	*1½D*		

Evaluation of Filtration
Beautiful Yellow No Bluishness

Evaluation of Exposure
Perfect

8, and *shadow* was written on the data form on the 8.2 line, which is Step 2½DB. The data form and value-selector chart were studied to determine the best steps for each color. The fact that yellow made up such a large proportion of the format indicated that it should be darker than its customary exposure on Steps 1½L or 1¾LY. A compromise exposure resulted in shaded green on Step 1½D, the large shadow on ½D, and yellow on Steps MV and ½L. The roof highlights were exposed on Steps ½L and 1L.

Elimination of the bluishness, combined with lightening of the slide, restored the yellow leaves to their proper value and chroma. Removal of the bluishness restored the brownish gray color to the roof and fence. Highlights of the roof, fence, and yellow leaves gave the scene impact that the original did not have. The defects in the slide were corrected by careful exposure and color correction in the duplicate (fig. C-47).

ADDITIONAL INFORMATION FOR THE EXPERIMENTER

Color Printing Filtration Information

The filtration grid color wheel can be used for color printing and will simplify selection of filters. The filter pack for the print material and enlarger light is determined by using narrower filter brackets than were described for duplicating film. The filter bracketing is based upon the filter pack recommendations contained with the print material. Determine the filter pack and make filtration grid color wheel charts to assist you. When printing from slides (positive to positive), the color correction is done by using the methods described for slide duplication. For example, if the picture is too yellow, remove yellow from the filter pack or add purple blue. When printing from color negatives (negative to positive), however, filter selection is reversed. For example, if the picture is too yellow, add more yellow. If the picture is too purple blue, add more purple blue. The use of the filtration grid color wheel will simplify selection of filters. The intensity of change will be similar to that described for duplicating slides.

Black-and-White Prints from Color Slides

Excellent black-and-white prints can be made from color slides by the procedures that have been described. Color balance can be disregarded when duplicating color slides on black-and-white film. Use the standard red, orange, and yellow filters in black-and-white duplication, just as they would be used under the original conditions. For example, if the color slide has a blue sky, use an orange filter when the film is exposed. This will produce a dark gray sky in the black-and-white print. To obtain a black sky, use a red filter. If the red and orange filters make the sky too dark, use a yellow filter or no filter.

Modify the exposure method slightly by positioning Step MV exactly between the darkest and lightest textured areas. If this distance exceeds nine steps, decide whether to sacrifice texture in shadows or highlights. Loss of texture will usually occur in black-and-white duplicates above Step 2L and below Step 2D, depending upon the development of the film.

Increased contrast occurs when slides are duplicated on black-and-white film, unless development time is reduced. Therefore, development time of the black-and-white film must be no longer than the manufacturer's "normal" recommenda-

tion. If the negatives are still too contrasty, reduce the development time by 25 to 50 percent. Experimentation will determine the proper shortened development time. This will prevent unwanted contrast in the black-and-white film and retain appropriate texture in the shadows and highlights.

All of the black-and-white prints in this book were made with the equipment and procedures described in this chapter. The prints were made with lower contrast than usual, however, in order to reproduce the same values in these prints that were present in the original color slides. Black-and-white prints are usually made more contrasty than the reproductions in this book. Contrast in black-and-white prints helps compensate for their lack of colors.

Double and Multiple Exposures in Duplicate Slides

Duplication offers the opportunity to make multiple exposures under controlled, easily repeatable conditions when there are no time pressures. Pictures can be taken for multiple exposures in the field, then combined for duplication at a later date, enabling correction of errors. When using duplicating film, the values will be identical to the original values, and the principles and practices described in the chapter on multiple exposure can be used. If ordinary color slide film (indoor or outdoor type) is used, however, the increased contrast and severe narrowing of the texture range will present numerous problems, including difficulties with accurate exposure determination. Multiple-exposure procedures can also be combined with duplication of montages.

Dodging and Burning In

Dodging and burning in are procedures that have been used by darkroom photographers for many years to lighten or darken selected areas of a picture. When duplicating slides, position a piece of matte board between the light source and the opal glass. The distance it is positioned behind the opal glass will determine how sharp or blurred the shaded edge will be in the duplicate. When the slide projector is the light source, you can evaluate this while viewing the picture through the camera viewfinder. If you want a very blurred edge of shading in the duplicate, position the matte board about six inches behind the opal glass. If you wish to darken the top of the picture, slowly lower the matte board into the rays of light. Use the spot meter to determine exactly what step will result from this procedure. The Cokin creative filter system, marketed by Minolta Corporation, has several filters that are superior to matte board for this purpose. The Cokin filter may be attached to the camera lens or inserted between the light source and the slide to be duplicated. Darkening an area more than one f/stop will cause a color shift. Selective filtration of a picture area can also be done by positioning the filters to change the light reaching part of the film. Keep very careful records of what you do so you can master these procedures.

Creative Filtration

Cokin creative filters and other brands of similar filters can be used to achieve spectacular effects in slide duplication. Soft-focus and diffusion filters will change flowers into dreamy fantasies. Graduated gray filters can be used to darken or lighten areas in the duplicate. Graduated orange and graduated red filters are ideal for intensifying sky color in sunrise and sunset pictures. Center spot filters will accentuate selected areas, plus blur, lighten, or darken surrounding areas. Over

one hundred additional effects can be achieved with the remainder of the Cokin filter system, including diffraction, starburst, framing, double-exposure framing, colored diffusion, multi-image, rainbows, and fog effect. Colored vaseline and colored varnish are also available from Cokin. Their instructions include nothing on the use of Cokin filters in duplication, but go ahead and experiment as much as you please.

Filter Packs for Additional Light Sources and Films

This chapter has elaborated on the use of one film-and-light-source combination. Other light sources, films, and filter pack combinations can also be used. It is our opinion that these present a variety of disadvantages when compared to the combination of slide projector light source and duplicating film. The filter combinations may vary with your procedures and processing. The following information is offered to assist you.

Film	Light source	Filter pack	Comments
outdoor slide film 5500°K	Electronic flash	no filters	cannot use meter, cannot visually darken areas, contrasty results
outdoor slide film 5500°K	blue flood light 4800°K	CC 20 cyan plus CC 05 magenta	less intense light, bulb is hot, contrasty results
indoor slide film 3200°K	slide projector	CC 20 magenta plus CC 20 yellow	contrasty results
duplicating film 3200°K	electronic flash	CC 110 yellow plus CC 20 cyan	cannot use meter, cannot visually darken areas

The direction and distance of filter selection across the grids as illustrated earlier in this chapter will produce similar results when used with other films and light sources. Use the filtration grid color wheel charts to help determine corrective or creative filter selections. The intensity of color changes or color shifts around any filter pack will be similar to the descriptions that have been given.

ANNOTATED
BIBLIOGRAPHY

ABEEL, E. A. "More on Copying Slides." *Photographic Society of America Journal*, December 1967, pp. 37–39. Instructions for making a color slide duplicator box and the procedure for using it with sunlight.

ANTOS, ROBERT. "Color Slide Blending." *Photographic Society of America Journal*, September 1966, pp. 26–27. Describes creative multiple-projector blending of two pictures on the screen during slide presentations.

BELANGER, ARMAND. "Filming Superimposed Titles." *Photographic Society of America Journal*, July 1967, pp. 39–40. A titling procedure using Kodalith high-contrast black-and-white film.

BLAKE, GLEN T. "Better Duplicate Slides." *Photographic Society of America Journal*, February 1967, pp. 38–40. A detailed description of homemade duplicating equipment and the procedure for using it with electronic flash and photo floodlights.

BOND, FRED. "Color—How to See and Use It." *Photographic Society of America Journal*, November 1972, pp. 34–37. The Munsell color wheel and color solid are described from the standpoint of color harmony.

BRANCH, EYRE. "Titling Techniques and Ideas." *Photographic Society of America Journal*, March 1967, p. 20. Describes a wide variety of creative title-making techniques using many types of letters and materials.

CORNFIELD, JIM. "Duping for Better Color." *Petersen's Photographic Magazine*, June 1974, pp. 30–34. An illustrated discussion of duplicating techniques: cropping, contrast, texture, diffusion, color correction, and color effects.

DRUKKER, LEENDERT. "Choosing the Right Screen." *Popular Photography*, March 1979, p. 14. Advantages and disadvantages of various types of screens and screen surfaces.

EASTMAN KODAK. *The Here's How Book of Photography*. New York: Eastman Kodak, 1972. Contains chapters on titling techniques, slide-duplicating (types, equipment, films, light sources, color correction, and contrast control), and night photography, including a technique for double-exposing the moon for use with other subjects.

ERSKINE, HELEN W. "Montages in Stereo." *Photographic Society of America Journal*, September 1966, pp. 18–21. Describes montages for titles and unusual effects. Although written for stereo photographers, the techniques are applicable to all 35mm slide photographers.

FARBER, ED. "Photo-Electronics: Elements that Distort Color Slides." *Popular Photography*, September 1979, p. 16. Discusses the effects of different screens, projectors, projector bulbs, voltage changes, and ambient light conditions on the appearance of slides.

FEININGER, ANDREAS. *Basic Color Photography.* New York: Amphoto, 1972. Basic camera operation, exposure meters, and polarization.

———. *The Color Photo Book.* Englewood Cliffs, New Jersey: Prentice-Hall, 1969. Description of polarizers and their use.

———. *Successful Color Photography.* Englewood Cliffs, New Jersey: Prentice-Hall, 1966. Discussion of the use of polarizing filters.

FILSON, RALPH. "Build This Dissolve Unit." *Photographic Society of America Journal,* August 1973, pp. 27–30. Detailed plans for building a plywood fade-and-dissolve unit for two stacked carousel slide projectors.

GANGL, OTT. "Copy Your Slides." *Popular Photography,* April 1972, pp. 74–75. How to attach a camera to a photographic enlarger to make duplicate slides.

HAAGA, ADELINE. "Slide Copying Controls." *Photographic Society of America Journal,* March 1976, pp. 23–27. Explains how to build a simple duplicating device and the procedures for cropping, correcting exposure, making multiple exposures, and producing other creative slides by duplication.

HARSHBARGER, F. "Double Exposed Movie Titles." *Photographic Society of America Journal,* February 1971, pp. 37. Titling technique using Kodalith film.

HATTERSLEY, RALPH M. "How to Shoot Close-ups." *Popular Photography,* January 1980, p. 98. Illustrated description of equipment and procedures for doing macrophotography with a bellows and portrait lenses.

HERCHE, EDWARD F. "Mood and Montage Weather." *Photographic Society of America Journal,* December 1975, pp. 16–17. Discussion of eight comparative color examples of montage showing the dramatic lighting effects that resulted.

HIROSHI, KIMATA, AND WERNER, KENNETH. "What Do Through-the-Lens Meters Really Measure?" *Modern Photography,* July 1975, pp. 78–83. An outstanding evaluation of built-in meter sensitivity patterns of many cameras and a discussion of the implications of using this type of meter.

HORWITZ, SILOM. "Copying Positives and Negatives." *Photographic Society of America Journal,* June 1967, pp. 42–43. Combining a camera and a photographic enlarger to make duplicate slides.

———. "Ektachrome 5038 for Dupes." *Photographic Society of America Journal,* August 1973, pp. 25–26. A discussion of color correction, exposure factors, and various light sources, in addition to specific instructions for using Kodak 5038 slide-duplicating film.

HOWELL, EDWARD T. "Copying Prints and Slides." *Photographic Society of America Journal.* February, 1973, p. 33. How to build a slide copy box.

———. "Photographing the Screen—Slide Montages." *Photographic Society of America Journal,* March 1973, pp. 29–30. A color slide duplication technique for montages using two projectors, each of which projects an image on the screen at the same time.

HYPES, GEORGE P., AND HYPES, CAROL L. "Accurate Time Exposures." *Photographic Society of America Journal,* April 1972, pp. 39–44. The correction of exposure time to counteract reciprocity failure.

———. *Creative Tape Recording for Amateur Photographers and Audio-Visual Education.* Rev. ed. Greeley, Colorado: Tribune-Republican Publishing Company, 1975. Selection of equipment to make and present tape-recorded slide shows, description of many recording and dubbing techniques, list of 2,500 music titles classified by photographic subject, showmanship ideas; profusely illustrated.

———. "Fun with Diazochrome." *Photographic Society of America Journal,* August 1971, pp. 13–16. Montage techniques using various colors and several layers of Diazochrome film. Instructions for processing Diazochrome.

———. "Mt. Rushmore—A Giant Assignment." *Photographic Society of America Journal,* May 1973, pp. 10–13. Illustrations and description of viewpoints, lenses, and exposures for photographing Mount Rushmore day and night.

———. *Plywood Dissolve Control Plans.* Greeley, Colorado: Tribune-Republican Publishing Company, 1972. Plans and instructions for building a dissolve control for double-projector showmanship. Adaptable to all projectors.

JORDAN, ROY D. "Exposure Minders." *Photographic Society of America Journal,* February 1973, pp. 36–37. A quick and easy method of determining exposure modifications for macrophotography and slide duplication when using a bellows.

KELLY, KENNETH L. "A Universal Color Language." *Color Engineering,* March–April, 1965. A descrip-

tion of color-solid centroid colors and of a six-level system of color accuracy. Contains a list of fifty-three references.

KELLY, KENNETH L., AND JUDD, DEANE B. *Color: Universal Language and Names Dictionary.* Special Publication 440. Washington, DC: United States National Bureau of Standards, December 1976. Contains two lists of approximately twelve thousand synonyms and near synonymous color names for the National Bureau of Standards centroid color samples. The first list is categorized under each of the centroid colors; the second list is alphabetical. These lists include names of companies and organizations that use each of the names. The color names for the stair-step exposure system were adapted from this book.

————. *The Inter-Society Color Council–National Bureau of Standards Centroid Color Charts.* SRM #2106, Supplement to the National Bureau of Standards Special Publication 440. Washington, DC: United States Natinoal Bureau of Standards, 1965. These eighteen hue charts contain 251 color chips and 267 color names representing centroid colors in the Munsell color solid.

KENNEDY, CORA WRIGHT. "Tools and Techniques: Cropping Your 35mm Slides." *Popular Photography,* March 1980, p. 230. Materials and procedures to eliminate unwanted areas in slides.

KISNER, V. P. "Build a Horizontal Copy Stand for Greater Versatility." *Petersen's Photographic Magazine,* February 1978, pp. 49C–55. Simple, homemade slide-duplicating device.

KÜPPERS, HARALD. *Color.* London: Van Nostrand Reinhold, Ltd., 1972. The origin, systems, and uses of color. Superbly and profusely illustrated. Pages 16–19: illustrated discussion regarding which color names are "right." Page 110: color reproduction of a three-dimensional representation of the CIE system (Commission Internationale de l'Eclairage). Page 111: color reproduction of the CIE chromaticity diagram. Pages 107, 115, 118: color reproductions of eight color solids from other color classification systems (excluding the Munsell color solid).

LIFE LIBRARY OF PHOTOGRAPHY. Light and Film. New York: Time-Life Books, 1970. Illustrated discussion of light meters: spot, built-in, center-weighted, and automatic.

LUEBKE, PAUL T. "Making Title Slides." *Photographic Society of America Journal,* December 1973, pp. 32–35. Creative slide-title techniques using props, artwork, high-contrast copy film, Kodalith, color gels, double exposure, montage, and various types of letters. Thirteen illustrations.

MCCARTHY, TOM. "Double Your Fun with Double Exposures." *Photographic Society of America Journal,* February 1967, pp. 18–19. Description of how color slides become brighter and more colorful as multiple images are exposed on the film.

MARLOR, GEORGE. *Selective Entertainment.* San Diego, CA: Western Photographer. Practical ideas for improving showmanship in color slide programs.

MAYER, SAUL. "Rear Projection Photography." *Petersen's Photographic Magazine,* February 1978, p. 32. Duplication of color slides by photographing the projected image of the slides. Creative rear-projection techniques include double-projector montage, textured glass, cropping, titles, glassware, etc. Twelve illustrations.

MINOLTA CORPORATION. *Cokin Creative Filter System.* This forty-page advertising pamphlet is profusely illustrated with examples of the effects of 158 different filters. Available from Minolta Corporation, P.O. Box 600, Garden City, NY 11530.

MUNSELL, ALBERT H. *A Color Notation.* 12th ed. Baltimore, MD: Munsell Color, 1975. Albert H. Munsell's original illustrated description of his system for defining all colors and their relationships to each other by measured scales of hue, value, and chroma. Includes a glossary of color terms. Munsell's book contains the color theory that underlies the stair-step exposure system.

————. *A Grammar of Color.* Edited by Faber Birren. New York: Van Nostrand Reinhold Company Inc., 1969. A basic treatise on the color system of Albert H. Munsell, including chapters on color harmony. This is an edited, expanded, and more illustrated version of Munsell's original book *A Color Notation.* The stair-step exposure system is based on Munsell's color classification system.

MUNSELL BOOK OF COLOR GLOSSY FINISH COLLECTION. Baltimore, MD: Munsell Color, 1976. Displays 1,488 color chips inserted in slots on forty pages. Each page represents a different hue. This is the source of the ten color charts of the stair-step system. The *Munsell Book of Color* is available only from Munsell Color. It is not available in most libraries or through the national interlibrary loan system.

MUNSELL—COLOR: NOTATION, STANDARDS, EQUIPMENT, TECHNICAL SERVICES. Baltimore, Maryland: Munsell Color. Contains a brief description of the Munsell system of color classification and applications of the Munsell system. Includes a catalog of Munsell products and technical services.

NAGLER, MONTY. "Spice Up Drab Slides with 3M Color Key." *Darkroom Photography*, July-August 1980, p. 70. The use of 3M Color Key for montages.

NEWHALL, S. M., NICKERSON, D., AND JUDD, DEANE B. "Final Report of the Optometric Society of America Subcommittee on the Spacing of the Munsell Colors." *Journal of the Optometric Society of America* 33: (1943) p. 385.

PALMER, J. S. "Slide Copying Computer." *Photographic Society of America Journal*, February 1967, pp. 35–38. Instructions for making a computer wheel that takes into account exposure factors when duplicating slides: ASA, filter factor, magnification, f/stop, and light source distance. A homemade slide-copying apparatus is also described and illustrated.

PARTRIDGE, EDWARD C. *Beginner's Guide to Photography.* New York: McBride Books, 1962. Basic camera instruction.

PATTERSON, FREEMAN. *Photography and the Art of Seeing.* Toronto: Van Nostrand Reinhold Ltd., 1979. Discussion of composition, principles of visual design, photographic expression, and color. Superbly illustrated with sixty-eight color slide reproductions in 156 pages.

REED, STEVE. "The Sky Isn't the Limit—Astrophotography." *Petersen's Photographic Magazine*, March 1980, p. 26. Determination of exposure for various night-sky pictures. Describes deep-sky photographs taken with highly specialized equipment that greatly reduces or eliminates reciprocity failure in color films.

RHODE, ROBERT, AND MCCALL, FLOYD H. *Introduction to Photography.* New York: Macmillan Company, 1965. Basic photographic instruction and use of polarizers.

ROTHSCHILD, NORMAN. "How to Double or Quadruple Your Vision." *Popular Photography*, February 1980, pp. 98–100. Multiple-exposure techniques by slide duplication. Fourteen illustrations.

————. "Multiple Exposures through Color Filters." *Popular Photography*, August 1975, p. 82. Use of deeply colored filters and various focal lengths to obtain creative results.

————. "What You Should Know About Filter Attachments." *Popular Photography*, May 1969, p. 96.

RYAN, ART, APSA. "Modular Photo Stand." *Photographic Society of America Journal*, April 1972, pp. 34–35. Illustrated article describing a multipurpose, homemade table including a slide-duplicating box.

SCIENCE OF COLOR. New York: Thomas Y. Crowell Company, 1953. Page 26: color reproduction of the refraction of a beam of white light by a glass prism. Page 247: color reproduction of the CIE chromaticity diagram.

SHELTON, KEN. "Fireworks—Photographing the Lights Fantastic." *Petersen's Photographic Magazine*, July 1980, pp. 64–67. Illustrated article describing single and multiple exposure of fireworks.

SHIPMAN, CARL. *Single Lens Reflex Photographers' Handbook.* Tucson, AZ: H. P. Books, 1977. Basic instruction for beginning and advanced photographers.

SKOGLAND, GOSTA. *Colour in Your Camera.* New York: Chilton Book Company, 1969. Good discussion of focal length and picture size, lens apertures and shutter speeds, depth of field, and color temperature.

SORENSON, ALBAN C. "Alignment of Multiple Slide Projectors." *Photographic Society of America Journal*, January 1979, p. 45. Showmanship information for program presenters who use more than one projector.

STELL, BERNARD S. "Dupes with an Enlarger." *Photographic Society of America Journal*, November 1973, pp. 42–43. Instructions for using a 35mm camera body and a photographic enlarger to make color slide duplicates.

SUSSMAN, AARON. *The Amateur Photographers' Handbook.* New York: Thomas Y. Crowell Company, 1973. Discussions of f/stop, depth of field, exposure value scale, and spot meters.

TIMMES, NANCY M. "Fireworks!" *Popular Photography*, July 1979, p. 92. Equipment and techniques for exposure of fireworks, montage of fireworks, and tinting colors.

TISCHENKO, JOHANN. "Tricks with Round Masks." *Photographic Society of America Journal*, March 1967, p. 29. Equipment and procedures for making double exposures without overlapping by masking parts of the picture.

USA STANDARD PHOTOGRAPHIC EXPOSURE GUIDE. PH2.7-1966. New York: American National Standards Institute, Inc., 1966. Provides information about natural lighting and includes graphic aids to compute exposures for daylight and moonlight photography around the world.

VAUGHAN, BRUCE. "A Convenient Slide Copier." *Photographic Society of America Journal*, November 1977, pp. 22–24. Plans and instructions for building and using a slide copier.

WACHTER, HANNAH P. "Crazy Slides with Color Key." *Photographic Society of America Journal*, August 1971, p. 17. Montage techniques using multiple layers and different hues of 3M Color Key film.

WEIGOLD, AUDREY A. "Easy to Make Titling Frame." *Photographic Society of America Journal,* January 1979, p. 19. Description of a homemade plywood frame for photographing slide titles and instructions for how to use it.

WOLF, JULIUS. "Photographing the Screen—Multiple Images." *Photographic Society of America Journal,* March 1973, p. 28. Duplication of slides by photographing them on a projection screen. Use of a five-image prism lens when duplicating slides.

WOOLEY, A. E. *Creative 35mm Techniques.* New York: A. S. Barnes and Company, 1963. Basic instruction.

WYSZECKI, GUNTER, AND STILES, W. S. *Color Science: Concepts and Methods, Quantitative Data and Formulas.* New York: John Wiley and Sons, Inc., 1967. Technical discussion of polarizers, lightness scales and reflectance curves of four experiments including the Munsell system, the Munsell color classification system and nine diagrams showing locations of Munsell hue and chroma chips on the CIE chromaticity diagrams for nine Munsell values.

INDEX